CRITICIZING
PHOTOGRAPHS

CRITICIZING PHOTOGRAPHS

AN INTRODUCTION TO UNDERSTANDING IMAGES

TERRY BARRETT
THE OHIO STATE UNIVERSITY

Mayfield Publishing Company
Mountain View, California
London • Toronto

Library of Congress Cataloging-in-Publication Data
Barrett, Terry Michael
 Criticizing photographs: an introduction to understanding images
 / Terry Barrett.
 p. cm.
 Includes bibliographical references (p.) and index.
 1. Photography, Artistic. I. Title.
 TR642.B365 1990
 770'. 1—dc20 90–6292
 CIP

Manufactured in the United States of America
10 9 8 7 6 5 4 3 2 1

Mayfield Publishing Company
1240 Villa Street
Mountain View, California 94041

Sponsoring editor, Janet M. Beatty; managing editor, Linda Toy; production editor, Sondra
Glider; manuscript editor, Margaret Moore; text and cover designer, Jeanne M. Schreiber;
production artist, Jean Mailander. The text was set in 10.5/12.5 Times and printed on 50#
Finch Opaque by Malloy Lithographing.

Photograph credits appear on a continuation of the copyright page, p. 168.

Cover image: William Wegman, *Leopard/Zebra-Zebra/Leopard,* 1981, Polacolor II prints,
61.0 x 105.0 cm, loan of Sherry and Alan Koppel, RX17461, © The Art Institute of Chicago.
All rights reserved.

For Dad

CONTENTS

PREFACE

Years of teaching art criticism have convinced me that one of the best ways to appreciate an image is to observe, think, and talk about it. This is what art criticism entails, and it's what this book is about. My goal is to help both beginning and advanced students of photography use the activities of criticism in order to better appreciate and understand photographs.

The book is organized according to the major activities of criticism which Morris Weitz identified in his study of *Hamlet* criticism, namely, describing, interpreting, evaluating, and theorizing. His breakdown is sufficiently broad so as not to exclude any considerations about criticism, and sufficiently narrow to provide a directed and clear consideration of the complex activities of criticizing photographs. The goal of these activities is always increased appreciation an understanding, or what Harry Broudy, the father of aesthetic education, calls "enlightened cherishing." I like his compound concept because it acknowledges feeling as well as thought, without creating a dichotomy.

The following chapters consider describing photographs, interpreting and evaluating them, and theorizing about photography, in that order. I've placed major emphasis on the interpretation of photographs because I believe that discussion of meaning is more important than pronouncements of judgment and that interpretation is the most important and rewarding aspect of criticism. Interpretive discussion increases understanding and thus deepens appreciation, whether that appreciation is ultimately negative or positive. A judgment rendered without an understanding is irresponsive and irresponsible. Unfortunately, *criticism* is too frequently confused with negative value judgments because of its everyday connotations. The term *criticism* in the language of aesthetics encompasses much more.

For the present, at the risk of oversimplification, the four activities of criticism—describing, interpreting, evaluating, and theorizing—can be thought of as seeking answers to four basic questions: What is here? What is it about? How good is it? Is it art? This book explores the criticism of photographs by means of these major questions.

The book also provides a variety of answers to these questions by critics who sometimes agree and sometimes disagree about the same photographs. I've cited dozens of critics and many more photographers. In my selections I've tried to present a diversity of critical voices to responsibly provide readers a range of critical stances and approaches from which to choose. I chose these particular critics and photographers as being especially appropriate to the points being discussed; no hierarchy of critics or photographers is implied by my choices.

Two appendixes should prove helpful to students who are asked to write about or critique photographs. Appendix A, Writing About Photographs, provides some practical guidelines about choosing a topic, noting down thoughts, organizing information, drafting a paper, and refining a draft. Appendix B, Talking About Photographs, offers students advice on conducting considerate and caring discussions of their classmates photographs.

I love photography, students, teaching, and writing. I hope these feelings infuse this book with a passion that each reader feels and responds to in his or her own consideration of photographs.

ACKNOWLEDGMENTS

This book may never have happened without my serendipitous meeting of Jan Beatty of Mayfield and her continued gentle and joyful handling of the entire editorial process. All of the Mayfield staff have been extremely pleasant to work with, especially Sondra Glider, Margaret Moore, and Debby Horowitz. The book would be more flawed than it may be without the careful and diligent reading and reflecting, chapter by chapter, of Mike Parsons. Mom and Jesse provided frequent and supportive interest in the book from afar. Its writing certainly would not have been as enjoyable without the loving celebrations, each step along the way, of Pam Reese.

I'd also like to thank the reviewers of this manuscript for their incisive comments, especially Bea Nettles, University of Illinois, as well as Thomas Barrow, University of New Mexico; Daryl Curran, California State University, Fullerton; Carol Flax, California State University, Northridge; Dan Powell, University of Oregon; David Read, University of Nebraska; Richard Stevens, University of Notre Dame; and Stan Strembicki, Washington University.

1
ABOUT ART CRITICISM

DEFINING CRITICISM

This book is about reading and doing photography criticism, so that you can better appreciate photographs by means of the critical process. Unfortunately, we usually don't equate criticism with appreciation because in everyday language the term *criticism* has negative connotations: It is used to refer to the act of making judgments, usually negative judgments, and the act of expressing disapproval. In mass media, critics are portrayed as judges of art: Reviewers in newspapers give movies one to four stars, and critics on television rate movies from 1 to 10. Of all the words art critics write, those most often quoted are judgments: "The best play of the season!" "Dazzling!" "Brilliant!" These are the words highlighted in bold type in movie and theater ads because these are the words that sell tickets. But they comprise few of the critic's total output of words, and they have been quoted out of context. The value of these snippets for our reaching an understanding of a play or a movie is minimal.

Some critics don't want to be called critics because of the negative connotations of the term. Art critic and poet Rene Ricard, writing in *Artforum,* says: "In point of fact I'm not an art critic. I am an enthusiast. I like to drum up interest in artists who have somehow inspired me to be able to say something about their work."[1] Similarly, Lucy Lippard is usually supportive of the art she writes about, but she says she is sometimes accused of not being critical, of not being a critic at all. She responds, "That's okay with me, since I never liked the term anyway. Its negative connotations place the writer in fundamental antagonism to the artists."[2] She and other critics do not want to be thought of as being opposed to artists.

The term *criticism,* however, is complex: It has several different meanings. In the language of aestheticians who philosophize about art and art criticism, and in the language of art critics, criticism usually refers to a much broader range of activities than just the act of judging. Morris Weitz, an aesthetician interested in art criticism, sought to discover more about it by studying what critics do when they criticize art.[3] He took as his test case all the criticism ever written about Shakespeare's *Hamlet.* After reading the several books of *Hamlet* criticism written through the ages, Weitz concluded that when critics criticize they do one or more of four things: They *describe* the work of art, they *interpret* it, they *evaluate* it, and they *theorize* about it. Some critics engage primarily in descriptive criticism; others describe, but mainly as a means of furthering their interpretations; still others do all four activities. Weitz drew several conclusions about criticism, most notably that any one of these four activities constitutes criticism and that evaluation is not a necessary part of criticism. He found that several critics criticized *Hamlet* without ever judging it.

When critics criticize they do much more than express their likes and dislikes—and much more than approve and disapprove of works of art. Critics do judge artworks, and sometimes negatively, but often their judgments are positive rather than negative: As Rene Ricard says, "Why give publicity to something you hate?" Abigail Solomon-Godeau, who writes frequently about photography, says there are instances when it is clear that something is nonsense and should be called nonsense, but she finds it more beneficial to ask questions about meaning than about aesthetic worth.[4]

Edmund Feldman, an art historian and art educator, has written much about art criticism and defines it as "informed talk about art."[5] He also minimizes the act of evaluation, or judging art, saying that it is the least important of the critical procedures. A. D. Coleman, a pioneering and prolific critic of recent photography, defines what he does as "the intersecting of photographic images with words."[6] He adds: "I merely look closely at and into all sorts of photographic images and attempt to pinpoint in words what they provoke me to feel and think and understand." Morris Weitz defines criticism as "a form of studied discourse about works of art. It is a use of language designed to facilitate and enrich the understanding of art."[7]

Throughout this book the term *criticism* will not refer to the act of negative judgment; it will refer to a much wider range of activities and will adhere to this broad definition: Criticism is informed discourse about art to increase understanding and appreciation of art. This definition includes criticism of all artforms including dance, music, poetry, painting, and photography. "Discourse" includes talking and writing. "Informed" is an important qualifier that distinguishes criticism from mere talk and uninformed opinion about art. Not all writing about art is criticism. Some art writing, for example, is journalism rather than criticism: It is news reporting on artists and artworld events rather than critical analysis.

A way of becoming informed about art is by critically thinking about it. Criticism is a means toward the end of understanding and appreciating photographs.

In some cases, a carefully thought-out response to a photograph may result in negative appreciation or informed dislike. More often than not, however, especially when considering the work of prominent photographers, careful critical attention to a photograph or group of photographs will result in fuller understanding and positive appreciation. Criticism should result in what Harry Broudy, a philosopher promoting aesthetic education, calls "enlightened cherishing."[8] Broudy's "enlightened cherishing" is a compound concept that combines *thought* (by the term *enlightened)* with *feeling* (by the term *cherishing)*. He reminds us that both thought and feeling are necessary components that need to be combined to achieve understanding and appreciation. Criticism is not a coldly intellectual endeavor.

SOURCES OF CRITICISM

Photography criticism can be found in many places, in photography classrooms, lecture halls, and publications. Published criticism appears in books, exhibition catalogues, art magazines, photography magazines, and in the popular press. Susan Sontag's criticism of photography began as a series of articles and became the book *On Photography.* Jonathan Green's book *American Photography* is a critical treatment of recent American photography. Much critical writing about photography has appeared in exhibition catalogues such as *The New Color Photography* by Sally Eauclaire and *Mirrors and Windows* by John Szarkowski. These two catalogues are based on exhibitions that these curators have organized. As curator of photography at the Museum of Modern Art in New York, Szarkowski organizes many exhibitions and often prepares accompanying exhibition catalogues. Sally Eauclaire is a freelance curator who designs shows for museums and prepares catalogues. Exhibition catalogues list the exhibited works, reproduce several if not all of the pictures, and usually have an introductory essay explaining why the curator selected this group of works for an exhibition. Such essays often offer insightful interpretive commentary on photographs and photographers. After the exhibitions, the catalogues are marketed as books and take on a life of their own.

The majority of photography criticism, however, is found in the art press—the large art magazines such as *Artforum* and *Art in America,* and regional art journals such as *Dialogue* from Columbus, Ohio, *New Art Examiner* from Chicago, and *Artweek* from California. Much photography criticism is also published in journals specifically devoted to photographic media, such as *Afterimage,* or in photography publications including *Aperture* and *Exposure.* Reviews of photography exhibitions appear in daily newspapers of national import such as the *New York Times* and in local newspapers. Some critics choose to write for very large audiences and publish in mass media circulations: Abigail Solomon-Godeau has published her criticism in *Vogue,* and Robert Hughes and Douglas Davis write art criticism for *Time* and *Newsweek.*

Each of these publications has its own editorial tone and policy, and critics

sometimes choose their publications according to their style of writing and their critical interests. They also adapt their styles to fit certain publications. Editors often provide direction, sometimes quite specifically. The *New Art Examiner,* for instance, instructs its reviewers that "the writer's opinion of the work is the backbone of a review. Set up your thesis by the third paragraph and use the rest of the space to substantiate it."[9] The editors add: "Keep descriptions brief and within the context of the ideas you are developing." *Dialogue* similarly defines reviews as the "personal assessments of individual shows or of more than one related show or event."[10] *Dialogue's* editors also ask that writers include only sufficient description for intelligibility but add: "Use descriptions to help the reader see the work in a new way and/or to illuminate connections between the exhibited work and the larger art world." Both publications distinguish short reviews from feature articles and have different editorial guidelines for each.

Policies about what they cover vary from publication to publication, too. Grace Glueck, an art critic for the *New York Times,* explains that her paper covers important museum and gallery shows because that is what the readers expect. Similarly, because his magazine is national and devotes comparatively little space to art, Mark Stevens of *Newsweek* covers museum shows, almost exclusively, but tries to write about as many museum shows of contemporary art as possible. Kay Larson, however, says, "I write about what interests me."[11] She writes for the weekly *New York Magazine* and, like many critics, has editorial independence about what she covers. She explains that she tries to see everything in town that she can manage to see, looks for things that she likes, and then makes her choices about what to write: "Ultimately I base my decisions not only on whom I like but whom I feel I can say something about. There are many artists every week whom I do like and whom I feel I can't say anything about."

DIFFERENT AUDIENCES

When critics write for different publications, they are writing for different audiences. Their choices of what to write about and their approaches to their chosen or assigned topics vary according to which publication they are writing for and who they imagine their readers to be. A review of an exhibition written for a daily newspaper of a small midwestern city will likely differ in tone and content from a review written for the Sunday *New York Times* because the readers are different. The *Times* has national as well as regional distribution, and its readers are better informed about the arts than are average newspaper readers; a critic writing for the *Times* can assume knowledge that a critic writing for a regional newspaper cannot.

A. D. Coleman's topics, for example, change according to the sponsoring publication. When writing regularly for the *Times,* for instance, Coleman usually reviewed the current shows of recent work by contemporary photographers. He was limited to about 1,500 words, sometimes with one reproduction, for his reviews

of the work of such photographers as Roy DeCarava, Robert Heinecken, Bruce Davidson, Duane Michals, Diane Arbus, Les Krims, Bea Nettles, Judy Dater, Emmet Gowin, Abigail Heyman and Imogen Cunningham, and others. When writing occasionally for *Artforum,* however, Coleman had at least three times the space and more reproductions, and he could develop larger themes and bigger ideas. In "The Directorial Mode: Notes Toward a Definition," for example, he identified and defined a whole genre of photography, "directorial photography," which accounted for a large segment of work by several different photographers, and he distinguished it from other types of photography. That article is more theoretical and inclusive than his shorter and more specific reviews.

KINDS OF CRITICISM

In an editorial in the *Journal of Aesthetic Education,* Ralph Smith distinguishes two types of aesthetic criticism, both of which are useful, but for different purposes: exploratory aesthetic criticism and argumentative aesthetic criticism. In doing exploratory aesthetic criticism, a critic delays judgments of value and attempts rather to ascertain an object's aesthetic aspects as completely as possible, to ensure that readers will experience all that can be seen in a work of art. This kind of criticism relies heavily on descriptive and interpretive thought. Its aim is to sustain aesthetic experience. In doing argumentative aesthetic criticism, after sufficient interpretive analysis has been done, critics estimate the work's positive aspects, or lack of them, and give a full account of their judgments based on explicitly stated criteria and standards. The critics argue in favor of their judgments and attempt to persuade others that the object is best considered in the way they have interpreted and judged it, and they are prepared to defend their conclusions.

Andy Grundberg, a photography critic for the *New York Times,* perceives two basic approaches to photography criticism: the applied and the theoretical. Applied criticism is practical, immediate, and directed at the work; theoretical criticism is more philosophical, attempts to define photography, and uses photographs only as examples to clarify its arguments. Applied criticism tends toward journalism; theoretical criticism tends toward aesthetics.[12]

Examples of applied criticism are reviews of shows, such as those written by A. D. Coleman. Coleman also writes theoretical criticism as in his "Directorial Mode" article. Other examples of theoretical criticism are the writings of Allan Sekula, such as his essay "The Invention of Photographic Meaning," in which he explores how photographs mean and how photography signifies. He is interested in all of photography, or in photographs as kinds of pictures, and only refers to specific photographs and individual photographers to support his broadly theoretical arguments. Similarly, Roland Barthes's book, *Camera Lucida: Reflections on Photography,* is a theoretical treatment of photography that attempts to distinguish photography from other kinds of picture making. Later in this book we will explore

in detail theories of art and photography, theoretical criticism, and how theory influences both criticism and photography.

Grundberg also identifies another type of criticism as "connoisseurship," which he rejects as severely limited. The connoisseur, of wine or photographs, asks "Is this good or bad?" and makes a proclamation based on his or her particular taste. This kind of criticism, which is often used in casual speech and sometimes found in professional writing, is extremely limited in scope because the judgments it yields are usually proclaimed without supporting reasons or the benefit of explicit criteria, and thus they are neither very informative nor useful. Statements based on taste are simply too idiosyncratic to be worth disputing. As Grundberg adds, "Criticism's task is to make arguments, not pronouncements."

THE BACKGROUNDS OF CRITICS

Critics come to criticism from varied backgrounds. Many art critics have advanced degrees in art history and support themselves by teaching art history as they write criticism. Several come from studio art backgrounds. Some critics are exhibiting artists who write criticism, such as Peter Plagens, who is a painter and a critic, and Barbara Kruger, who exhibits photographs and writes criticism. Rene Ricard is a poet and critic; Carrie Rickey writes film criticism for the popular press and art criticism for the art press.

A. D. Coleman became a full-time, freelance critic of photography in 1968. He wrote a regular column called "Latent Image" for the *Village Voice* and also wrote for *Popular Photography* and the Sunday *New York Times*. Since 1974 he has written for a variety of publications including *Artforum* and currently is photography critic for the weekly *New York Observer*. He also provides commentary for National Public Radio's "Performance Today." Coleman is not a photographer and was never formally schooled in photography; prior to writing about photography, he wrote theater criticism for the *Village Voice*. He began writing about photography because he was "excited by photographs, curious about the medium, and fascinated—even frightened—by its impact on our culture." He thinks of himself as a voice from the audience of photography and wrote over four hundred articles from that vantage between 1968 and 1978.

Before she began writing photography criticism, Abigail Solomon-Godeau, was a photo editor with an undergraduate degree in art history, and her own business of providing pictures for magazines, textbook publishers, educational film strips, and advertisers. She eventually became bored with her work and also became aware that she was part of what culture critics were deriding as the "consciousness industry." About that she says: "Here was an enterprise that was literally producing a certain reality that people, or students, or whoever, wouldn't question because it was perceived as real [because it was photographed]. That's when I started thinking that I would really like to write about photography."[13] After trying for two years to make a living as a critic in New York, she realized that the only way

she could economically survive as a critic was to teach. She earned her Ph.D. in art history to gain access to jobs in higher education. While teaching, she writes for publications as diverse as *Vogue, Afterimage,* and *October.*

Grace Glueck believes that to become educated the critic needs to look at as much art as possible and at "anything that deals with form including architecture, movies, dance, theater, even street furniture." Mark Stevens agrees and stresses the importance of spending time in museums: "Immersion in excellent examples of different kinds of past art is the best training for the eye."

STANCES TOWARD CRITICISM

Criticism is a complex activity and critics take various stances on what criticism should be and how it should be conducted. Abigail Solomon-Godeau views her chosen critical agenda as one of asking questions: "Primarily, all critical practices—literary or artistic—should probably be about asking questions. That's what I do in my teaching and it's what I attempt to do in my writing. Of course, there are certain instances in which you can say with certainty, 'this is what's going on here,' or 'this is nonsense, mystification or falsification.' But in the most profound sense, this is still asking—what does it mean, how does it work, can we think something differently about it."[14]

Grace Glueck sees her role as a critic as being one of informing members of the public about works of art: She aspires to "inform, elucidate, explain, and enlighten."[15] She wants "to help a reader place art in a context, establish where it's coming from, what feeds it, how it stacks up in relation to other art." Glueck is quick to add, however, that she needs to take stands "against slipshod standards, sloppy work, imprecision, mistaken notions, and *for* good work of whatever stripe."

Coleman specified, in 1975, his premises and parameters for critical writing:

> A critic should be independent of the artists and institutions about which he/she writes. His/her writing should appear regularly in a magazine, newspaper, or other forum of opinion. The work considered within that writing should be publicly accessible, and at least in part should represent the output of the critic's contemporaries and/or younger, less established artists in all their diversity. And he/she should be willing to adopt openly that skeptic's posture which is necessary to serious criticism. [16]

These are clear statements of what Coleman believes criticism should be and how it should be conducted. He is arguing for an independent, skeptical criticism and for critics who are independent of artists and the museums and galleries that sponsor those artists. He is acutely aware of possible conflicts of interest between critic and artist or critic and institutional sponsor: He does not want the critic to be anyone's mouthpiece but rather to be an independent voice. Coleman argues that because criticism is a public activity, the critic's writing should be available to interested readers, and that the artwork which is criticized should also be open to public

scrutiny. This would presumably preclude a critic's visiting an artist's studio and writing about that work, because that work is only privately available.

Coleman makes a distinction between curators and historians who write about art, and critics. He argues that curators, who gather work and show it in galleries and museums, and historians, who place older work in context, write from privileged positions: The historian's is the privilege of hindsight; the curator's is the power of patronage. Coleman cautions that the writer, historian, curator, or critic who befriends the artist by sponsoring his or her work will have a difficult time being skeptical. He is quick to point out, however, that skepticism is not enmity or hostility. Coleman's goal is one of constructive, affirmative criticism, and he adds: "The greatest abuses of a critic's role stem from the hunger for power and the need to be liked."[17]

Mark Stevens agrees that there should be distinctions maintained between writing criticism and writing history: "The trouble with acting like an art historian is that it detracts from the job critics can do better than anybody else, and that is to be lively, spontaneous, impressionistic, quick to the present—shapers, in short, of the mind of the moment."[18]

Lucy Lippard is a widely published independent art critic who assumes a posture different from Coleman's, and her personal policies for criticism are in disagreement with those of his just cited. She terms her art writing "advocacy criticism."[19] As an "advocate critic" Lippard is openly leftist and feminist and rejects the notion that good criticism is objective criticism. Instead, she wants a criticism that takes a political stand. She seeks out and promotes "the unheard voices, the unseen images, or the unconsidered people." She chooses to write about art that is critical of mainstream society and which is therefore not often exhibited. Lippard chooses to work in partnership with socially oppositional artists to get their work seen and their voices heard.

Lippard also rejects as a false dichotomy that there should be distance between critics and artists. She says that her ideas about art have consistently emerged from contact with artists and their studios rather than from galleries and magazines. She acknowledges that the lines between advocacy, promotion, and propaganda are thin, but she rejects critical objectivity and neutrality as false myths and thinks her approach is more honest than that of critics who claim to be removed from special interests.

CRITICS AND ARTISTS

Lippard and Coleman raise a key question in criticism about the critic's relation to the artist. And they each have different answers: Coleman advocates a skeptical distance between critic and artist, and Lippard a partnership between them. These are two polar positions and critics take various positions between them. Kay Larson, for example, feels that to be informed she is required to study history and also to

"talk to artists."[20] She struggles with the issue of responsibility and states, "Your responsibility to the artist is to be as fair as possible," and in a second thought adds, "You have a responsibility to your taste and values." Mark Stevens sees his primary responsibility being "to his own opinion." He also tries "to be fair, and not to be nasty," and he regrets the few times he's been sarcastic.[21] He thinks that knowing artists is difficult because he doesn't want to hurt their feelings or champion work that he doesn't think is good. He thinks "it's probably a bad idea to know artists too well, to accept works of art or to know dealers too well."

Editors of criticism publications are also sensitive to issues of integrity and possible conflicts of interest between a critic and an artist or institution. The *New Art Examiner,* for example, declares in bold type in its reviewer's guidelines: "Under no circumstances are manuscripts to be shared with outsiders (the artist, dealer, sponsor, etc.)." *Dialogue* disallows reviews from writers who have a business interest in a gallery where the show is located, a close personal relationship with the exhibiting artist, any position within the sponsoring institution, and previous experiences with the artist or sponsoring institution. These policies are instituted to avoid damage to a publication's and a writer's credibility.

There aren't easy answers to questions of the ethics of criticism, or to deciding personal or editorial policy. The question is less difficult, however, if we realize that critics write for readers other than the artist whose work they are considering. Critics do not write criticism for the one painter or photographer who is exhibiting; they write for a public. Grace Glueck thinks that, at best, the critic gives the artist an idea of how his or her work is being perceived or misperceived by the public.

The relation between the critic and the artist also becomes less clear when we realize that criticism is much more than the judging of art. This point is easily forgotten because in art studios, in schools, and in classrooms of photography, criticism is often, unfortunately, understood solely as judgment. The primary purpose of school criticism is usually seen very narrowly as the improvement of art making; little time is spent in describing student work, interpreting it, or in examining assumptions about what art is or is not.[22] Thus we tend to think that published professional criticism is judgment and judgment for the artist and the improvement of art making. This conception of professional criticism, as we have seen, is far from accurate.

CRITICIZING CRITICISM

Although these critics have seriously considered their positions regarding criticism, their positions differ, and their theories and approaches do not combine into a cohesive and comprehensive single theory of criticism. Quite the contrary. Critics frequently take issue with each other's ideas. Art critic Hilton Kramer has dismissed Lucy Lippard's writing as "straightout political propaganda."[23] John Szarkowski is frequently accused by socially minded critics of "aestheticizing" photographs—

turning too many of them into "art," particularly socially oppositional photographs. Allan Sekula's writing is so suspicious of photography that it has been called "almost paranoid" and has been likened to a history of women written by a misogynist.[24] These conflicting views contribute to an ongoing, interesting, and informative dialogue about criticism and photographs that enlivens the reading of criticism as well as the viewing of photographs.

Art critic Donald Kuspit is the editor of a series of books that anthologize the major writings of such contemporary art critics as Lawrence Alloway, Dennis Adrian, Dore Ashton, Nicolas Calas, Joseph Masheck, Robert Pincus-Witten, Peter Plagens, and Peter Seltz. In his foreword to their writings, he calls them "master art critics" and provides some reasons for his positive appraisal of their criticism. He thinks they provide sophisticated treatment of complex art. They have all thought deeply about the nature of art criticism and have seriously considered how they should go about doing it. He praises the independence of their points of view and their self-consciousness about it. Kuspit knows they have all expanded their criticism well beyond journalistic reporting and have avoided promotional reporting of the artist stars of their day. He admires that these critics are passionate about art and their criticism and that they depend on reason to prove their point. In their passion and reason they have avoided becoming dogmatic—they "sting us into consciousness."

In these statements Kuspit provides criteria for good criticism by which he can measure and weigh the writings of others about art. Mark Stevens offers these criteria for good criticism: Critics should be "honest in their judgment, clear in their writing, straightforward in their argument, and unpretentious in their manner."[25] He adds that good criticism is like good conversation— "direct, fresh, personal, incomplete." Not all criticism is good criticism, and even if all criticism were good criticism, critics would have differing points of view and would want to argue them. Those in the business of criticizing art and criticizing criticism understand that what they do is tentative, or "incomplete" in Stevens's terms, open to revision, and vulnerable to counterargument. The best of critics realize that they cannot afford to be dogmatic about their views because they can always be corrected. They can be passionate and often are, but the best of them rely on reason rather than emotion to convince another of their way of seeing a work of art. Critics believe in how they see and in what they write, and they try to persuade their readers that their way is the best way, or at least a very good way, to see and understand. They are also open to another's point of view, but that other will likewise have to persuade them, on the basis of reason, before they change their views.

THE VALUE OF CRITICISM

The value of *reading* good criticism is increased knowledge and appreciation of art. Reading about art with which we are unfamiliar increases our knowledge. If we already know and appreciate an artwork, reading someone else's view of it may

expand our own if we agree, or it may intensify our own if we choose to disagree and formulate counterarguments.

There are also considerable advantages for *doing* criticism. Marcia Siegel, dance critic for *The Hudson Review* and author of several books of dance criticism, talks about the value for her of the process of writing criticism: "Very often it turns out that as I write about something, it gets better. It's not that I'm so enthusiastic that I make it better, but that in writing, because the words are an instrument of thinking, I can often get deeper into a choreographer's thoughts or processes and see more logic, more reason."[26]

Similarly, A. D. Coleman began studying photography and writing photography criticism in the late 1960s because he realized that photography was shaping him and his culture; he wanted to know more about it and "came to feel that there might be some value to threshing out, in public and in print, some understandings of the medium's role in our lives."[27] For him the process of doing criticism was valuable toward understanding photographs, and he hoped that his thinking in public and in print would help him and others to better understand photographs and their effects on viewers.

If the process of doing criticism is personally valuable even for frequently published, professional critics, then it is likely that there are considerable advantages for others who are less experienced with criticizing art. An immediate advantage of engaging thoughtfully with an artwork is that the observer's viewing time is slowed down and measurably prolonged. This point is obvious but important: Most people visiting museums consider an artwork in less than five seconds. Five seconds of viewing compared to hours and hours of crafting by the artist seems woefully out of balance. Considering descriptive, interpretive, and evaluative questions about an artwork ought to significantly expand one's attention to an artwork and considerably alter one's perception of the work.

By criticizing an art object for a reader or viewer, critics must struggle to translate their complex jumble of thoughts and feelings about art into words that can be understood first by themselves and then by others. Everyday viewers of art can walk away from a picture or an exhibit with minimal responses, unarticulated feelings, and incomplete thoughts. Critics who view artworks as professionals, however, have a responsibility to struggle with meaning and address questions that the artwork poses, or to raise questions that the artwork does not.

Critics usually consider artworks from a broader perspective than the single picture or the single show. They put the work in a much larger context of other works by the artist, works by other artists of the day, and art of the past. They are able to do this because they see much more art than does the average viewer—they consider art for a living. Their audiences will not be satisfied with one-word responses, quick dismissals, or empty praises. Critics have to argue for their positions and base their arguments on the artwork and how they understand it. Viewers who consider art as a critic would consider it will likely increase their own understanding and appreciation of art—that is the goal and the reward.

2
DESCRIBING PHOTOGRAPHS

DEFINING DESCRIPTION

To describe a photograph, or an exhibition, is to notice things about it and to tell another, out loud or in print, what one notices. Description is a data-gathering process, a listing of facts. Descriptions are answers to the questions: What is here? What am I looking at? What do I know with certainty about this image? The answers are identifications of both the obvious and not so obvious. Even when certain things seem obvious to critics, they point them out because they know that what is obvious to one viewer might be invisible to another. Descriptive information includes statements about the photograph's subject matter, medium, and form, and then more generally, about the photograph's causal environment, including information about the photographer who made it, the times during which it was made, and the social milieu from which it emerged. Descriptive information is true (or false), accurate (or inaccurate), factual (or contrary to fact): Avedon either used an 8 x 10 Deardorff or he didn't; he either exposed more than 17,000 sheets of film or he didn't. Descriptive statements are verifiable by observation and an appeal to factual evidence. Although in principle descriptive claims can be shown to be true or false, in practice critics sometimes find it difficult to do so.

Critics obtain descriptive information from two sources—internal and external. They derive much descriptive information by closely attending to what can be seen within the photograph. They also seek descriptive information from external sources including libraries, the artists who made the pictures, press releases, and other sources.

Describing is a logical place to start when viewing an exhibition or a particular photograph because it is a means of gathering basic information upon

which understanding is built. Psychologically, however, we often want to judge first, and our first statements often express approval or disapproval. There is nothing inherently wrong with judging first as long as we realize that responsible judgments need to be informed and relevant information needs to be descriptively accurate. Whether we judge first and then revise a judgment based on description, or describe and interpret first and then judge, is a matter of choice. The starting point is not crucial, but accurate description is an essential part of holding defensible critical positions. Interpretations and judgments that omit facts or are contrary to fact are seriously flawed.

Critics inevitably and frequently describe, but in print they don't necessarily first describe, next interpret, and then judge. They might first describe to themselves privately before they write, but in print they might start with a judgment, or an interpretive thesis, or a question, or a quotation, or any number of literary devices, in order to get and hold the attention of their readers. They would probably be dreadfully boring if they first described and then interpreted and then judged. In the same sentence critics often mix descriptive information with an interpretive claim or with a judgment of value. For our immediate aim of learning the descriptive process of criticism, however, we are sorting and highlighting descriptive data in the writing of critics.

DAVIS ON AVEDON'S "IN THE AMERICAN WEST"

When Richard Avedon's photographs "In the American West" were first shown, Douglas Davis was in the difficult position in which art critics often find themselves—he had to write some of the first words about some new and challenging work. He also had to write for an audience of readers who had not seen the work. Avedon's American West work is now relatively well known because it has been exhibited and in book form since 1985,[1] and it has been considered by several critics. But the work wasn't known when Davis wrote about it for *Newsweek* magazine, shortly after its inaugural exhibition opened. His article is one magazine page plus a column in length, about 1,000 words, and is accompanied by four of Avedon's photographs from the exhibition. Davis's review is full of descriptive information, that is, facts and verifiable observations about the work in question.

He opens his article with this sentence: "In the thick of the crowd of portraits on display in Ft. Worth by famed fashion photographer Richard Avedon to document the American West, there is one immensely ambitious—and revealing—triptych."[2] Thus, because his readers may or may not know of Richard Avedon, Davis quickly and without condescension informs them that Avedon is a famed fashion photographer. He also explains that the show is of portraits, that there are a lot of them—"in the thick of the crowd of portraits"—and that they are on display in Ft. Worth. That they are on display in Ft. Worth, although basic, is interesting to note because major shows by a famed fashion photographer, and by Avedon, are more likely to open in New York City than in a city in Texas. That

they were made "to document" the American West becomes important for Davis's ultimate judgment of the show.

Davis begins his review of the show by discussing one piece, which he calls "immensely ambitious" and "revealing." It is a complicated piece and not re-printed with the article. Our mental image of it depends on Davis's description: "More than 10 feet long, almost 5 feet high, it is the largest image in an exhibition dominated by life-size faces and torsos." The work is very large by photographic standards; Davis emphasizes the dimensions of it and also reveals that most of the show is life-size: "Here we stand face to face with four grimy coal miners lined up across three separate photographs." Readers who may not know the term *trip-tych* can now decipher that this piece is composed of three separate photographs. Davis identifies the subject matter of this piece as four coal miners whom he describes as "grimy" and as "lined up." He also describes the experience of viewing this large image: "we stand face to face" with them.

Davis's description of the images' size is important to note because when and if his readers see these photographs they will likely see them as pages in Avedon's book, small reproductions in magazines or newspapers, or perhaps as slides on a screen in a classroom, but not as they were presented life-size in a museum. One of the purposes of descriptive accounts is for understanding in the present; another is to accurately record for posterity. Some of today's criticism of new work will eventually become part of the art historical accounts for future generations long after exhibitions have closed.

Davis then explains that one of the four miners in the triptych appears twice, with his face split by the separation between two of the three pictures. Davis finds this split "hypnotic and arresting." In one picture the miner wears a beard and in the other he does not. Davis explains that Avedon photographed the miner twice, at three-month intervals: the first time the miner had a beard, the second time he did not.

All of this description of the one triptych appears in Davis's first paragraph of the article. And this information sets up his ensuing interpretation of what the work is about and then his evaluative conclusion about how good it is: "In many ways, Avedon's long awaited new body of work . . . is as two faced as this miner."

For Davis, this new work is two-faced because, first, it has been promoted as a forthright, direct, and "documentary" treatment of the West and as a depar-ture from Avedon's high-fashion style for which he is famous. But according to Davis, although the photographs may seem candid and spontaneous, they are highly contrived: "As always he pursued style, manner and effect." The show, Davis concludes in the last sentence of the article, does not document the West, but rather documents Avedon himself and his style. Thus, Davis's judgment is mixed: The show fails because it is not an accurate documentation of the West as it was promoted and as it pretends; but it succeeds as the continuation of a photographer's "exhilarating pursuit of the perfect photographic style."

Between the opening paragraph about the triptych and the concluding paragraph containing Davis's judgment of the work are three paragraphs of descriptive information. Not only are descriptions interesting and enlightening in themselves, but they are also used to support a critic's interpretation and judgment. Davis's interpretation of the work is that it is very stylized, and his judgment is that the work both fails and succeeds because of its stylization. We and other critics may agree or disagree with Davis's decisions about Avedon's work, and in Chapters 3–6 we will fully consider interpreting and judging photographs, but our primary concern here is description. Although description, interpretation, and evaluation overlap in a critic's writing, often in the same phrase or sentence, we will continue sorting out Davis's descriptive language and consider all the descriptive information he provides in his brief article.

In the next paragraph we learn that the work was long-awaited and that it has been highly advertised as different from the work that made Avedon famous in the sixties. Davis typifies the style of earlier work as "mannered high-fashion." In the first paragraph he said there were many photographs; now he specifies that there are 124 pictures on display and that they are reproduced in a book published by Abrams. In a judgment and not a description, Davis calls the book "handsome." He also adds that the photographs have "seeming candor and spontaneity."

In the third paragraph Davis informs that this work was commissioned in 1980 by the Amon Carter Museum of Ft. Worth where the show opened. Davis tells us that Avedon traveled extensively and went to the Rattlesnake Roundup in Sweetwater, Texas, to a rodeo in Augusta, Montana, and to coal mines in Paonia, Colorado. He held 752 photo sessions and shot 17,000 pictures. Davis states that Avedon's project was as immense as the documentary efforts of William Henry Jackson and Edward Curtis, who also surveyed regions of the American West in the late nineteenth and early twentieth centuries.

In the fourth paragraph Davis discusses Avedon's method of shooting. He tells us that Avedon has "a bare chested beekeeper stand before the lens with scores of bees crawling across his skin." Davis claims that Avedon's subjects seem relaxed and real, and he attributes this to Avedon's method of photographing, which he also describes. He relates that in making these photographs Avedon used an 8 x 10 inch Deardorff camera, permitting him to stand close to the subjects, talk with them, and snap the shutter while he was standing away from the camera. Davis observes that the backgrounds are all uniformly white, made with a sheet of seamless paper hung behind the subjects; that the exposures were by natural daylight; and that all the prints are enlarged from uncropped and unretouched negatives.

In the final paragraph he quotes Avedon as saying that when looking at one of these photographs he wants us to believe that the subject "was not even in the presence of a photographer." He offers more descriptive language about Avedon's stylistic treatment of the subjects—"the deadpan stare into the camera, the slouch

Richard Avedon, *Carl Hoefert, Unemployed Blackjack Dealer, Reno, Nevada, 8/30/83*, 47 1/2" x 37 1/2".

of the body, the cropped arm or head at the edge of the frame." He describes the subject matter of another picture as a "burly lumber salesman holding his impassive baby upside down" and mentions another coal miner who has a face "painted with rock dust" before he draws his conclusion in his final sentence, quoted earlier, that Avedon exhilaratingly pursues the perfect photographic style.

OTHER CRITICS ON AVEDON

Davis's article is written for a mass circulation magazine with readers of diverse interests. It is relatively short, of "review" length rather than "feature" length. Another review of about the same length was published in *Artforum*[3] in the same month that Davis's appeared in *Newsweek*. It is written by William Wilson, identified in a by-line as a writer and editor. A feature article called "Avedon Goes West" was written by Susan Weiley and published in *Artnews* six months later.[4] Both *Artforum* and *Artnews* are national in scope and devoted exclusively to visual art. Whereas the Davis and Wilson reviews are about one magazine page in length and about 1,000 words, Weiley's is six pages and about 3,500 words. One photograph accompanies Wilson's review, and four are printed with Weiley's article.

Davis and Wilson generally agree about their appraisals of the show. Although they both approve of the work, they have reservations. Like Davis, Wilson does not accept the work as an accurate documentation of the West. He sees it as Avedon's fiction, but he doesn't mind that; rather, he enjoys the photographs as he would a good story. Although he faults some of the photographs as "self-important" and "patronizing" and mere "fashion,"[5] he is positive about the exhibition. Susan Weiley, however, clearly disapproves of the work. Although she admires Avedon's "flawless craftmanship," for her the American West project is "cold and mechanical" and "without that power to deeply disturb."[6] For her it is "fashion, not art." With these brief overviews of the positions taken by Wilson and Weiley, we have two more critical positions on Davis to consider as we continue to explore description in criticism. In addition to analyzing descriptive statements about Avedon's work by these three critics, we will also consider describing other types of photographs.

DESCRIBING SUBJECT MATTER

Descriptive statements about subject matter identify and typify persons, objects, places, or events in a photograph. When describing subject matter, critics name what they see and also characterize it.

Because there are 124 portraits in the Avedon exhibition, many of which are group portraits, there are too many to list individually. Davis chooses to summarily

Richard Avedon, *Boyd Fortin, Thirteen Year Old Rattlesnake Skinner, Sweetwater, Texas, 3/10/83*, 56½" x 45".

describe the subjects of the show as "ranchers, housekeepers, rodeo riders and oil drillers, pig men, meatpackers and an army of unemployed drifters."[7] Some of these nouns were supplied by Avedon as part of his titles—for example, *David Beason, shipping clerk, Denver, Colorado, 7/25/81*—and Davis has included several of them. But he invents the phrase "an army of unemployed drifters." He adds that one of the coal miners is "tall and enigmatic," and he writes of a boy "with a snake wrapped coyly around his arms." These descriptions of subject matter seem simple, straightforward, and obvious when we read them, but Davis had to fashion these subjects with carefully selected words. The photographer gives us images; the critic gives us words for the images.

In his *Artforum* review, William Wilson describes the same subject matter that Davis saw but summarizes it differently. He calls the subject of the show "a human cyclorama" and says that the show includes not only the expected "cowboys and Indians" but also "a couple of mental-hospital patients; a physical therapist; three sisters from Wildhorse, Colorado."[8] About the three sisters, Wilson adds that they have served as co-presidents of the Loretta Lynn Fan Club for the past twenty-five years. In colorful descriptive language utilizing alliteration, Williams mentions "soot and grime and rips and rashes and blood" and states that the heads of slaughtered sheep and steers are important inclusions in these portraits.

In her feature article in *Artnews* Susan Weiley had considerably more space than the one page allotted to the reviews by Davis and Williams, and she chooses to describe a lot of Avedon's work, starting with his older fashion work which, she tells us, began in 1946. She discusses how his work differed from that of his peers who photographed fashion, and she explains that he freed the fashion photograph from the still studio pose. She uses lively descriptive language to discuss the subject matter of his fashion work and how he presented it: In real and recognizable places he photographed models as they "leaped off curbs or bounced down a beach or swirled their New Look skirts through Parisian streets or gamed at a roulette table."[9] Weiley also relates that in addition to his commercial fashion work in the sixties and seventies Avedon made portraits of celebrities. Beyond merely identifying the subjects as portraits of artists, writers, and politicians, she characterizes them in carefully chosen descriptive language: "Avedon presented the frailties of the body: the sags and bags, lines and pouches that flesh is heir to, the double chins, enlarged pores, glazed eyes and sullen expressions of the rich, the powerful, the famous." She also describes a "devastating series" of portraits Avedon made of his father as he was dying of cancer.

When she discusses his American West work, Weiley not only describes the subjects he photographs but also those he does *not* photograph: "fearless gunslingers or stalwart lawmen or fierce cattlemen or Houston oil barons, or any of the stock characters that live in our imagination of the West." She too, as do Davis and Wilson, lists the persons in the photographs by their jobs but further describes the lot as "a catalogue of the odd, the bizarre, the defective, the deformed, the

demented and the maimed." And like Wilson, but unlike Davis, she mentions the bloodiness of some of the subjects: "Slaughterhouse workers and their implements are drenched in blood, and severed, bloodied calf, steer and sheep heads all have their likenesses immortalized."

Weiley concludes that Avedon's choice of subject matter is more interpretive than descriptive: "After a short time one realizes the westerners were selected solely for their strange physical characteristics." She is not alone in her conclusion. Richard Bolton, writing in *Afterimage,* considers Avedon's work exploitative and asks of the subjects of the photographs: "Were they told that, had they been less dirty, less debilitated, or had better taste, or better posture, they might not have been chosen to be photographed?"[10]

These critics have seen the same work and write about the same exhibition, but in describing the subjects of the photographs they have us notice different aspects and characteristics. There is much overlap in their observations about the subject matter, because they are writing about observable facts, but there is also room for different selections of what to include and what to exclude as well as considerable variance in the language they use to describe the subject matter once they have named it.

Avedon's subject matter is mostly people and is relatively uncomplicated— usually one person to a photograph. But as we have just seen, describing that subject matter is not an easy task. The subject matter of many other photographs is also simple, but when criticizing it, we characterize what is there. Edward Weston's subject matter for an entire series of photographs is green peppers. The subject matter of a Minor White photograph is bird droppings on a boulder. Irving Penn's subject matter for a series of photographs is cigarette butts.

Some photographers utilize *a lot* of simple objects as their subject matter. In a series of still lifes begun in 1977, Jan Groover "took her camera to the kitchen sink."[11] She photographs complicated arrangements of kitchen utensils such as knives, forks, spoons, plates, cups, plastic glasses and glass glasses, pastry and aspic molds, metal funnels, whisks, plants, and vegetables. Most of the objects are recognizable, but some are abstracted in the composition so that they are "surfaces and textures" and not recognizable on the basis of what is shown. Although in real life Groover's subject matter is a pie pan, on the basis of what is seen in the photograph it can be identified only as "a brushed aluminum surface" or "a glistening metallic plane." The subject matter of many abstract works can be described only with abstract terms, but critics still can and should describe it.

The subject matter of some photographs is seemingly simple but actually very elusive. Cindy Sherman's traveling retrospective exhibition of 1987 provides several examples. Most of these photographs are self-portraits, so in one sense her subject matter is herself. But she titles black and white self-portraits made between 1977 and 1980 "Untitled Film Stills." In them she pictures herself, but as a woman in a wide variety of guises from hitchhiker to housewife. Moreover, these pictures look like stills from old movies. In 1981 she did a series of "centerfolds" for which

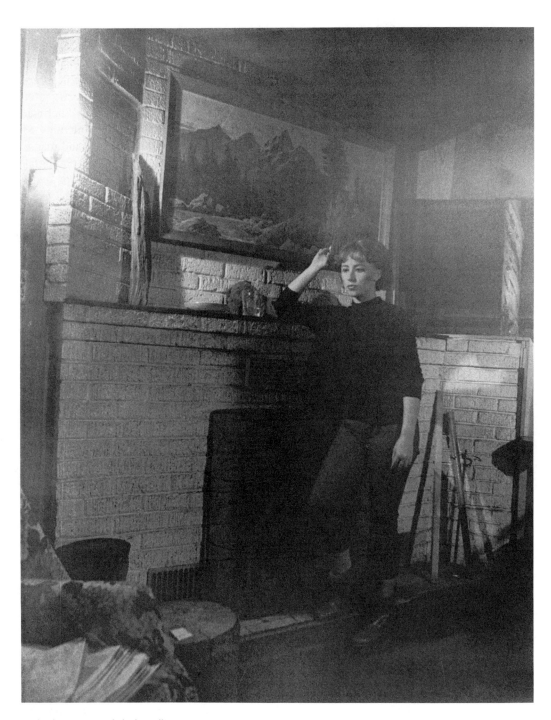

Cindy Sherman, *Untitled Film Still*, 1979.

she posed clothed and in the manner of soft-porn magazine photographs. So what is the subject matter of these pictures? In a *New York Times* review, Michael Brenson names the subject matter of the film still photographs "stock characters in old melodramas and suspense films."[12] But Eleanor Heartney, writing in *Afterimage,* says that both the self-portraits and the film still photographs directly refer to "the cultural construction of femininity."[13] They are pictures of Cindy Sherman and pictures of Cindy Sherman disguised as others; they are also pictures of women as women are represented in cultural artifacts such as movies and magazines, especially as pictured by male producers, directors, editors, and photographers. To simply identify them as "portraits" or "portraits of women" or "self-portraits" or "self-portraits of Cindy Sherman" would be inaccurate and in a sense would be to misidentify them.

Some photographs, such as those of Joel-Peter Witkin, have obviously complex subject matter. His subject matter is sometimes difficult to decipher and always demands attention because it is usually shocking. In a feature article in *Exposure,* Cynthia Chris characterizes Witkin's subject matter as sexual, violent, and perverse and itemizes it in this litany: "fetus, child, male, female, hermaphrodite, corpse, skeleton, the beautiful, the deformed, the obese, live animal and taxidermic specimen."[14] Hal Fischer in *Artweek* describes some of the subject matter as "tortured figures, obese women, carrot dildos, fetuses and anything else which may enter this photographer's imagination are fabricated into enigmatic, often grotesque tableaux."[15] Witkin uses models which Fischer describes as "earth-mother goddesses, trans-sexuals, masked and bound men and other inhabitants of the demimonde." In her article Chris states: "Usually nude, they are less dressed than entangled in hats, hoods, masks, wings, rubber hoses, flora, fauna, food, and sex toys."[16] The subjects are sometimes further altered by scratching and other manual manipulations done to the negatives before they are printed, and many of the photographs are collages of different negatives.

Witkin also includes other art objects, or segments of them, in his tableaux, and frequently refers to artworks by artists of earlier times. Van Deren Coke details some of these art objects and art references in his introductory essay to an exhibition catalogue of Witkin's work.[17] A 1981 photograph by Witkin entitled *The Prince Imperial* refers to a portrait of the son of Napoleon III made in the 1860s. Witkin's *Mandan* is based on a painting done in the 1830s by George Catlin, and *Courbet in Rejlander's Pool* refers to both the painter Courbet and the photographer Rejlander. Some of Witkin's photographs refer so closely to other artworks that Coke includes the historic paintings in the catalogue of Witkin's contemporary work: *The Little Fur,* painted around 1638 by Peter Paul Rubens, is printed opposite Witkin's *Helena Fourment.* In a footnote, Coke relates that Witkin's photograph parodies a portrait of Rubens's wife, Helena Fourment. Witkin also parodies portraits by Goya and Grant Wood *(Portrait of Nan)* and a sculpture of Venus by Canova. In another of Witkin's photographs, *Pygmalion,* segments of reproductions of Picasso's paintings are part of the photograph. Thus

Joel-Peter Witkin, *Portrait of Nan*, 1984.

the subject matter of this photograph is other art, which is observable only if the viewer knows the other art or is told of the references by someone else, such as a critic. The parodies in particular are problematic because a parody is not effective unless the reader or viewer knows that it is a parody and how it ridicules what it refers to. In these examples, the subject matter is not obvious, so the critic must describe it accurately and completely.

DESCRIBING FORM

Form refers to how the subject matter is presented. Ben Shahn, the painter and photographer who worked in the 1930s, said that form is the shape of content. Descriptive statements about a photograph's form concern how it is composed, arranged, and constructed visually. We can attend to a photograph's form by considering how it uses what are called "formal elements." From the older artforms of painting and drawing, photography has inherited these formal elements: dot, line, shape, light and value, color, texture, mass, space, and volume. Other formal elements identified for photographs include: black and white tonal range; subject contrast; film contrast; negative contrast; paper contrast; film format; point of view, which includes the distance from which the photograph was made and the lens that was used; angle and lens; frame and edge; depth of field; sharpness of grain; and degree of focus. Critics refer to the ways that photographers use these formal elements as "principles of design," which include scale, proportion, unity within variety, repetition and rhythm, balance, directional forces, emphasis, and subordination.

Edward Weston identified some of the choices of formal elements the photographer has when exposing a piece of film: "By varying the position of his camera, his camera angle, or the focal length of his lens, the photographer can achieve an infinite number of varied compositions with a single stationary subject."[18] More recently John Szarkowski, curator of photography at the Museum of Modern Art in New York, reiterated what Weston observed over fifty years ago and added an important insight: "The simplicity of photography lies in the fact that it is very easy to make a picture. The staggering complexity of it lies in the fact that a thousand other pictures of the same subject would have been equally easy."[19]

In an essay for an exhibition catalogue of Jan Groover's work, Susan Kismaric provides a paragraph that is a wonderful example of how a critic can describe form and its effects on subject matter:

> The formal element put to most startling use in these pictures is the scale of the objects in them. Houseplants, knives, forks, and spoons appear larger than life. Our common understanding of the meaning of these pedestrian objects is transformed to a perception of them as exotic and mysterious. Arrangements of plates, knives, and houseplants engage and delight our sight through their glamorous new incarnation while they simultaneously undermine our

Jan Groover, *Untitled,* palladium print, 1977.

sense of their purpose in the natural world. Meticulously controlled artificial light contributes to this effect. Reflections of color and shapes on glass, metal, and water, perceived only for an instant or not at all in real life, are stilled here, creating a new subject for our contemplation. The natural colors of the things photographed are intensified and heightened. Organic objects are juxtaposed with manmade ones. Soft textures balance against, and touch, hard ones. The sensuous is pitted against the elemental.[20]

The formal elements to which Kismaric refers are light, color, and texture; the principles of design are scale, arrangements of objects, and juxtapositions. She cites scale as the most dominant design principle and then describes the effects of Groover's use of scale on the photographs and our perception of them. She identifies the light as artificial and tells us that it is meticulously controlled. The colors are natural; some of the shapes are manufactured and others are organic, and they are juxtaposed. She identifies the textures as soft and hard, sensuous and elemental. Kismaric's description of these elements, and her explanation of their effects, contributes to our knowledge and enhances our appreciation of Groover's work.

Kismaric's paragraph shows how a critic simultaneously describes subject matter and form and also how in a single paragraph a critic describes, interprets, and evaluates. To name the objects is to be descriptive, but to say how the objects become exotic and mysterious is to interpret the photographs. The tone of the whole paragraph is very positive. After reading the paragraph we know that Kismaric thinks Groover's photographs are very good and we are provided reasons for this judgment that are based on what she describes in the photographs.

DESCRIBING MEDIUM

The term *medium* refers to what an art object is made of. In a review of Bea Nettles's photographs in the seventies, A. D. Coleman described the media she was using: "stitching, sensitized plastics and fabrics, dry and liquid extra-photographic materials…hair, dried fish, Kool Aid, feathers, and assorted other things."[21] Descriptive statements about a picture's medium, however, usually identify it as a photograph, an oil painting, or an etching. They may also include information about the kind and size of film that was used, the size of the print, whether it is black and white or in color, characteristics of the camera that was used, and other technical information about how the picture was made, including how the photographer photographs. Each one of the three critics talks about how Avedon made the pictures in his American West exhibition.

Davis tells us that Avedon's prints are uncropped and not retouched, that the subjects were illuminated with natural light in front of white paper, and that Avedon held 752 photo sessions with the subjects of the portraits and shot 17,000 sheets of film. He also relates that Avedon used an 8 x 10 inch Deardorff view

camera, which allowed him to stand close to the subjects and talk to them as he shot.

Wilson mentions the camera and tripod, the rolls of white paper for background, and Avedon's ability to stand by his subjects rather than behind the camera when shooting. He also tells us that Avedon held 752 shooting sessions, and adds that he did this work over five consecutive summers and traveled through seventeen western states, from Kansas to California.

Weiley does not detail much technical information, but she describes Avedon's positioning of the subjects in front of white paper on location and tells us that two assistants load his camera. She describes his method of photographing and inter- prets with the psychological effects of his method: "He is in total control, has complete authority over his subjects. He selects, arranges, directs, just as he would a fashion shot."[22]

In her essay on Groover's work, Kismaric specifies that some of the still lifes are done in the platinum-palladium process. She explains that this method of working was invented in 1873 for its permanence, but she also details its aesthetic qualities—"delicacy, soft grays, and warm tones."[23] Kismaric considers further her choice of photography rather than painting even though Groover was trained as a painter: "By using photography instead of painting, Groover complicates the notion of representation, and emphasizes the capacity of photography to make works of the imagination."

Critics of Witkin's work usually discuss how he uses the medium of photography. Gary Indiana in a review in *Art in America* says that "many of the prints have been made to look like daguerreotypes salvaged from partial decomposition" and adds that "the edges are scored with black lines and smudges suggestive of Action Painting."[24] In a review in *Artweek*, Hal Fischer also describes how Witkin treats the medium of photography and posits some of the effects of his treatments: "By etching into his negatives and selectively bleaching and toning the prints, this artist imbues his imagery with a nineteenth century aura without compromising the sense of photographic reality."[25] In the same publication a year later, Jim Jordan agrees that Witkin's formal treatments of his photographs make them look old, from the eighteenth century and the court of Louis XVI. Jordan further relates that Witkin uses a Rolleiflex camera, prints on Portriga paper, sometimes through a tissue paper overlay that he sprinkles with water and toning chemicals.[26]

Thus the description of medium involves more than just using museum labels, as in labeling Jan Groover images as "three chromogenic color prints," or "platinum-palladium print," or "Gelatin-silver print." To fully describe the medium that a photographer is using is not only to iterate facts about the process he or she uses, the type of camera, and kind of print, but also to discuss these things in light of the effects that their use has on their expression and overall impact. The critic might more fully explore these effects as part of his or her interpretation or judgment of the work, but they ought to explicitly mention the properties of the medium in the descriptive phase of criticism.

DESCRIBING STYLE

Style indicates a resemblance among diverse art objects from an artist, movement, time period, or geographic location and is recognized by a characteristic handling of subject matter and formal elements. Neo-expressionism is a commonly recognized, recent style of painting, and Pictorialism, "directorial" photography,[27] and the "snapshot aesthetic"[28] are styles of photography.

To consider a photographer's style is to attend to what subjects he or she chooses to photograph, how the medium of photography is used, and how the picture is formally arranged. Attending to style can be much more interpretive than descriptive. Labeling photographs "contemporary American" or "turn of the century" is less controversial than is labeling them "realistic" or "straight" or "manipulated" or "documentary." The three critics of Avedon's work being considered here are particularly interested in determining whether his style is "documentary," or "fictional," or "fashion." Determining Avedon's style involves considerably more than describing but it does include descriptions of who he photographs, how he photographs them, and what his pictures look like.

Of the three treatments of Avedon's style, Weiley's is the most complete. She begins with his earlier portraits, claiming that he "Avedonizes" his subjects.[29] She generalizes his early portrait work as "confrontational" and typifies it as "frontal, direct, with a single subject centered, staring directly out at the viewer." She explains that he undermined the glamour of the famous people he photographed—that he stripped them of their masks and "brought the mighty down to human scale, assassinating all possibility of grace or vanity." Weiley is much less sympathetic with Avedon's treatment of his subjects in the American West work; she finds his manner of working "disagreeable," "condescending to his subjects," and "frankly arrogant" in its exploitation. Whereas the famous people he photographs are media smart and used to being photographed and publicized, the westerners are not, and she thinks that in the hands of Avedon they are "like innocents led to slaughter." Thus, on the basis of descriptive facts about Avedon's style, namely who he photographs and how he photographs them, Weiley goes beyond describing and interpreting his style and forms a negative judgment about it.

COMPARING AND CONTRASTING

A common method of critically analyzing a photographer's work is to compare and contrast it to other work by the same photographer, to other photographers' works, or to works by other artists. To compare and contrast is to see what the work in question has in common with and how the work is different from another body of work. Each one of the three critics under consideration here descriptively compares Avedon's work to that of other photographers.

Davis compares the size of Avedon's American West project to the late nineteenth and early twentieth century documentary projects of William Henry Jackson and Edward Curtis.[30] Jackson was an explorer, writer, and photographer who over twenty-five years produced tens of thousands of negatives of Indians and the western landscape. Curtis published twenty volumes of *The North American Indian* between 1907 and 1934. Although Davis compares the three photographers, he does not equate Avedon with the other two in terms of merit. In a judgment and not a description, Davis states that "Avedon is no Jackson or Curtis."

Critics need not limit their comparisons of a photographer to another photographer. Wilson makes comparative references between Avedon and several others of various professions, most of whom are not photographers but rather literary sources he knows and figures in fashion and popular culture: Sam Shepard, Edward Curtis, Mathew Brady, August Sander, Joan Didion, Norman Mailer, Truman Capote, Evil Knievel, Salvador Dali, Elsa Schiaparelli, Charles James, Andy Warhol, Tom Wolfe, Calvin Klein, Georgia O'Keeffe, Ansel Adams, and Irving Penn. Wilson compares Avedon to other storytellers, and to others who bridged the gap between fashion and art, because Wilson interpretively understands Avedon to be telling stories and attempting to transcend fashion with his photographs.

Of the three critics, Weiley makes the most use of in-depth comparisons, paying particular attention to the similarities and mostly the differences between Avedon's work and that of Robert Frank, August Sander, and Diane Arbus. She cites Robert Frank's book, *The Americans* (1959), because like Avedon's it is "a harsh vision of America"[31] and because both are outsiders to the cultures they photographed: Frank is Swiss, and Avedon is not a cowboy. To compare Avedon with Frank, Sander, and Arbus, Weiley has to describe each one's photographs and manners of working and then specify how each is different from and similar to one another.

INTERNAL AND EXTERNAL SOURCES OF INFORMATION

We have seen that a critic can find much to mention about the photograph by attending to subject, form, medium, and style. And, as mentioned earlier, critics often go to external sources to gather descriptive information that increases understanding of that photograph. In their writings the three critics of Avedon's work each used much information not decipherable in the photographs. By looking only at his American West photographs, a viewer cannot tell that Avedon's exhibited photographs were selected from 17,000 negatives, that he held 752 shooting sessions, that the work was commissioned by the Amon Carter Museum, or that they were made by a famous fashion photographer with a large body of

images made previously. This information comes from a variety of sources including press releases, interviews with the artist, the exhibition catalogue, and knowledge of photography history.

And to compare and contrast Avedon's work with his own earlier work and with the work of others including nonvisual work, each of the three critics went to external sources.

In an example different from the critical treatments of Avedon's work, Van Deren Coke relies primarily on external information to provide an introduction to Witkin's work in an exhibition catalogue.[32] Coke gathered the information from Witkin's master's thesis, written at the University of New Mexico in 1976, and from statements that Witkin has made about his work. Much of the information that Coke provides is biographical, about the facts of Witkin's life and about his psychological motivations for making specific images. Coke believes that information about Witkin's life illuminates his photographs, and Coke includes as psychological motivation Witkin's shocking story of how at the age of six he witnessed a car accident and stood close to the decapitated head of a little girl. Coke also relates that Witkin's father was an orthodox Jew and his mother a Catholic and that they divorced over religious differences, that Witkin's first sexual experience was with a hermaphrodite, that he studied sculpture in the evenings at Cooper Union School of Art in New York, that he was an army photographer during the Vietnam War, and that one of his assignments was to photograph accident and suicide victims.

In her article on Witkin, Cynthia Chris relies on external information that includes Coke's catalogue essay and a lecture which Witkin delivered at the Art Institute of Chicago. She particularly notes how Witkin obtains the unusual subjects for his photographs—by searching the streets, by following people, through want ads, and through an afterword in his book "that reads like a shopping list"—because she finds his methods objectionable.[33]

Critics and theoreticians of criticism differ on the importance and desirability of external information, on certain types of information, and on the means of gathering it. As we saw in Chapter 1, A. D. Coleman, for example, advocates distance between the critic and the artist, and distinctions between curating and criticizing and between writing history and criticism. Lucy Lippard, however, assumes a partnership with the artists she writes about and feels comfortable interviewing them and seeking their views of their work. In the past, critics rejected biographical and psychological information about artists as irrelevant and advocated instead that the artwork be the source of criticism, that the rest was distracting. Most contemporary critics, however, embrace a more contextual view of criticism and art and carefully consider the photograph's causal environment including the context in which it was made. The importance of considering context will be explored in Chapter 5.

The test of including or excluding external descriptive information is one of relevancy. The critic's task in deciding what to describe and what to ignore is one

of sorting the relevant information from the irrelevant, the insightful from the trivial and distracting. When doing criticism, however, one would not want to substitute biography for criticism, or lose sight of the work amidst interesting facts about the artist.

DESCRIPTION AND INTERPRETATION

It is probably as impossible to describe without interpreting as it is to interpret without describing. A critic can begin to mentally list descriptive elements in a photograph, but at the same time he or she has to constantly see those elements in terms of the whole photographs, if those elements are to make any sense. But the whole makes sense only in terms of its parts. The relationship between describing and interpreting is circular, moving from whole to part and part to whole.

Though a critic might want to mentally list as many descriptive elements as possible, in writing criticism he or she has to limit all that can be said about a photograph to what is relevant to providing an understanding and appreciation of the picture. Critics determine relevancy by their interpretation of what the photograph expresses. In a finished piece of criticism, it would be tedious to read descriptive item after descriptive item, or fact after fact, without some understanding on which to hang the facts. That structure is based on how the critic understands the picture, or how one evaluates it. At the same time, however, it would be a mistake to interpret without having considered fully what there is in the picture, and interpretations that do not (or worse, cannot) account for all the descriptive elements in a work are flawed interpretations. Similarly, it would be irresponsible to judge without the benefit of a thorough accounting of what we are judging.

DESCRIPTION AND EVALUATION

Joel-Peter Witkin is a controversial photographer who makes controversial photographs. Critics judge him differently and their judgments, positive or negative or ambivalent, influence their descriptions of his work. Cynthia Chris clearly disapproves of the work: "Witkin's altered photographs are representations of some of the most repressed and oppressed images of human behavior and appearance,"[34] whereas Hal Fischer writes that "Joel-Peter Witkin, maker of bizarre, sometimes extraordinary imagery, is one of the most provocative artists to have emerged in the past decade."[35] And Gene Thornton of the *New York Times* calls Witkin "one of the great originals of contemporary photography."[36] Their evaluations, positive or negative, are often mixed into their descriptions. For example, Gary Indiana uses the phrases "smeared with burnt-in blotches" and "the usual fuzz around the edges" to describe some formal characteristics of Witkin's prints,[37] and Bill Berkson describes the same edges as "syrupy."[38] These are not

value-neutral descriptors but rather are descriptors that suggest disapproval. Another critic, Jim Jordan, talks about "Witkin's incredible range of form definition within the prints" and claims that Witkin's surface treatments "inform the viewer that these are works of art."[39] Jordan's phrase "incredible range of form definition" is also a mix of description and judgment, with positive connotations.

In published criticism, descriptions are rarely value free. Critics color their descriptions according to whether they are positive or negative about the work, and they use descriptors that are simultaneously descriptive and evaluative to influence the reader's view of the artwork. Critics attempt to be persuasive in their writing. The reader, however, ought to be able to sort the critic's descriptions from judgments, and value-neutral descriptions from value-laden descriptions, however subtly they are written, so that he or she can more intelligently assent or dissent.

Novice critics can find it beneficial to attempt to describe a photograph without connoting positive or negative value judgments about it. They may then be more sensitive to and aware of when descriptions are accurate and neutral and when they are positively or negatively judgmental.

THE IMPORTANCE OF DESCRIPTION TO READERS

As we have seen throughout the chapter, describing is an extremely important activity for critics, established or novice, because it is a time for "getting to know" a piece of art, especially if that art is previously unknown and by an unfamiliar artist. Descriptions are also important to readers, because they contain crucial and interesting information that leads them to understand and appreciate images. Descriptions provide information about photographs and exhibitions that readers may never get to see and otherwise would not experience at all. Descriptions are also the basis on which they can agree or disagree with the critic's interpretation and judgment.

Describing photographs and reading descriptions of photographs are particularly important activities because people tend to look through photographs as if they were windows rather than pictures. Because of the usual stylistic realism of many photographs, and because people know that photographs are made with a machine, people tend to consider photographs as if they were real events or living people rather than *pictures* of events or people. Pictures are not nature and they are not natural; they are human constructs. Photographs, no matter how objective or scientific, are the constructions of individuals with beliefs and biases, and we need to consider them as such. To describe subject, form, medium, and style is to consider photographs as pictures made by individuals and not to mistake them for anything more or less.

Description is not a prelude to criticism, description *is* criticism. Careful descriptive accounts by insightful critics using carefully constructed language are informed discourse about photographs that increases our understanding and appreciation of photographs.

3
INTERPRETING
PHOTOGRAPHS

As a culture we are perhaps more accustomed to thinking of interpreting poems and paintings than photographs. But all photographs—even simple ones—demand interpretation in order to be fully understood and appreciated. They need to be recognized as pictures about something and for some communicative and expressive purpose. Joel-Peter Witkin's bizarre photographs attract interpretive questions and thoughts because they are different from our common experiences, but many photographs look natural and are sometimes no more cause of notice than tables and trees. We accept photographs in newspapers and on newscasts as facts about the world and facts, once seen, that require no scrutiny.

Photographs that are made in a straightforward, stylistically realistic manner especially need interpretation. They look so natural, they seem to have been made by themselves, as if there had been no photographer. If we consider at all how these photographs were made, we may accept them as if they were made by an objective, impartial, recording machine. Andy Grundberg, reviewing an exhibition of *National Geographic* photographs, makes this point about these kinds of photographs: "As a result of their naturalism and apparent effortlessness, they have the capacity to lull us into believing that they are evidence of an impartial, uninflected sort. Nothing could be further from the truth."[1]

Nothing could be further from the truth because photographs *are* partial and *are* inflected. People's knowledge, beliefs, values, and attitudes—heavily influenced by their culture—are reflected in the photographs they take. Each photograph embodies a particular way of seeing and showing the world. Photographers make choices not only about what to photograph but also about how to capture an image on film, and often these choices are very sophisticated. We need to interpret photographs so that these *inflections* become explicit.

When looking at photographs, we tend to think of them as "innocent"—that is, as bare facts, as direct surrogates of reality, as substitutes for real things, as direct reflections. But there is no such thing as an innocent eye.[2] We cannot see the world and at the same time ignore our prior experience in and knowledge of the world. Philosopher Nelson Goodman puts it like this:

> ...as Ernst Gombrich insists, there is no innocent eye. The eye comes always ancient to its work, obsessed by its past and by old and new insinuations of the ear, nose, tongue, fingers, heart, and brain. It functions not as an instrument self-powered and alone, but as a dutiful member of a complex and capricious organism. Not only how but what it sees is regulated by need and prejudice.[3]

If there is no such thing as the innocent eye, there certainly isn't an innocent camera.

What Goodman says of the eye is true of the camera, the photograph, and the "photographer's eye" as well:

> It selects, rejects, organizes, discriminates, associates, classifies, analyzes, constructs. It does not so much mirror as take and make; and what it takes and makes it sees not bare, as items without attributes, but as things, as food, as people, as enemies, as stars, as weapons.

Thus, all photographs, even very straightforward, direct, and realistic looking ones need to be interpreted. They are not innocent, or free of insinuations and devoid of prejudices, nor are they simple mirror images. They are made, taken, and constructed by skillful artists and deserve to be read, explained, analyzed, and, deconstructed.

DEFINING INTERPRETATION

While describing, a critic names and characterizes all that can be seen in the photograph. Interpretation occurs whenever attention and discussion move beyond offering information to matters of meaning. To interpret is to account for all the described aspects of a photograph and to posit meaningful relationships between the aspects.

When doing criticism, to interpret a photograph is to tell someone else, in speech or in writing, what one understands about a photograph, especially what one thinks a photograph is about. Interpreting is telling about the point, the meaning, the sense, the tone, or the mood of the photograph. When critics interpret a work of art, they seek to find out and tell others what they think is most important in an image, how its parts fit together, and how its form affects its subject. Critics base interpretations on what is shown in the work and on relevant information outside of the work, or what in Chapter 2 we called the photograph's causal environment. Interpretations go beyond description to decipher meaning.

Another way of understanding interpretation is to think of all photographs as metaphors in need of being deciphered. A metaphor is an implied comparison between unlike things. Qualities of one thing are implicitly transferred to another. Verbal metaphors have two levels of meaning: the literal and the implied. Visual metaphors also have levels of meaning: what is shown and what is implied. A photograph always shows us something as something. In the simple sense, a portrait of a man shows us the man as a picture, that is, as a flat piece of paper with clusters of tones from a light-sensitive emulsion. In another simple sense, a photograph always shows us a certain aspect of something. A portrait of Igor Stravinsky by Arnold Newman shows us Stravinsky *somehow*, *as* something. In Goodman's words, "*the* object before me is a man, a swarm of atoms, a complex of cells, a fiddler, a friend, a fool, and much more." The photograph represents the thing or person as something or as some kind of person. Newman's portrait of Stravinsky shows the man sitting at a piano. In a more complex way, however, the portrait of Stravinsky shows Stravinksy not only as a man sitting at a piano but also as a brilliant man, or a profound man, or a troubled man. The more complex "as" requires interpretation. To miss the metaphoric and to see only the literal is to misunderstand the expressive aspects of photographs.

Roland Barthes, the late French scholar, was a semiotician who investigated how culture signifies, or expresses meaning, and paid particular attention to how photographs signify. He identified two signifying practices: *denotations* and *connotations*.[4] A photographed still life arrangement may denote (show) flowers in a vase on a wooden table; it may connote (suggest, imply) peace, tranquility, and the delightfulness of the simple. These connotations may be conveyed by the lighting, colors, and the absence of superfluous objects. A fashion photograph may denote a model wearing a coat and a hat but may connote flair, sophistication, and daring by the look and pose of the model and the setting. To look at the photographs and to see only flowers in a vase on a table, or a hat and a coat on a woman, and not to recognize what they express, is to miss the point of the pictures.

The distinction between denotations and connotations is made clearer by an interpretation of a magazine advertisement, which Barthes provides.[5] The advertisement is a photographic ad for "Panzani" spaghetti products that appears in a French magazine. The ad shows cellophane packages of uncooked spaghetti, a can of tomato sauce, a cellophane package of Parmesan cheese, and tomatoes, onions, peppers, and mushrooms emerging from an open-string shopping bag. The color scheme is yellows and greens against a red background. The Panzani label is on the can and cellophane packages. Barthes identifies three parts of the ad: the linguistic message, the denoted image, and the connoted image. The linguistic message is the word Panzani, which is both denotational and connotational. Barthes explains that the word denotes a brand name of the packaged products but that it connotes, just by the way it sounds, "Italianicity." The word would not work in Italy for Italian readers because they would not perceive that the word sounded Italian.

The photographic image itself denotes what it shows: a can, spaghetti packages, mushrooms, peppers, and so forth. But Barthes explains that the image connotes several other messages. The ad represents a return from the market, and it implies two values: freshness of the products and the goodness of home cooking. The variety of the objects connotes the idea of total culinary service as if Panzani provided everything needed for a carefully prepared dish. The vegetables imply that the concentrate in the can is equivalent to the vegetables surrounding it. The predominance of red, yellow, and green reinforces Italianicity. The composition, focus, lighting, and color transmit a further value: the aesthetic goodness of a still life.

Barthes's schema can be applied to all photographs, not only photographic advertisements. It is another way of emphasizing that photographs need to be interpreted. All photographs connote, and without some understanding that photographs connote or imply or suggest, viewers will not get beyond the obvious and will see photographs as reality rather than pictures of reality.

THE OBJECTS OF INTERPRETATIONS

Sometimes critics interpret single photographs, but they often interpret whole bodies of work by a photographer and even the photography of a country or a period in history. Here are a series of interpretive statements by several critics, each considering the work of a different photographer. These interpretive statements show a range from the particular to the general: from consideration of a single photograph, to a set of photographs, to a photographer's career, and to a historical decade of photography.

John Szarkowski interprets one hundred individual photographs, one at a time, and one page to each, in his book *Looking at Photographs*. In discussing a Josef Koudelka photograph (*Untitled*. No date. 71/4 x 111/2), he explains that Koudelka is dedicated to photographing the Gypsies of eastern Europe, who are in danger of vanishing. Szarkowski relates that the photographs contain specific information about Gypsies' everyday life, but adds that "such anthropological data does not seem their real point." So, Szarkowski is providing general descriptive information about the photographer—that he is committed to the subject of Gypsies—and general descriptive information about the photographs—that they give us much detailed, anthropological data about the Gypsies' way of life. But then he states that even though this information is apparent on the surface, it is not what the photographs are *really* about. He adds: "They seem instead to aim at a visual distillation of a pattern of human values: a pattern that involves theater, large gesture, brave style, precious camaraderie, and bitter loneliness. The pattern and texture of his pictures form the silent equivalent of an epic drama."[6] Szarkowski then discusses the specific untitled photograph and tells how it is an epic drama about human values.

This statement by Sally Eauclaire offers interpretive insights into a set of photographs: "As a black American, he vowed to record this part of his heritage and to revive interest in this custom, which has been dying out since World War II."[7] The photographs to which she refers are those made by Daniel Williams of Emancipation Day celebrations. She explains that these events are held sporadically around the country, depending on the initiation of local people. The photographs themselves depict black people in family gatherings at picnics, and without some explanation beyond the photographs themselves, a viewer would not know that these pictures had anything to do with slavery or emancipation from it or with Emancipation Day celebrations.

Shelley Rice writes about the photographer Mary Ellen Mark: "In other words, Mark's career—and photographic production—have been characterized by an almost dizzying diversity, a catch-as-catch-can quality that is as dependent on chance in the assignments offered to her as it is upon her own personal choices of subjects and themes."[8] Rice writes the statement after describing the diversity of subjects Mark has photographed for *Life, Look, Esquire, Paris-Match, Ms. Magazine,* and other publications, and lists some of her subjects: celebrities, women in a psychiatric ward in Oregon, prostitutes in Bombay, battered wives, abused children, famine victims in Ethiopia, and neo-Nazis in the United States. Rice's statement about Mark is interpretive in that she provides a generalization about the whole of the photographer's life work, typifying it as having "dizzying diversity." Rice also explains that Mark's work is the result of a combination of accepting assignments from others and choosing topics for herself.

About photography made over more than ten years, Johathan Green states: "In the seventies straight photography moved away from documentation of the outcast, the bizarre, and the freak and turned back to the most basic source of American myth and symbol: the American land."[9] Green is writing about American photography, and particularly a style, straight photography. He summarizes the straight photography of the sixties as documentation of unusual people and then generalizes that in the seventies photographers who were working in the straight mode began making landscapes. He also states that their choice of the land as subject matter was a return to the past. In the same sentence, Green then says that the American land is the most basic source of American myth and symbols. Thus, in this one sentence there are several interpretive statements, very general, about large time periods, huge amounts of work, and grand ideas about the land. This sentence by Green is the first sentence of the eleventh chapter of his book *American Photography.*

In an introductory essay to a book of John Pfahl's color photographs utilizing picture windows, Edward Bryant writes: "Since the 1950s the picture window has been commonplace in the American visual vernacular. Its ubiquity has coincided with that of the wide-screen movie, the undivided windshield, the big painting, and that ultimate picture window, the television set."[10] This too is an interpretive statement, although it is not directly about the photographs of Pfahl.

It is about the importance of the picture window in American society, and it helps us think about aspects of our cultural environment as well as preparing us to consider the pictures of picture windows by Pfahl. As Green writes about the land as a source of symbols for photographers, Bryant considers the picture window. Interpretive statements about photographs are not limited to photographs: They "may be of more general importance, helping us to an improved understanding of important parts of our cultural environment."[11]

INTERPRETIVE CLAIMS AND ARGUMENTS

These quotations of Szarkowski, Eauclaire, Rice, Green, and Bryant not only provide descriptive information about photographs and photographers but also provide interpretations of the photographs. Although they are declarative sentences, usually stated with unflinching authority, these statements should all be considered to be interpretive *claims*. Even though the authors do not express any doubts about their ideas and assert them as if they were self-evident and undeniable truths, they realize, and informed readers of criticism realize, that their interpretive statements are claims to truth and that if readers of criticism are to accept them as true or reasonable, they will want evidence for the claims before they accept the interpretations.

Each of these quoted sentences is from a larger piece of writing. The sentence by Szarkowski is part of a one-page essay, and the sentence from Green is from a whole book. In the complete pieces, the critics do provide reasons for their understandings of the photographs they are writing about.

Interpretations are more than the single or few sentence statements quoted earlier. Such statements are claims in need of arguments, or hypotheses in need of a convincing body of evidence. A fully developed interpretation is an argument that has premises leading logically and forcefully to a conclusion. A fully developed interpretation is rarely written as a logical argument, with premises one, two, three, and four clearly stated and a conclusion clearly drawn. Instead, interpretations are often mixed with descriptions and sometimes with evaluations. But a reader could analyze a fully developed interpretation by identifying its premises and conclusion, and then seeing if and how the premises lead to and support the conclusion.

Interpretations are answers to questions people have about photographs. The main interpretive questions that critics ask of photographs are "What do these photographs mean? What are they about?" All interpretations share a fundamental principle—that photographs have meanings deeper than what appears on their surfaces. The surface meaning is that which is obvious and evident about what is pictured, and the deeper meanings are those that are implied by what is pictured and how it is pictured. Looking at the surface of Cindy Sherman's film still photographs, for example, which were discussed in Chapter 2, they seem to be

about a woman on the road hitchhiking or a housewife in a kitchen. Less obviously, however, they are pictures of the artist herself, in various guises, and they are self-portraits. Because of how the subject is photographed, the film stills can also be understood to refer to media representations and to how popular media represent women. And, in an interpretive statement by Eleanor Heartney, they are, less obviously still, about "the cultural construction of femininity."[12] Heartney, and other critics who consider Sherman's work, are not content to understand the film stills simply as pictures of women doing various things, or as self-portraits of Cindy Sherman, or as self-portraits of an artist in artful disguises. They look not only at the surface but also beyond the surface for deeper meanings about femininity, the representation of femininity, and culture.

INTERPRETIVE PERSPECTIVES

Critics interpret photographs from a wide range of perspectives. Following are brief interpretations by different photographers, each written from a different vantage point to show the variety of strategies critics use to decipher images. The first three interpretations are by different writers on the same images, Harry Callahan's photographs of his wife, Eleanor, which are titled *Eleanor, Port Huron,* 1954. These examples show how critics can vary in their interpretations and how their variations on the same images can alter our perceptions and understandings. Then interpretations of other photographers' works are used as examples of a variety of interpretive strategies.

Three Interpretations of *Eleanor*

A Comparative Interpretation John Szarkowski claims that most people who have produced lasting images in the history of photography have dealt with aspects of their everyday lives and that Callahan is one of them. For many decades he has photographed his wife, his child, his neighborhoods, and the landscapes to which he escapes. Szarkowski notes that Callahan is different from most photographers who work from their personal experiences. Whereas they try to make universal statements from their specifics, Callahan, according to Szarkowski, "draws us ever more insistently inward toward the center of [his] private sensibility.... Photography has been his method of focusing the meaning of that life.... Photography has been a way of living."[13]

An Archetypal Interpretation In *American Photography,* Jonathan Green[14] devotes several pages to Callahan and reproduces five of the "Eleanor" photographs. In contradistinction to Szarkowski, Green sees them as elevating Eleanor the woman to an impersonal, universal, mythical, and archetypal status. About a photograph of Eleanor emerging from water, he writes: "We experience the *fons et origo* of

Harry Callahan, cover of *Eleanor*, 1984.

all the possibilities of existence. Eleanor becomes the Heliopolitan goddess rising from the primordial ocean and the *Terra Mater* emerging from the sea: the embodiment and vehicle of all births and creations." Green continues:

> Over and over again, Callahan sees Eleanor in the context of creation: she has become for him the elemental condition of existence, she is essential womanhood, a force rather than an embodiment, an energy rather than a substance. As such she appears cold and inaccessible, beyond the human passions of lust or grief. She is the word made flesh.

A Feminist Interpretation In a personally revealing critique, and one quite different from the two preceding interpretations, Diane Neumaier traces the development of her thinking regarding women, particularly photographers' wives, including Eleanor, as the subject matter of photographs. She recounts when as an undergraduate in 1976 she discovered photography and excitedly changed her concentration from printmaking to photography. She became acquainted with the work of such prominent photographers as Alfred Stieglitz and Emmet Gowin, and their photographs of their wives Georgia O'Keeffe and Edith. Neumaier was thrilled with the romanticism of these three famous couples, and she hoped to be like them and do similar work. However, as years passed, and as her consciousness grew through the experiences of being simultaneously a wife, mother, and artist, her conflicts also increased:

> I simultaneously wanted to be Harry, Alfred, or Emmet, *and* I wanted to be their adored captive subjects. I wanted to be Eleanor, or Edith and have my man focus on me and our child, *and* I wanted to be Georgia, passive beauty and active artist. Together these couples embodied all my most romantic, contradictory, and impossible dreams.[15]

Neumaier unsuccessfully attempted to photograph her husband as these men had photographed their wives: "To possess one's wife is to honor and revere her. To possess one's husband is impossible or castrating." In years following her divorce, she attempted to immortalize her son in her photographs, as Gowin has his children. But these efforts also failed because of her mother/son relationship (she could no longer manipulate her son into photographs) and because her time for art was limited by her mothering. She had to reevaluate those early pictures of the photographers' wives, and for her, feminist conclusions strongly emerged, and she could now see them as pictures of domination:

> These awe-inspiring, beautiful photographs of women are extremely oppressive. They fit the old traditions of woman as possession and woman as giver and sacrificer In this aesthetically veiled form of misogyny, the artist expects his wife to take off her clothing, then he photographs her naked (politely known as nude), and after showing everybody the resulting pictures he gets famous. . . . The subtle practice of capturing, exposing, and exhibiting one's wife is praised as sensitive.

Other Interpretive Strategies

Psychoanalytic Interpretation Laurie Simmons has made a series of photographs using dolls and figurines in different dollhouse settings. In writing about Simmons's work, Anne Hoy states that these female dolls are trapped in environments in which they are dwarfed by TV sets and out-of-scale grocery items. In contrast to the trapped dolls, Simmons later suggested freedom by photographing cowboy dolls outside, but their liberation was illusory because even the grass in the pictures outsized them. In the early eighties, Simmons made a series of swimmers using figurines and live nude models underwater. About these, Hoy writes: "In a Freudian interpretation, they suggest the equivalence of drowning and sexual surrender and the sensations of weightlessness associated with those twin abandonments."[16]

Formalist Interpretation Richard Misrach has been photographing the desert for a number of years, first at night with flash in black and white and then in the day in color. Kathleen McCarthy Gauss offers this interpretation of one of the color photographs, *The Santa Fe,* 1982; ". . . a unique configuration of space, light, and events." She continues:

> A highly formalized balance is established between the nubby ground and smooth, blue sky, both neatly cordoned off along the horizon by red and white boxcars. The most reductive, minimal composition is captured. The train rolls along just perceptibly below the horizon, bisecting the frame into two horizontal registers. Yet, this is another illusion, for the train is in fact standing still. [17]

Gauss's treatment of this image mixes her descriptive observations with interpretive insights. She is content to leave this image with these observations and insights about its compositional arrangement, and not to conjecture further.

Semiotic Interpretation Roland Barthes's interpretation of the Panzani advertisement detailed earlier is an example of an interpretation that seeks more to understand *how* an image means than *what* it means. Bill Nichols uses a similar interpretive strategy to understand a *Sports Illustrated* cover published during the first week of football season when Dan Devine began coaching the Notre Dame football team. The photographic cover shows a close-up of the quarterback ready to receive a hike and an inset of Devine gesturing from the sideline. Nichols points out that the eyeline of the two suggests that they are looking at each other and that their expressions suggest that the quarterback is wondering what to do and the coach is providing him an answer. Nichols interprets the contrast between the large size of the photograph of the quarterback and the smaller photograph of the coach as signifying the brawn of the player and the brain of the coach. He surmises:

This unspoken bond invokes much of the lure football holds for the armchair quarterback—the formulation of strategy, the crossing of the boundary between brain/brawn—and its very invocation upon the magazine's cover carries with it a promise of revelation: within the issue's interior, mysteries of strategy and relationship will be unveiled.[18]

Marxist Interpretation Linda Andre provides a sample of the kinds of questions a Marxist critic might ask about an exhibition of Avedon's celebrity photographs:

> We might look at the enormous popularity of Richard Avedon's photographs at the Metropolitan Museum of Art as attributable as much to the public's hunger for pictures of the rich, famous and stylish—a hunger usually sated not by museums but by the daily tabloids—as to his photographic virtuosity. To broaden the focus even more, we might ask what kind of society creates such a need—obviously one where enormous class inequalities exist and where there is little hope of entering a different class—and what role Avedon's pictures might play in the maintenance of this system.[19]

Andre explains that one of her attempts as a critic is to place photographs in the context of social reality—to interpret them as manifestations of larger societal developments and social history, as well as photography and art history.

Interpretation Based on Stylistic Influences Critics often explain or offer explanatory information about a photographer's work by putting it into a historical and stylistic context. In an introduction to the work of Duane Michals, for example, Anne Hoy writes that Michals's images "pay homage to the spare, realistic styles and dreamlike subjects of the Surrealist painters René Magritte, Giorgio de Chirico, and Balthus."[20] Such contextual information helps us to see the work of one photographer in a broader framework, and it implicitly reinforces the notion that all art comes in part from other art, or that all artists are influenced by other artists' work. Such comparisons demand that readers have certain knowledge: If they do not know the work of Magritte, de Chirico, and Balthus, for example, then Hoy's interpretive claim will not have much explanatory force for them. If they do possess such knowledge, however, then they can examine Michals's work in this broader context.

Biographical Interpretation Critics also provide answers to the question "Why does the photographer make these kinds of images (rather than some other kind)?" One way of answering this question is to provide biographical information about the photographer. In his introduction to the work of Joel-Peter Witkin discussed in Chapter 2, Van Deren Coke provided a lot of biographical information about the photographer.[21] In writing about the images, Coke strongly implies a cause-and-effect relationship between Witkin's life experiences and the way his images look. For instance, after relating that Witkin's family had little extra money, Coke says:

"This explains in part why we find in Witkin's photographs echoes of a sense of deprivation and insecurity." For some critics, however, such a jump from an artist's biography to a direct account of their images is too broad a leap. Regarding Coke's claim, for instance, we could first ask to be shown that there is a sense of deprivation and insecurity in the work, and then we could still be skeptical that the reason, even "in part," is because Witkin's family had little extra money. There could be another reason, or many reasons, or different reasons, or no available reasons why there is, if indeed there is, a sense of deprivation and insecurity in Witkin's photographs.

Intentionalist Interpretations It is a natural inclination to want to know what the maker intended in an image or a body of work. So when critics interview artists, they seek their intended meanings for their work, how they understand their own photographs. Well-known photographers are frequently invited to travel and talk about their work in public, and sometimes they explain their intentions in making their photographs. Although the views of the makers about their own works can, and should, influence our understanding of their work, they should not *determine* the meaning of the work or be used as *the* standard against which other interpretations are measured. We will discuss the problems of intentionalism as an interpretive method later in this chapter.

Interpretations Based on Technique Critics also provide answers to the question "How does the photographer make these images?" In answering this question, the critic may provide much interesting information about how the photographer works—his or her choice of subject, use of medium, printing methods, and so forth. Although these accounts provide useful information, they are descriptive accounts about media and how photographers manipulate media rather than interpretive accounts of what the photographs mean, or what they express by means of the surface and beyond the surface. Interpretations usually account for how the photographs are made and then consider the effects of the making on the meanings.

Combinations of Interpretive Approaches

When critics interpret photographs, they are likely to use a hybrid of approaches, rather than just one approach. For his analyses of photographs, Bill Nichols, for example, claims to draw upon Marxism, psychoanalysis, communication theory, semiotics, structuralism, and the psychology of perception. A feminist may or may not use a Marxist approach, and Marxist approaches are many, not just one. A critic may also choose among approaches depending on the kinds of photographs being considered. Finally, a critic may consider one photograph from several of these perspectives at a time, resulting in several competing interpretations. This raises issues about the correctness of interpretations.

"Right" Interpretations

"Surely there are many literary works of art of which it can be said that they are understood better by some readers than by others."[22] Monroe Beardsley is an aesthetician who said this about interpreting literature. And because some people understand artworks better than others do, concludes Beardsley, some interpretations are better than others. If someone understands a photograph better than I do, then it would be desirable that I know that interpretation to increase my own understanding. If someone has a better interpretation than I do, then it follows that better (and worse) interpretations are possible. In essence, not all interpretations are equal; some are better than others, and some can be shown to be wrong. Unlike Beardsley, however, the aesthetician Joseph Margolis takes a softer position on the truth and falsity of interpretations—the position that interpretations are not so much true or false as they are plausible (or implausible), reasonable (or unreasonable).[23] This more flexible view of interpretation allows us to accept several competing interpretations as long as they are plausible. Instead of looking for *the* true interpretation, we should be willing to consider a variety of plausible interpretations from a range of perspectives: modernist, Marxist, feminist, formalist, and so forth.

Although we will not use the term *true* for a good interpretation, we will use such terms as *plausible, interesting, enlightening, insightful, meaningful, revealing, original;* or conversely, *unreasonable, unlikely, impossible, inappropriate, absurd, farfetched,* or *strained.* Good interpretations are convincing and weak ones are not.

When people talk about art in a democratic society such as our own, they tend to unthinkingly hold that everyone's opinion is as good as everyone else's. Thus, in a discussion in which we are trying to interpret or evaluate an artwork and there is a point of view offered that is contrary to our own, we might say, "That's just your opinion," implying that all opinions are equal, and especially that our own is equal to any other. Opinions that are not backed with reasons, however, are not particularly useful or meaningful. Those that are arrived at after careful thought and which can be backed with evidence should carry weight. To dismiss a carefully thought out opinion with a comment like "That's just your opinion!" is intellectually irresponsible. This is not to say that any reasoned opinion or conclusion must be accepted, but rather that a reasoned opinion or conclusion deserves a reasoned response.

Another widespread and false assumption in our culture about discussing art goes something like this: "It doesn't matter what you say about art, because it's all subjective anyway." This is extreme relativism about art that doesn't allow for truth and falsity, or plausibility and reasonability, and which makes it futile to argue about art and about competing understandings of art. Talk about art can be objective, if the viewer relates his or her statements to the *object,* the artwork. Although each of us comes to artworks with our own knowledge, beliefs, values,

and attitudes, we can talk and be understood such that we make sense of photo-graphs; in this sense, we can be objective.

There are two criteria by which we can appraise interpretations: *correspon-dence* and *coherence*.[24] An interpretation ought to *correspond* to and account for all that appears in the picture and the relevant facts pertaining to the picture. If there are items in the picture that are not accounted for by the interpretation, then the interpretation is flawed. Similarly, if the interpretation is too removed from what is shown, then it is also flawed. The criterion of correspondence helps to keep interpretations focused on the object and from being too subjective. This criterion also "insists on the difference between explaining a work of art and changing it into a different one."[25] We want to deal with what is there and not make our own work of art by seeing things not there, or by changing the work into something that we wish it were or which it might have been.

We also want to build an interpretation, or accept the interpretation, that shows the photograph to be the best work of art it can be. This means that given several interpretations, we will not choose the ones that render the photograph insignificant but rather the ones that give the most credit to the photograph—the ones that show it to be the most significant work it can be.

The criterion of correspondence also allays the fear of "reading too much into" a work of art or photograph. If the interpretation is grounded in the object, if it corresponds to the object, then it is probably not too far removed from, and is not reading too much into, the photograph.

According to the second criterion, *coherence,* the interpretation ought to make sense in and of itself, apart from the photograph. That is, it should not be internally inconsistent or contradictory. Interpretations are arguments, hypotheses backed by evidence, cases built for a certain understanding of a photograph. The interpreter draws the evidence from what is within the photograph and from his or her experience of the world. The interpretive argument is either convincing because it accounts for all the facts of the picture in a reasonable way, or it is not convincing.

Interpretations and the Artist's Intent

Minor White, the photographer and influential teacher of photography, once said that "photographers frequently photograph better than they know."[26] He was cautioning against placing too much emphasis on what photographers think they have photographed. White placed the responsibility of interpretation on the viewer rather than on the photographer, in response to the problem in criticism of "inten-tionalism," or what aestheticians refer to as "the intentional fallacy."[27] Intention-alism is a faulty critical method by which images (or literature) are interpreted and judged according to what the maker intended by them. According to those who subscribe to intentionalism, if the photographer, for instance, intended to communicate *x,* then that is what the image is about, and interpretations are

measured against the intent of the photographer. In judging photographs, the critic is to somehow determine what the photographer intended to communicate with the photograph and then on that basis to judge whether the photographer has been successful or not. If the photographer has achieved his or her intent, then the image is good; if not, the image is unsuccessful.

There are several problems with intentionalism as a critical method. First it is difficult to find out what the intent of the photographer was. Some photographers are unavailable for comment about their images; others don't express their intents. Several photographers would rather not have to make images *and* criticize them. As Cindy Sherman has said, "I've only been interested in making the work and leaving the analysis to the critics."

Some photographers are unaware of their intents when they photograph. Jerry Uelsmann, for example, works very intuitively and spontaneously: "I don't have an agenda when I begin. I'm trying to create something that's visually stimulating, exciting, that has never been done before but has some visual cohesiveness for me, has its own sort of life."[28] He tells of how he made an image of a young woman, standing nude, presenting a glowing apple, and the picture now seems to him to be obviously an "Eve image." But at the time he made the multiply exposed photograph, he was unaware of this connotation:

> Because I concentrate so intensely on detail while I'm working, it wasn't really until the next morning that I recognized the obvious iconographic implications of the image that are so blatantly there. It seems impossible, in retrospect, that I didn't plan to do an Eve photograph. But at the time I was working the idea didn't enter my conscious thought.

Most importantly, perhaps, the interpretive task should be on the viewer and not on the photographer. By relying on or waiting for the photographer to explain his or her intents, we are abnegating our responsibility of interpreting what we see. For all of the reasons given earlier, intentionalism is a flawed and weak critical method. Some critics advocate that viewers should ignore photographers' statements of intent as irrelevant, but a less extreme position seems more reasonable. When expressed intents are available, we can consider them as part of the photograph's causal environment and part of the evidence for interpretation. Edward Weston has written two volumes of diaries, *The Daybooks*, which offer insights about him and his work. In our highly mobile society, photographers frequently travel and speak about the intents of their work, which can increase our general understanding and appreciation of their photographs. When a photographer does offer particular interpretations of specific images or general interpretations which apply to his or her work, that interpretation is only one among many possible or actual interpretations. If the artist's interpretation is to be accepted as sound, it must adequately account for what is presented in the picture and conform to the standards of coherence and correspondence as must all interpretations. We should take an artist's interpretation as an argument and evaluate it on the same

grounds as we do other interpretations that are offered. We should not consider an interpretation more privileged because it comes from the artist.

INTERPRETATIONS AND FEELINGS

Interpreting photographs, or responding to them in other ways, should not be solely an intellectual endeavor. As an art educator studying criticism has observed, "What *really* happens in art criticism relies heavily on that flash of insight based on gut feelings, life experiences, and perceptual information coming together just right."[29] Feelings provide important clues to learning about the content of an image. If we are aware that a picture evokes feelings in us, then we can identify them, acknowledge them, and try to decipher what and whether something in the picture triggers such feelings in us. Then we need to relate those feelings back to the image, perhaps through questions: What is it that I am feeling? Why is it? Is there a certain subject or the form or a particular use of the media that I am reacting to? Being attuned to our feelings when viewing images is a way to get beyond the obvious, to begin to identify the connotations of images.

As well as being a clue toward understanding and a possible starting point for interpretation, feeling is also an appropriate result. The end goal of the critical process is "enlightened cherishing";[30] through criticism we want to become "affectionately knowledgeable"[31] about photography.

INTERPRETATION, MEANING, AND PERSONAL SIGNIFICANCE

A distinction can be made between *significance* and *meaning*.[32] Significance is more personal than meaning. Significance refers to how a photograph affects us or what it means to us. Meaning is more objective than significance, referring to what the photograph is about in itself, or what several people would infer, or what can be made obvious to any informed viewer. A similar distinction between "meaning *in*" and "meaning *to*"[33] helps the interpreter stay on track in presenting an interpretation of the photograph. What a photograph means *to me* may not be what the photograph is about in itself. Personal significance and personal associations with photographs are valuable to each of us, but they may be too idiosyncratic, too personal, to be valuable to others who wish to understand more about the image itself. If our interpretations are too personal and too idiosyncratic, they become more about us and less about the image. Another way of saying this is that "if interpretation is not referenced to visual properties (in the image), discourse leaves the realm of criticism and becomes conjecture, therapy, reminiscence, or some other manner of purely subjective functioning."[34]

THE COMMUNITY OF INTERPRETERS

Ultimately, correct interpretations are those held by a community of informed interpreters that includes critics, artists, historians, dealers, collectors, and viewers. Interpretations, in the end, are a collective endeavor arrived at by a variety of people observing, talking, and writing about, and revising their understandings of complex and dynamic images made by sophisticated image makers. Michael Parsons, an art educator, has written insightfully about this community of art interpreters:

> . . . as we look at a painting, we presuppose the company of others who are also looking at it. We are imaginatively one of a group who discuss the painting because they see the same details, and can help each other to understand them. The painting exists not between the two individual poles of the artist and the viewer but in the midst of an indefinite group of persons who are continually reconstructing it—a community of viewers.[35]

The community is corrective: It won't accept any interpretation unless the interpretation is sensible and contributes to knowledge; on the other hand, the community of interpreters disallows dogmatic and inflexible understandings because it knows that art objects are ultimately rich objects that are less than determinable and that our understandings of them will continue to shift, usually subtly but sometimes dramatically. By following the principles detailed in this chapter we can join in that dialogue, contribute to it, and benefit from it.

4
TYPES OF
PHOTOGRAPHS

Since the early years of photography, people have been placing photographs in categories. In 1839, the year the medium was invented, photography was divided into its two oldest and most enduring categories when it was proclaimed to be both a science and an art.[1]

Another time-honored division from the early years of photography, and still in use but with different labels, divides art photographs into two groups, pictorialist and purist. More current terms for these divisions are "manipulated" and "straight." The division was antagonistic; at issue was the means of making photographs. In 1861 C. Jabez Hughes, a pictorialist, declared: "If a picture cannot be produced by one negative, let him have two or ten; but . . . the picture when finished must stand or fall entirely by the effects produced and not the means employed."[2] The straight aesthetic, however, would mandate that photographers use techniques considered "photographic" rather than hand-manipulated and "painterly." In 1904 critic Sadakichi Hartmann promoted straight photography: "In short, compose the picture which you intend to take so well that the negative will be absolutely perfect and in need of no or but slight manipulation."[3] About twenty years later Edward Weston reiterated the straight position, declaring "the approach to photography is through realism."[4]

Photography historian Beaumont Newhall, in his 1964 edition of *The History of Photography*, divides photographs into four stylistic trends: straight photography, the formalistic, documentary, and the equivalent.[5] He identifies Alfred Stieglitz, Paul Strand, Edward Weston, and Ansel Adams as paradigm examples of those employing a straight approach "in which the ability of the camera to record exact images with rich texture and great detail is used to interpret nature

and man, never losing contact with reality." Man Ray and Lazlo Moholy-Nagy are identified with the formalistic style, which Newhall typifies as a means of isolating and organizing form for its own sake without the use of cameras and without a concern for the photograph. The subject matter is paramount in "documentary," which is essentially a desire "to record without intrusion, to inform honestly, accurately, and above all, convincingly." The term *equivalent*, borrowed from Stieglitz, designates photographic metaphors, "charged with emotional significance and inner meaning," but which are "first of all, photographs." Newhall is not neutral about these categories and promotes the straight aesthetic and approaches that are considered uniquely photographic.

In two of the photography exhibitions he has organized, John Szarkowski proposes categories through which we may view photographs. In the exhibition and the subsequent book published in 1966, *The Photographer's Eye,* he embraces photographs from both the art and science categories and identifies five characteristics that he considers unique to photography:

> The thing itself—photography deals with the actual.
>
> The detail—photography is tied to the facts of things.
>
> The frame—the photograph is selected, not conceived.
>
> Time—photographs are time exposures and describe discrete parcels of time.
>
> Vantage point—photographs provide us new views of the world.[6]

In 1978, with a traveling exhibition and in a book, Szarkowski proposed a breakdown for looking at photographs made since 1960: mirrors and windows. Although he presents mirrors and windows as the two poles of a continuum between which photographs can be placed, he divides the photographs in the book and the exhibition into two distinct groups rather than placing them along a continuum. He aligns mirrors with the romantic tradition, and windows with the realist tradition, in literature and art:

> The romantic view is that the meanings of the world are dependent on our own understandings. The field mouse, the skylark, the sky itself do not earn their meanings out of their own evolutionary history, but are meaningful in terms of the anthropocentric metaphors we assign to them. It is the realist view that the world exists independent of human attention, that it contains discoverable patterns of intrinsic meaning, and that by discerning these patterns, and forming models or symbols of them with the materials of his art, the artist is joined to a larger intelligence.[7]

Mirrors tell us more about the artist, and windows more about the world. Mirrors are romantically self-expressive, exhibit concern for formal elegance rather than description, are generally made from a close vantage point for simplicity by abstraction, and favor subject matter such as virgin landscapes, pure geometry, the

unidentifiable nude, and social abstractions such as "the young." Windows are realistic explorations more concerned with description than suggestion that attempt to explain more and dramatize less and which usually deal with subject matter that is specific to a particular time and space, and they can usually be dated by evidence within the picture.

In the 1970s Time-Life publications came out with a widely distributed series of books, the Life Library of Photography. One book of the series, *The Great Themes,* uses these categories to cover photography: the human condition, still life, portraits, the nude, nature, war.

There are also subdivisions of categories. Sally Eauclaire, as the curator of a traveling exhibition of color photographs, wrote an accompanying catalogue, *The New Color Photography of the 1970s.* She divided the large category of recent color work into seven subsets: self-reflections, formalism, the vivid vernacular, documentation, moral vision, enchantments, and fabricated fictions. Estelle Jussim and Elizabeth Lindquist-Cock, in 1985, looked specifically at another category of photographs, landscapes, in *Landscape as Photograph* and subdivided that category into landscape as God, fact, symbol, pure form, popular culture, concept, politics and propaganda. In *Fabrications: Staged, Altered, and Appropriated Photographs,* Anne Hoy divided recent photography into five categories: narrative tableaux, portraits and self-portraits, still-life constructions, appropriated images and words, manipulated prints and photo-collages.

Categories are designed for different purposes, and they use various means to distinguish photographs. The Time-Life great themes are distinguished by subject matter and are easy to use. The pictorialist and purist, and straight and manipulated, categories attend to photographic procedure and resulting photographic form. They tend, however, to wrongly suggest that straight photographs are not manipulated. Newhall's categories are dated and he no longer uses them. Szarkowski's photographer's eye categories and mirrors and windows also start with form, and then ask us to consider how form affects meaning. They consider photography to be a unique medium. Hoy's and Eauclaire's divisions help us make sense of bodies of new work in specific, contemporary times, and Jussim and Lindquist-Cock's ask us to think about photographs with one subject matter, the landscape, throughout time.

This chapter presents a new category system that incorporates the best of the categories just mentioned. It covers all photographs, art and non-art, family snapshots and museum prints. It is not based on subject matter or form but rather on how photographs are made to function and how they are used to function. This system is designed to help viewers think about photographs, and especially to interpret them. It has six categories: descriptive, explanatory, interpretive, ethically evaluative, aesthetically evaluative, and theoretical. The categories have distinguishing characteristics, but photographs overlap them. It is the viewer's task to figure out in which categories a photograph fits, and in which one or more it fits

best. The categories are explained in the sections that follow, and examples of photographs are given for each.

DESCRIPTIVE PHOTOGRAPHS

All photographs describe in the sense that they offer descriptive, visual information, with greater or lesser detail and clarity, about the surfaces of people and objects. Some photographs, however, are not meant to be more than descriptions, such as identification photographs, medical X-rays, photomicrographs, NASA space exploration photographs, surveillance photographs, and reproductions of artworks. Their photographers are attempting to accurately record subject matter, and in many cases these photographs are painstakingly produced to be accurately descriptive and to be interpretatively and evaluatively neutral. An ID photograph attempts neither to express the sitter's personality nor to flatter the sitter's appearance but rather to accurately describe the sitter so that someone can match the photograph to the person.

In an elaborate descriptive undertaking in 1982, the Eastman Kodak Company, in collaboration with Musées de France Research Laboratory, meticulously reconstituted the Bull Room of the cave at Lascaux, France, for exhibition at the Grand Palais des Champs Élysées in Paris. The celebrated 17,000-year-old bison paintings on the walls of the cave at Lascaux were closed to public viewing in 1963 to save them from environmental deterioration. Set designers used details from surveyors' photographs made with a pair of stereoscopic cameras to build contours of the cave walls. Twenty-five photographs of the bison paintings were taken with a photogrammetric camera and flash and were printed in a 1:1 ratio on Ektacolor paper. The prints were assembled as a flat mosaic under the direction of a physicist who ensured that they were fit together in such a way that distortions would be avoided when the photo mosaic was adhered to the contours of the overhanging, concave sides of the reconstructed cave walls. The print mosaic was placed on decalomania paper, separated from its Ektacolor base, and adhered to the artificial rock face and its myriad indentations. The cave paintings were accurately reproduced.

A Meeting with the Universe is a book produced by NASA that is full of astonishing descriptive photographs. A photograph of Jupiter, taken from *Voyager 1,* shows the planet with its Red Spot behind two of its moons, each about the size of Earth's moon. The photograph was made from about 12 million miles away but provides detail of Jupiter's turbulent atmosphere. At the other end of the size and distance scale is a photograph that shows a speck of cosmic dust less than one-tenth of a millimeter across, photographed under an electron microscope.

As *Voyager 2* departed the Sun's family in 1989, it sent back a flood of photographs including rings circling Neptune, which were previously unknown.

EXPLANATORY PHOTOGRAPHS

The difference between "photographic descriptions" and "photographic explanations" is small but there is enough difference between an ID photograph on a driver's license and Eadweard Muybridge's photographs of how animals and people move, to merit separate categories. Photographs made by Muybridge around the turn of the century typify what we call explanatory photographs.

While employed as a photographic surveyor of the Pacific coast in the 1870s, Muybridge, an Englishman, met Leland Stanford, a railroad magnate, lover of horses, and founder of Stanford University. Stanford was engaged in an argument with a man named Frederick MacCrellish over whether a trotting horse ever had all four of its hooves off the ground at the same time. Stanford believed it did, MacCrellish did not, and they wagered $25,000. Stanford hired Muybridge to solve the issue and supplied him with whatever research funds he needed. Muybridge laid a track made of rubber to eliminate dust, hung a white cloth with numbered vertical lines as a backdrop to the track, and pointed twelve cameras at it. He designed the cameras so that they would be electronically tripped in sequence when a horse broke a thread stretched across the track as it moved down the track. Muybridge's photographs showed all the different gaits of the horse, which further showed that in the midst of its gait, trot, and gallop, all four of its hooves were off the ground at the same time. Stanford won his bet, and to the chagrin of many artists, previously painted and sculpted representations of horses, from ancient times to contemporary, were shown to be inaccurate. Muybridge offered a visual explanation of how horses move. A question had been asked of him and answered by him through his invention of equipment and procedures that provided an explanation in photographs. He went on to refine his techniques, and eventually, with the support of the University of Pennsylvania, made over 100,000 photographs of moving animals, including ostriches and baboons, and men, women, and children in a variety of movements and actions.

Stimulated by the work of Muybridge, Etienne Jules Marey, a French physiologist researching locomotion, invented in 1883 a single camera that could take a series of pictures on a single photographic plate. He clothed men in black, painted white lines down their arms and legs, and photographed them moving against a dark background. The resulting pictures were linear graphs of motion of arms and legs, trajectory paths, and oscillation patterns of movements. Marey's intent clearly was to explain with photographs: "By means of chronophotography we arrived at a scientific interpretation of the various bodily movements."[8] His and Muybridge's experiments led to more sophisticated time-motion studies in relation to efficient human industrial labor. Marey's photographs and diagrams are also identified as the visual source for Marcel Duchamp's famous painting, *Nude Descending a Staircase* (1911–12) and other art by the Italian futurists at the turn of the century.[9]

Contemporarily, physicist Harold Edgerton has photographically examined

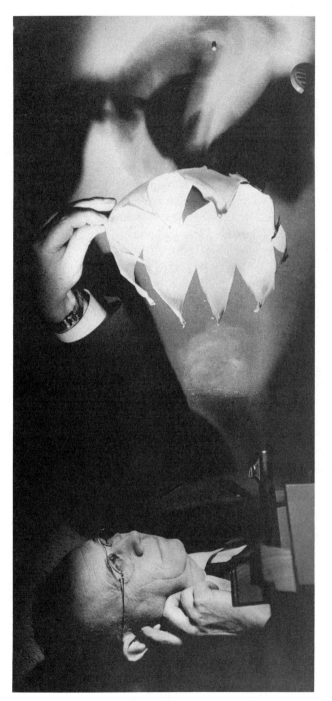

Harold Edgerton, *Self-portrait with Balloon and Bullet*, 1959.

the characteristics of bullets in flight and other fast-moving objects with the stroboscopic equipment and technologies he invented for his photographic studies. By photographically stopping the action of bullets moving 15,000 miles per hour with strobe exposures of a millionth of a second, he has discovered that as a bullet strikes a hard object the bullet liquifies for an instant, losing its shape as it compresses upon itself, and then solidifies again in shattered fragments.

Social scientists also use photographs to explain. Sometimes their work is called "visual sociology" and "visual anthropology." Howard Becker was the curator of a show of photographs in 1981 called "Exploring Society Photographically," which explored investigations that used photography "to understand the workings of the social world." The photographers Becker used in the show included both artists and scientists: "The photographers represented here cover the full range of possibilities. Some are more concerned with the presentation of evidence than others. . . . They all leave us knowing more about some aspect of society than we did before we absorbed their work."[10]

Most press photographs[11] can be placed in the explanatory category, but not all, because some go beyond explaining and also evaluate, condemning or praising aspects of society, and thus would better fit in the ethically evaluative category. Press photographs that attempt neutral, objective reportings about persons, places, and events fit in the explanatory category. Szarkowski's observation about windows applies to photographs in this category: Most explanatory photographs deal with subject matter that is specific to a particular time and place and that can be dated by visual evidence within the photograph.[12] Formally, these photographs usually use an angle of view that places the subject in a social context; they are usually printed so that details are not lost in tones that are too dark; and they favor a contrast range that can be duplicated clearly in the inks of offset printing. Explanatory photographs are often made to be reproduced in books, magazines, and newspapers.

A seminal project of this explanatory type from the early 1970s is Bill Owens's *Suburbia*, which the photographer describes as a photographic study "to document Americans in Suburbia." His photographs of interiors, exteriors, parents, children, and pets in three California suburbs are accompanied by comments from the subjects. His next project followed in 1975—*Our Kind of People: American Groups and Rituals*. After photographing the meetings of various civic and social clubs and organizations for his newspaper, Owens remained to shoot photographs for his book. He returned to meetings on evenings and weekends and photographed over three hundred groups over two years. These photographs are captioned with statements from club members.

Mary Ellen Mark is a photojournalist whose work fits within this explanatory category. Mark has photographed for a variety of magazines and the *New York Times*. She also has produced books including *Ward 81*, about women in the psychiatric ward of Oregon State Hospital, where she lived for thirty-six days, and *Falkland Road,* about prostitutes in Bombay, with whom she stayed for three

Bill Owens, cover of *Suburbia*, 1973.

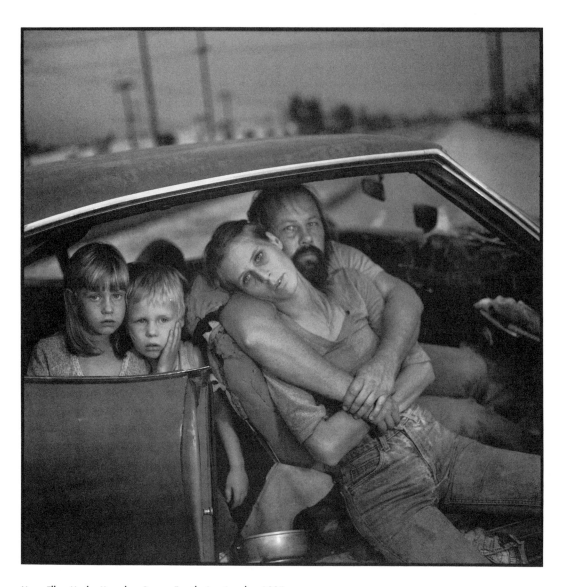

Mary Ellen Mark, *Homeless Damm Family*, Los Angeles, 1987.

months. About Mark's work, critic Shelley Rice says:

> Mark is a photographer who has been intensely, indeed passionately, involved with only one theme during the 23 years of her career: people. The concept "people" is only an abstract, a historical idea, but Mary Ellen has spent several decades giving this idea flesh, showing us what it means in the most concrete possible terms. She has sought out men, women and children of different nations, classes, beliefs, customs, lifestyles and circumstances; she has recorded their dreams, their realities, their tragedies and their joys.[13]

According to Rice, Mark's work is rooted in "the particular, in the day-to-day struggles, rituals and relationships that make up a life, however heroic or tragic." Raisa Fastman's *A Portrait of American Mothers and Daughters* is a book of photographs of mothers and daughters in everyday situations, rituals, and sometimes struggles. *Subway* by Bruce Davidson explores traveling on subways in New York, close-up, in color, conveying danger and fear and self-protective postures of the travelers. Both of these books belong in the explanatory category.

To be accurately placed in this category, a photograph should provide visual explanations that are in principle verifiable on scientific grounds. Edgerton's photographs should provide valid data for other physicists, and Becker's exhibition of photographs that explore society ought to provide valid information for social scientists. Fastman's photographs, if they are explanatory, should be valuable to social psychologists interested in mother-daughter relationships. Whereas the claims to truth that explanatory photographs make should be verifiable (or refutable) with further evidence of a scientific type, photographs in the next category, interpretive photographs, cannot be verified or refuted with scientific evidence. They make claims that are not meant to be subjected to the rigors of science.

INTERPRETIVE PHOTOGRAPHS

Interpretive photographs, like explanatory photographs, also seek to explain how things are, but they do not attempt scientific accuracy, nor are they accountable to scientific testing procedures. They are personal and subjective interpretations, more like poetry than a scientific report. They are usually fictional and often use the "directorial mode" of photography defined by A. D. Coleman as one in which the photographer caused "something to take place which would not have occurred had the photographer not made it happen."[14] Photographers working directorially stage people or objects in front of the lens, or intervene in real-life situations directing the participants, or they do both. Coleman traced this tradition from the beginning of photography to the present and identified the work of several in the past as directorial, including Anne Brigman, Clarence White, F. Holland Day, Gertrude Käsebier, and in the present including the work of Clarence John

Laughlin, Ralph Eugene Meatyard, Jerry Uelsmann, Les Krims, Duane Michals, Ken Josephson, Arthur Tress, Ralph Gibson, and Robert Cumming.

Interpretive photographs are closer to Szarkowski's mirrors than to his windows. They are self-expressive and reveal a lot about the world views of the photographers who make them. They are exploratory and not necessarily logical, and sometimes they overtly defy logic. They are usually dramatic rather than subtle and are generally concerned with formal excellence and good print quality. If a viewer questioned their claims, he or she would be hard pressed to find either confirming or denying scientific evidence. This is not to say, however, that interpretive photographs make no claims to truth or that they do not have truth value. Fiction can offer truths about the world.

Most of Duane Michals's sequences would be placed in this category, as would the multiple exposures of Jerry Uelsmann; the trilogy of surrealistic photography books by Ralph Gibson, *The Somnambulist*, *Déjà-Vu*, and *Days at Sea*; the directed portraits and self-portraits by Judy Dater; the highly manipulated, "phototransformation" self-portraits with Polaroid prints by Lucas Samaras; the overtly fictional family studies by Ralph Eugene Meatyard and the less obviously directed family studies by Emmet Gowin; the fictional environments that Sandy Skoglund[15] builds and photographs; Bea Nettles's *Mountain Dream Tarot*, *Events in the Sky*, and *The Elsewhere Bird; Theatre of the Mind* and *The Teapot Opera* by Arthur Tress; such works by Les Krims as *Fictcryptokrimsographs* and "Idiosyncratic Pictures"; *Ernie* and *Stories* by Tony Mendoza; works by Frederick Sommer; and the dramatically staged photographs of people in relationships by Jo Ann Callis.[16] Most of the work of Joel-Peter Witkin would fit here, as would Richard Avedon's book.

In *Contemporary American Photography Part I*, critic and curator Mark Johnstone makes observations about the staged photographs of Eileen Cowin, which symbolically address interpersonal relationships, and whose work is interpretive. His remarks about her work apply to all the photographs in this category: "Her photographs, unlike documentary photojournalism that seeks the seizure of a 'decisive moment,' are the creation of 'expansive moments.'"[17] The emphasis here is on creating moments in a studio situation rather than finding decisive moments on the street—a distinction between "making" and "taking."

ETHICALLY EVALUATIVE PHOTOGRAPHS

Ethically evaluative photographs describe—some attempt scientific explanations, others offer personal interpretations—but most distinctively, they all make ethical judgments. They praise or condemn aspects of society. They show how things ought or ought not to be. They are politically engaged and usually passionate. "Homeless in America" is an exhibition of ethically evaluative photographs. It is a traveling exhibition of eighty prints, including photographs by Eugene Richards

Jerry Uelsmann, *Untitled*, 1969.

and Mary Ellen Mark, which depicts the homeless, but more significantly, according to Andy Grundberg, "It aims not only to show us what the homeless look like and how they live, but also to move us to indignation and action. It is, in short, an exhibition with its heart in the right place—if you believe that hearts should be worn on the sleeve."[18]

There are several important examples of ethically evaluative photographic projects throughout the history of photography. Jacob Riis, an American "muckraker with a camera," was known at the turn of the century as the "Emancipator of the Slums." About his work the *Encyclopedia of Photography* declares: "His brutal documentation of sweatshops, disease-ridden tenements, and overcrowded schools aroused public indignation and helped effect significant reform in housing, education, and child-labor laws."[19] Dorothea Lange in the 1930s photographed migrant workers in California, and her work "helped establish the style of Farm Security Administration (FSA) photography as a compassionate factual record of people suffering hardships and the conditions they endured."[20] Although much of the work of FSA photographers Walker Evans, Lange, and others is today collected as art, "art was not the intent of the FSA."

Preceding and during World War II the Nazis used photography as propaganda. John Heartfield[21] countered with photomontages of his own in politically persuasive, satirical condemnations of Hitler and his regime. Both sets of work are forms of political advertisements in photographic form. Other advertisements, for products and services, also fit in the evaluative category. Advertisements for detergents, deodorants, and dog food promote values, certainly about the products they sell but also about life styles, attitudes, and aspects of what advertisers promote as "the good life." Much of the work of Robert Heinecken, in highly directed and manipulated photographs, pokes fun at aspects of our consumer society. Lynette Molnar's work takes a stand on issues of censorship, homophobia, and the invisibility of gays. These images also fit in this category.

The last book of the late W. Eugene Smith with his wife Aileen, *Minamata*, is an account of the struggle of Japanese village fishermen and farmers with the Chisso Corporation over the company's willful polluting of the sea and the resulting methyl mercury poisoning of the people who lived off the contaminated fish they caught in their bay. It is a paradigm example of work in this category. The dust jacket declares in bold type: "The story of the poisoning of a city, and of the people who chose to carry the burden of courage." The first line of the prologue states, "This is not an objective book," and later, "this is a passionate book."

Bruce Davidson was involved in the civil rights movement in the 1960s and made passionate photographs of the struggle. He also produced *East 100th Street*, which concentrated on living conditions in Harlem with the intent of improving them. Danny Lyon also worked within the civil rights movement, and his *Conversations with the Dead* sympathetically investigated the dire living conditions of penitentiary inmates. In pictures and interviews, Eugene Richards's *Below the*

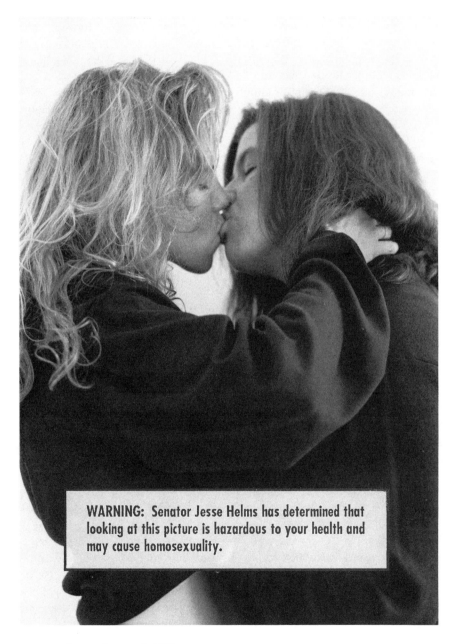

WARNING: Senator Jesse Helms has determined that looking at this picture is hazardous to your health and may cause homosexuality.

Lynette Molnar, *Talking Back*, 1990.

Line: Living Poor in America "captures the hopelessness of urban youth, the struggle of midwestern farmers, the squalor of day-to-day existence for Mexican-American immigrants living in Texas border towns" and others in deploring the poverty that exists in the United States in the 1980s. Carrie Mae Weems is a black woman who combines written accounts and photographs that expose racial prejudice in society. She draws upon autobiographical accounts, oral history, and especially racial jokes. These books and projects are all clear examples of ethically evaluative photographs.

Fred Lonidier,[22] Allan Sekula, Connie Hatch, and Steve Hagan work out of explicit Marxist bases to produce photographs that critique existing social conditions with the intent of radically changing them for the better. Most of their work fits in this category as do the visual condemnations of sexism in society by Laurie Simmons,[23] Vikky Alexander,[24] and Barbara Kruger.[25]

Ethically evaluative photographs can also be positive, as in Brian Lanker's traveling exhibition and book *I Dream a World: Portraits of Black Women Who Changed America.* The photographs are portraits, but are clearly meant to praise the seventy-five women pictured and to present them as inspirational people. About the project, Lanker writes: "My hope is that this project will allow readers and viewers to see something of those lives and feel the strength of those hearts for a brief moment, and to be informed by them and inspired by them as I have."[26]

AESTHETICALLY EVALUATIVE PHOTOGRAPHS

Other photographs make judgments, not about social issues but about aesthetic issues. The photographs in this category point out what their photographers consider to be worthy of aesthetic observation and contemplation. They are usually about the wonder of visual form in all its variety and how it can be rendered photographically. This is the kind of "art photography" most familiar to most people. Photographs in this category are usually of beautiful things photographed in beautiful ways. The subject matters are infinite, but the most conspicuous and common are the nude, the landscape, and the still life.

The nudes are usually faceless and nameless, sometimes only torsos, male and female, studies of the human form. They are carefully lit, posed, and composed for maximum aesthetic effect. The selected bodies are often svelte or muscular or youthful as in the black male nudes by Robert Mapplethorpe, but sometimes they are aging as in the self-portraits by John Copeland or obese as in some of the nudes by Irving Penn.[27] Sometimes the bodies are distorted by lens and angle of view as in the Surrealist nudes of Bill Brandt. Sometimes the prints are cut up and rearranged as in the abstracted nudes of Tetsu Okuhara.[28] Sometimes they are situated in vacant space, but often they are posed in the natural environment as are the nudes in sand dunes by Edward Weston and Wynn Bullock's nudes in the lush forests of the Northwest. Sometimes the human form is clothed as in

Brian Lanker, *Septima Clark*, 1987.

the portraits by Imogen Cunningham of Martha Graham dancing. But all of these photographs call our attention to the aesthetic appeal of the human form as it is situated and as it is rendered photographically.

The landscape has been and continues to be an endless source of fascination for artists of all types, especially photographers. Ansel Adams, in particular, built his monumental opus on the natural landscape of the American West. Others follow today in the tradition of Adams as he received it from Stieglitz and Weston before him. Paul Caponigro has photographed Stonehenge and the landscapes of the British Isles; Minor White, the New England landscape and close-ups of crashing waves; Harry Callahan, landscapes in city and public beaches and city scapes in the United States and abroad. John Szarkowski sums up some essential characteristics of this tradition in photography: "a love for the eloquently perfect print, an intense sensitivity to the mystical content of the natural landscape, a belief in the existence of a universal formal language, and a minimal interest in man as a social animal."[29]

Those working contemporarily with the landscape often include indications of human co-presence or intrusion. William Clift visits the same territory as Ansel Adams did, but whereas Adams minimized any suggestion of the human, Clift organizes some of his majestic western landscapes with dirt roads and barbed-wire fences. Joel Meyerowitz's *Cape Light* attends to the delicacy of the light and color on Cape Cod, but the photographs often include the ocean-front porches from which they were shot. After Cape Cod he brought his large camera to the city and produced *St. Louis and the Arch*. Barbara Kasten[30] starts with city buildings, usually new buildings publicized for their architecture such as the Museum of Contemporary Art in Los Angeles, and transforms them, with drastic camera angles, intense colored lighting, and mirrors, into colored geometric spectacles.

The still life, another time-honored theme in art and photography, includes objects as they are found and, more commonly, objects that are carefully selected and arranged by a photographer for maximum aesthetic interest. Jan Groover's still lifes discussed in Chapter 2 are aesthetically evaluative photographs in that she shows the formal elegance obtainable from the simplest and most ordinary objects with photographic materials and careful organization. Irving Penn and Marie Cosindas are two other recognized masters of the still life. Irving Penn has produced still lifes since the early 1940s for advertising accounts and as fine art. He has recently completed a series of animal skulls. Another series is also of platinum prints, of gutter debris "raised by isolation, enlargement, and tonal simplification to the level of formal art objects."[31] Cosindas's photographs are in richly saturated Polaroid colors of complex patterns of fabrics, flowers, and other visually complex objects. Aaron Siskind's are still lifes of another sort, made of close-ups of tattered billboards, peeling paint, or charred wood.

Although the nude, the landscape, and the still life are common subjects in the aesthetically evaluative category, the category is not subject specific and these subjects do not exhaust the category. Nor are all landscapes aesthetically evaluative.

Irving Penn, *Zebra*, 1986.

Many of Mark Klett's photographs[32] are formally exquisite views of majestic land and at first glance look like the others in this category, but upon closer examination it becomes obvious that they condemn the destruction of the land and fit better in the ethically evaluative category.

Barbara Crane's and Ray Metzker's[33] cut-up and collaged mosaics of photographs, David Hockney's mosaics of Polaroid prints, Betty Hahn's[34] experimental gum-bichromate images on stitched fabrics, Linda Connor's[35] intentionally softly focused prints, and other explorations of formal possibilities of the manipulated print can also be placed in this category.

Much "street photography" fits within this category, including a lot of the work of Henri Cartier-Bresson, Gary Winogrand, and Lee Friedlander. Bresson and Winogrand often photograph people who are identifiable, in locatable places. They are not arranged by the photographers except with their viewfinders. Winogrand's book *Women Are Beautiful,* for example, is of crowds of people on the street, at the beach, or in a park, quickly composed in Winogrand's viewfinder and frozen in visually harmonious relationships.

Whether waves, bodies, or pie tins are the subject of the photographs in this category, it is not only the subject matters that are called to our aesthetic attention but also the way they are photographed, printed, and presented. About Richard Misrach's stunning color photographs of the desert, Mark Johnstone writes that "while they tell us something about the place, these pictures are also about what it means to transform experiences of the world into photographs."[36] Similarly about the color work of Misrach, Meyerowitz, William Eggleston, and Stephen Shore, Jonathan Green states that their photographs are "all testaments not only to the beauty of existing light but to the range of color available to the medium.... These photographs are experiments in pure color, a collaboration of the world and the medium."[37]

THEORETICAL PHOTOGRAPHS

This last category of includes photographs about photography. These photographs comment on issues about art and art making, about the politics of art, about modes of representation, and other theoretical issues about photography and photographing. A prime example is Cindy Sherman's[38] "film stills," mentioned in Chapter 2, with which she comments on how women are represented in popular media. They are photographs about films, photographs about photographs, art about art, and can be considered a visual type of art criticism that uses pictures rather than words. Joel-Peter Witkin's photographs about historical paintings and sculptures, also mentioned in Chapter 2, are clearly art about art.

Many of the photographers who make theoretical photographs are very aware of and concerned in their picture making with the photographic medium itself, with what it does and does not do, how it pictures and to what effect. Since

Henri Cartier-Bresson, *Place de l'Europe, Paris*, 1932.

1977 Richard Prince[39] has been systematically rephotographing photographic ads in magazines and exhibiting them in galleries. Some of his works are rephotographs from ads of the heads of male models, or their wristwatches, or the eyes of female models, presented as a series and without the advertising copy. By photographically clipping them from their contexts, he draws our attention to the visual conventions of advertising and scornfully mocks it.

Vikky Alexander's[40] work is similar to Richard Prince's. In the early 1980s Alexander concentrated on fashion photography. In *Numero Deux*, for example, she alternated two close views of the face of a model six times in checkerboard fashion. Of this piece, Anne Hoy writes: "The repetition reveals the stereotyping of expressions popularly considered sexually alluring and the isolation suggests the use of women as sex objects generically, as multipurpose selling tools."[41]

Photographers who work in this mode are also concerned with aesthetic, that is, philosophical, issues not specific to photography. Sherrie Levine[42] has photographically copied the work of such photographers as Walker Evans and Edward Weston, and painters Piet Mondrian and Egon Schiele, and exhibits them. These appropriations have been understood to be attacks on such modernist beliefs as artistic genius, originality, the preciousness of the unique art object, and the expense of the art commodity. Much of the work in this category is postmodernist, and a rejection of modernism, but there are several theoretical photographs made before the postmodernism of the 1980s.

Between 1974 and 1976 Thomas Barrow[43] completed what he calls his "Cancellations" series. The photographs are straightforward, documentary shots of mundane scenes of the land and buildings, in unimaginative compositions. Each photograph has a large "x" from corner to corner scratched through its surface. The "x" can be read in a number of ways: as a rejection of the goal of neutrally and impersonally recording; as a rejection of the precious print; as a rejection of the straight, unmanipulated aesthetic; as a cancellation of the illusionary properties of photographs. In the early 1970s Ken Josephson[44] made a series of photographs about photographic postcards. In each photograph, a hand holds a postcard of the scene being photographed. They are literally photographs about photographs.

Much of the "conceptual art" and "conceptual photography" of the 1970s also fits in this category. Such photographers as John Baldessari,[45] Robert Cumming,[46] Victor Landweber,[47] and Eve Sonneman explored issues about the medium of photography itself. Sonneman's book *Real Time,* for example, is forty-six pages, two photographs on a page, a subject shot at different time intervals. She also did a series that shows four photographs of the same subject, two in black and white, two in color. Both of these projects direct the viewer's attention to properties of the photographic medium, how it is time specific, and differences between depictions in color and black and white. Of Cumming's work, which is elaborately set up to present the illusion of reality, Jonathan Green writes: "Cumming's intervention into the observable world makes the viewer constantly

question the relationship between fact and fiction, objectivity and subjectivity, the camera as recorder of reality and the camera as the fabricator of new information."[48] Although other directorial photographers set up situations to photograph, theirs are not necessarily about the camera or the objectivity of the camera as are Cumming's; thus, they might be placed in the interpretive category, whereas Cumming's belong in the theoretical category.

Les Krims produced a whole book, *Making Chicken Soup,* in 1972 that makes fun of ethically evaluative photographs. Those who make them are sometimes referred to as "concerned photographers." The International Center of Photography, for instance, uses "concerned photographer" in reference to such photographers as Bruce Davidson and Eugene Smith who are concerned with social issues and righting the wrongs of society. Krims dedicated his book to "my mother, and also to all concerned photographers—both make chicken soup." The book shows Krims's mother (nude except for a girdle) making chicken soup, step by step. The book is elaborate sarcasm directed at concerned photographers who, in Krims's view, do no more than serve up placebos to make us feel better about social issues, rather than changing them, much as moms serve chicken soup to cure colds. Krims's is a whole book of photographs about other photographs and thus fits within this category of theoretical photographs, even though the photographs for the book are staged and fictional as are many photographs in the interpretive category, and even though the book makes biting political commentary as do many works in the ethically evaluative category.

USING THE CATEGORIES

These six categories are for sorting photographs, not photographers. Photographers tend to make certain kinds of images with some consistency, but they also make departures from their usual work. Most of Edward Weston's photographs fit within the aesthetically evaluative category, but his photographs that condemn destruction of the environment belong in the ethically evaluative category. Many of Barbara Kruger's images are about social issues and are ethically evaluative, but some are more specifically about how we as a society use images; these would overlap into the theoretical category.

Photographs may fit well in more than one category, and more than one category may apply to any single photograph. For example, all photographs, no matter how abstract, give relatively accurate descriptive information about the people, places, and objects they show. Thus, all photographs could fit the descriptive category. Most photographs also interpret what they present photographically, because they are made by people with points of view, with understandings of the world, with passions. Thus, all photographs could be placed in the interpretive category. All art and all photographs are about other art in the sense that past art influences present art, and present art can always be read in the light of

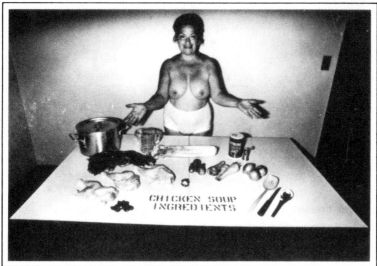

Les Krims, cover of *Making Chicken Soup*, 1972.

influences upon it. Thus, all photographs could fit in the theoretical category. Most of these placements, however, would be in a weak sense. To place a photograph into a category and show that it fits in a strong sense, we have to figure out what it does most, or what it does best, or how it is most clearly being used.

Krims's *Making Chicken Soup,* for example, is a cookbook, and an autotutorial, step-by-step device for learning to make chicken soup. It even has recipes in it, not only for chicken soup but and also for kreplach and matzo balls. We could easily place this in the descriptive category or the explanatory category. But if we understood the book to be simply a descriptive cookbook, or an explanatory device for learning to cook, we would misunderstand the point of the book. It does describe and it does explain, but most importantly, it sarcastically pokes fun at "concerned photographers" and "concerned photography." It is most importantly art about art and thus fits in the theoretical category.

Some photographs and photographic projects do fit accurately in more than one category and belong in more than one category in a strong sense. An example is the water tower project of Bernd and Hilla Becher. For years they have been systematically photographing water towers in Germany and America and in 1988 completed a book of 223 of them, *Water Towers.* Of these photographs, Andy Grundberg writes that they are presented "with such detail and tonal fidelity that they tempt us to see them as uninflected transcriptions," but he goes on to explain that the photographs "are equally allied with the practices of Conceptual and Post-modernist art, since they erect typologies of form that challenge the traditional meanings of art, architecture, and photography."[49] These photographs, in Grundberg's understanding, would fit best in both the descriptive and the theoretical categories: They meticulously describe a class of structures, water towers, but in their style, or more accurately, their conscious denial of style, they also comment on art and photography. To see them only as descriptive photographs of water towers and not also as art about art would be to misunderstand them.

Because the categories overlap, we can use them to see how any given photograph is descriptive, if and how it explains in any scientific sense, how it is inflected by the photographer's world view, if it makes a value judgment of an ethical or aesthetic type, and how it may be commenting on or influenced by other photographs and artworks.

Often photographs made to be a certain type of photograph are later used as another type. NASA's space exploration photographs were certainly made as descriptive and explanatory photographs, but some of them were later used as ads for Mobil Oil and Tang orange drink. Advertisers moved them from a descriptive category to an ethically evaluative one, from fact to advertisement. The Farm Security Administration photographs, in their day, were generally accepted as "documentary" but are now understood to be "propaganda"; yesterday they would have been placed in the explanatory category, today in the ethically evaluative category. Many photographs not made as art are often shown as art: Photomicrographs, space exploration photographs, and studies of motion once made for

science are published in coffee table books and hung on museum walls. Implications of category displacements such as these will be discussed in the next chapter, which considers how the context in which a photograph is seen affects its interpretation.

The most important aspect of these categories is that they are interpretive. That is, we must interpret a photograph before we can reasonably categorize it. As we have seen in the previous chapter, to interpret is to figure out what an image is about and to build an argument based on evidence for the understanding we have of an image. We do not have to do much interpretation to sort photographs into piles according to whether they are landscapes, nudes, still lifes, or portraits. But we do have to put a lot of interpretive thought into determining whether a portrait by Diane Arbus is like a portrait by Joel-Peter Witkin or one by Richard Avedon and whether any one of these is like a portrait on a driver's license or one made at a Sears department store.

To place a photograph in one or more of these categories is to interpret it. Interpretations, as we discussed in the previous chapter, are always open to counterargument. In this chapter, *Suburbia* by Bill Owens is placed in the explanatory category, because it uses straightforward photographs of people who are aware of being photographed and who are cooperating with the photographer. It uses the people's own words for its captions. Owens claims that it is a documentary project, and it seems a project that attempts, in scientific fashion, to pictorially survey a suburban community. In *American Photography,* however, Jonathan Green writes: "Although Owens's work purports to be neutral and objective, his final pronouncement is much harsher…. His conservative anecdotal and reportorial style documents a visual environment unrelieved in its superficiality. For Owens, suburbia is beyond redemption."[50] Presumably, if Green were to use these categories, he would place *Suburbia* into the ethically evaluative group because he sees it as a condemnation of that which it portrays. If we were using these categories to discuss *Suburbia,* we would find ourselves in disagreement and a friendly argument might ensue, and a very beneficial one, because deciding whether *Suburbia* is objective and neutral about what it presents, or whether it condemns, is essential to accurately understanding the book.

Photographs have been placed in categories in this chapter without argument and without presentation of much evidence for their placement, even without reproduction of the images, and you may think they have been placed incorrectly or inaccurately. You are invited to disagree and to provide evidence for more accurate placements. And although many photographers have been mentioned in this chapter, certainly not all could be. The ones who are mentioned are thought to provide the clearest examples for explaining the categories and how they can be used.

That is the point of creating these categories and for using them. Placing photographs in these categories demands interpretive thought and encourages

interpretive agreement and disagreement. These categories have been designed to encourage and facilitate interpretive discussion; they are not meant to end discussion through pigeonholing, or automatic sorting. If they are used in this way, they are rendered useless.

5
PHOTOGRAPHS
AND CONTEXTS

It is difficult to accurately place a single photograph of unknown origin in one of the six categories presented in the previous chapter. This is another way of saying that it is difficult for viewers to arrive at a trustworthy interpretation if they don't have some prior knowledge of the photograph: who made it, when, where, how, and for what purpose. This kind of information is contextual information, which can be either internal, original, or external.

INTERNAL CONTEXT

Some photographs are understandable just by looking at them and thinking about what is shown in them. If we are familiar with the culture in which some photographs were made, we don't need to know much about the origin of the photographs to understand what they are about. The photograph that won the 1959 Pulitzer Prize for press photography by Bill Seaman[1] is a good example of a photograph that is interpretable on the basis of what is shown in it. At the bottom edge in the photograph's foreground is a crushed wagon on the pavement at an intersection of two streets in a residential neighborhood. In the middle ground of the photograph, about a third up from the bottom, there is a blanket or sheet draped over a small body shape. A policeman writing on a pad of paper stands next to the covered shape, and a medic is walking away from it. Some bystanders, women and children, are looking on from a distance. People in cars are also gazing as they pass by. We know by looking at the photograph, and drawing upon our knowledge of draped body shapes, policemen, medics, crushed wagons, and fatal accidents, that

the photograph is about a child who has been run over by a vehicle. We would readily and correctly place the photograph in the explanatory category.

We can also readily interpret many art photographs—any of Edward Weston's photographs of peppers or seashells, for example—by considering what is shown. When we see Weston's *Pepper No. 30*,[2] 1930, we know that we are to attend to the pepper's form, to enjoy the twists of its sensuous curves, to note the lighting that makes it sculptural. We understand that we are to appreciate the photograph as an aesthetic object rather than as a botanical illustration of an edible vegetable. We would readily and correctly place this photograph in the aesthetically evaluative category. This understanding depends, however, on some general knowledge of contemporary Western culture, and especially on some familiarity with art of the twentieth century, abstraction, and the notion of art for the sake of art. But if we have gathered this knowledge, we can understand and appreciate *Pepper No. 30* based on what Weston shows in the photograph.

To consider a photograph's internal context is to pay attention to what is descriptively evident, as was discussed in Chapter 2: namely, the photograph's subject matter, medium, form, and the relations among the three.

ORIGINAL CONTEXT

Although the Weston art photograph and the Seaman press photograph are understandable on the basis of what they show, many photographs are inscrutable without some information beyond that which can be gathered from simply observing the photograph. Photographs in the theoretical category depend on knowledge of art and the art world. Les Krims's *Making Chicken Soup* seems pointless humor if the viewer does not know what it is making fun of—"concerned photography." Sherrie Levine's copies of Walker Evans's[3] photographs would be completely misunderstood if the viewer didn't know that they were copies. They are not labeled copies, they are titled "After Walker Evans," which probably would be misunderstood by casual observers to mean that they are "in the manner of" or "in homage to," rather than exact copies of Evans's photographs. Even if one knows they are copies, an uninformed viewer would still be perplexed as to why they are in a museum, why they are displayed as art. To be fully comprehended and appreciated, Levine's images require knowledge of Walker Evans and his stature in the history of photography, but especially knowledge of postmodernist theory and its rejection of such notions as the originality of the artist, the preciousness of the original art object, and artistic genius. Levine's images are irreverent challenges to a prior theory of art. Such knowledge cannot be gathered by merely considering what is shown in the photographs.

Photographs made for the press also benefit from, and often depend on, knowledge of the contexts from which they emerge. In 1973 Huynh Cong "Nick" Ut[4] made a horrifying photograph that shows children, crying and screaming, and soldiers, fleeing with smoke behind them, running on a country road toward us.

The children are obviously traumatized. A young girl in the center of the frame is naked. Because of the evident pain of the children, this is a horrifying image. It is all the more horrifying when one knows that the children have just been sprayed with napalm from a jet above and that the girl is naked because she tore off her clothes trying to remove the burning jelly from herself. They were bombed in a mistake. Although they are on the same side in a war, the pilot mistook the group as the enemy. The photograph itself reveals little. It is knowledge of the circumstances surrounding the making of the photograph that makes it more than a picture of traumatized children. The photograph has been credited with helping to stop American involvement in the Vietnam War.

Knowledge of context can also add richness to our understanding of easier photographs—those we can understand by looking at them. Photographs, by nature, are always swatches cut from seamless reality. They are segments, shot from close or afar, with a wide or narrow angle of view. By use of the viewfinder, photographers include and exclude. In a sense, all photographs are literally "out of context." They are out of a spatial context, and they are also out of a temporal flow. They are one instant stopped in time. To understand and appreciate photographs, it is sometimes very useful to imaginatively put them back into their original contexts, to see what the photographer has done to make a picture, to study what was included, and how, and to imagine what was excluded and why. To consider their temporal element, we can try to see them as if they were one frame from a feature length film. We can imaginatively consider what was physically available to the photographer at the time the exposure was made.

Knowledge of a photograph's original context includes knowledge of that which was psychologically present to the photographer at the time the exposure was made. To consider a photograph's original context is to consider certain information about the photographer and about the social times in which he or she was working. The photographer's intent—what he or she meant to do by taking a photograph—can be revealing when it is available and can aid in our understanding of a photograph. Many photographers have written about their work. Julia Margaret Cameron, for example, has written very personally about her work in portraiture. Her revelations about herself add insight to her photographs. Knowledge of the photographer's biography can also reveal much about influences, personal and stylistic, on his or her work.

Original context includes knowledge of other work by the photographer. One close-up photograph of a gnarled green pepper might seem strange, but knowing that it is one of some thirty photographs of green peppers by the same photographer, and that the photographer also made similar, close-up pictures of halved artichokes, cabbage leafs, toadstools, and halved and whole seashells, makes it less strange.

Knowledge of the work of other photographers and artists, literary and musical, and from dance, painting, and sculpture, made during the same period as the photographer in question may also provide considerable insight. Photographers do

not work in social and aesthetic vacuums. Like all artists, and all people, they are influenced by those around them, and by their culture and cultural heritage. Knowledge of the history, the politics, the religious and intellectual milieu of the period in which the photographer was working is important to a fuller understanding of a photograph. Much of the effect of Nick Ut's photograph depends on knowledge of Vietnam, the war, and napalm. Levine's photographs depend on knowledge of art history and art theory. Original context is history: social history, art history, and the history of the individual photograph and the photographer who made it.

EXTERNAL CONTEXT

External context is the situation in which a photograph is presented or found. Every photograph is intentionally, or accidentally, situated within a context. Usually we see photographs in very controlled situations: books, galleries, museums, newspapers, magazines, billboards, and classrooms. The meaning of any photograph is highly dependent on the context in which it is presented: How and where a photograph is seen radically affects its meaning. Gisèle Freund, a French scholar and photographer, relates how one of her countryman's photographs was placed in various external contexts that radically affected its meaning.[5]

In 1953 Robert Doisneau, a French photojournalist, made one of several photographs of French cafés, one of his favorite topics. In one café he entered he was charmed by a man and woman drinking wine at a bar and asked if he could photograph them. They consented, and eventually the photograph appeared in *Le Point,* a mass circulation magazine, in an issue devoted to cafés illustrated with his photographs. He then gave this and other photographs to his agent. Some time later, and without the consent of Doisneau or the photographed man and woman, the café photograph appeared in a brochure on the evils of alcohol published by a temperance league. It had been sold to the league by Doisneau's agent. Still later, and still without the photographer's or the subjects' consent, and this time without the agent's knowledge, the photograph again appeared, in a French gossip tabloid that had lifted it from *Le Point.* It appeared with the caption: "Prostitution in the Champs-Élysées." The man in the photograph sued the tabloid, the agency, and the photographer. The court fined the tabloid, and also found the agency guilty, but acquitted Doisneau.

The presentational environments in which this café photograph appeared overrode the content of the photograph and overdetermined its meaning in ways unfair to the photographer, the subjects, and the photograph itself, but that is the power of external context.

Since the 1950s Doisneau's café photograph has appeared in other notable external contexts that further change how it is received. It frequently hangs in the Museum of Modern Art in New York, matted and framed under glass, with this

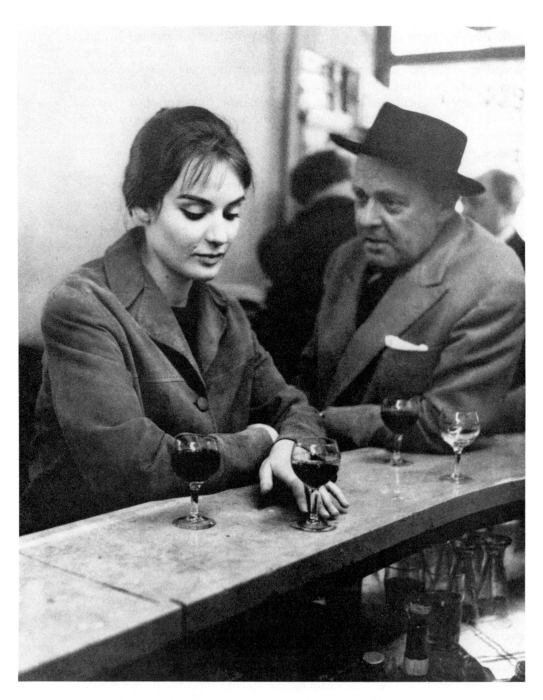

Robert Doisneau, *At the Café, Chez Fraysse, Rue de Seine, Paris*, 1958.

label on the wall: "Robert Doisneau, French, born 1912, *At the Café, Chez Fraysse. Rue de Seine, Paris. 1958. 11 7/8 x 9 3/8.*" In this external context, it is not part of a popular magazine spread on cafés, it is not used to preach against alcohol, it is not titillating readers about prostitution; it is hanging as a work of art in one of the most prestigious museums in the world.

This photograph also appears in John Szarkowski's *Looking at Photographs: 100 Pictures from the Museum of Modern Art*, with a one-page essay. Szarkowski interprets the photograph to be about the "secret venial sins of ordinary individuals," a sexual seduction:

> For the moment she enjoys the security of absolute power. One arm shields her body, her hand touches her glass as tentatively as if it were the first apple. The man for the moment is defenseless and vulnerable; impaled on the hook of his own desire, he has committed all his resources, and no satisfactory line of retreat remains. Worse yet, he is older than he should be, and knows that one way or another the adventure is certain to end badly. To keep his presentiment at bay, he is drinking his wine more rapidly than he should.[6]

Szarkowski backs his speculative understanding of the photograph with information from the photograph's internal context, or what is shown: The woman appears younger than the man, he appears to be gazing at her longingly, she looks more confident, and one of the two wine glasses before him is empty, although her two are nearly full. Although these observations do not automatically add up to an attempted seduction, Szarkowski argues for his interpretation and tries to convince us with evidence that his view is correct.

Szarkowski's treatment of the photograph is much more fair and reasonable than are those given it by the temperance league and the gossip tabloid: He lets his readers know that he is making an interpretation. The other two users ignore Doisneau, the intended purpose of the photograph as part of a photo essay on cafés, and impose their wills on the photograph to suit their purposes, without warning the viewer about what they have done.

EXTERNAL CONTEXTS AND CONNOTATIONS

Doisneau's café photograph has appeared in at least six very different contexts, including this book. Each of them strongly affects how the photograph is understood. These examples of one photograph in different external contexts illustrate how easily the meaning of a photograph can be altered, especially if text is added to it. Photographs are relatively indeterminate in meaning; their meaning can be easily altered by how they are situated, how they are presented.

Roland Barthes writes about the press photograph and how its meaning is heavily influenced by the publication that surrounds it, what he calls its "channel of transmission":

> As for the channel of transmission, this is the newspaper itself, or more precisely, a complex of concurrent messages with the photograph as the center and surrounds constituted by the text, the caption, the layout and, in a more abstract but in no less informative way, by the very name of the paper (this name represents a knowledge that can heavily orientate the reading of the message strictly speaking: a photograph can change its meaning as it passes from the very conservative *L'Aurore* to the communist *L'Humanité*).[7]

It is not hard to image the different connotations a photograph of a hunter beside a dead deer would receive in this country if it were printed on the covers of both the *Sports Afield* and *Vegetarian Times* magazines.

Other writers have attended to how the art museum orients our interpretations of photographs, and some critics are especially concerned about the common museum practice of placing photographs not initially made as art into artworld contexts. Martha Rosler complains that the specific content of such photographs gets transformed into content about the artists who made them: "More and more clearly, the subject of all high art has become the self, subjectivity, and what this has meant for photography is that all photographic practice being hustled into galleries must be reseen in terms of its revelatory character not in relation to its iconographic subject but in relation to its 'real' subject, the producer."[8] She worries that the content of the photograph is erased with concern about the artist.

This concern is sometimes called the "aestheticizing" of photographs, and although the term is recent, the warning is as old as the 1930s when Walter Benjamin, the German Marxist critic, made a similar accusation. He complained that photography "has succeeded in turning abject poverty itself, in handling it in a modish, technically perfect way, into an object of enjoyment."[9] More recently, Susan Sontag has voiced concern that the cultural demand for aesthetically pleasing photographs has caused even the most compassionate photojournalist to satisfy two sets of expectations, one for aesthetic pleasure and one for information about the world. She argues that Eugene Smith's photographs of the crippled and slowly dying villagers in Minamata "move us because they document a suffering which causes our indignation—and distance us because they are superb photographs of Agony, conforming to Surrealist standards of beauty."[10] She makes similar claims about Lewis Hine's photographs of exploited child laborers in turn-of-the-century textile mills: Their "lovely compositions and elegant perspective easily outlast the relevance of the subject matter.... The aestheticizing tendency of photography is such that the medium which conveys distress ends by neutralizing it. Cameras miniaturize experience, transform history into spectacle. As much as they create sympathy, photographs cut sympathy, distance the emotions."

The point of these examples is that it is important to examine the context in which a photograph has been placed, whether that be a newspaper, a magazine, a billboard, or a museum gallery. When an editor captions a photograph, that editor is interpreting it. When a curator places a photograph in a museum, in a gallery,

in a section of a show, under a heading such as "Mirrors," and with a label such as "Roy DeCarava, *Self-Portrait,* 1956, 101/8 x 1311/16 inches, Museum of Modern Art, New York, purchase," that curator is interpreting it.[11] A caption, or a placement of a photograph as part of a show, may not be fully developed interpretations, or reasoned arguments, but they are persuading us to understand an image in a certain way. External contexts, or presentational environments, are forms of interpretation. As such, they, like all interpretations, ought to be evaluated for accuracy, fairness, reasonableness, and for their consequences.

INTERPRETING BARBARA KRUGER'S *UNTITLED* ("SURVEILLANCE"),1983, WITH CONTEXTUAL INFORMATION

Following is an interpretation of this image by Barbara Kruger. The interpretation is based on internal, external, and original contextual information to show how context can be used to understand photographs.

"Surveillance" and Internal Context

This is a black and white photograph with words superimposed upon it—"Surveillance is your busywork." A man is peering at us through a photographer's lupe, a magnifying device for closely examining negatives, contact prints, slides, and photographs. The lupe is a fixed-focus device, a cube, and he has it and his other hand against something, perhaps a pane of glass, a window, or a light table used for viewing negatives and transparencies. One of his eyes is closed, the other open. The light source is directly in front of his face, and it is harsh, revealing pores of skin and stubbles of whiskers. He looks to be in his forties or fifties. He is intent and, on the basis of the photograph, would be difficult to identify. The photograph in "Surveillance" looks dated, out of style, but vaguely familiar. It is dramatically lit and shot from a dramatic angle and distance—reminiscent of black and white Hollywood movies on late-night television, tough-guy cops and robbers movies.

The photograph is approximately square. It was shot either from a distance with a telephoto lens or from very close with a normal lens. Halftone dots are apparent—it is a halftone reproduction rather than a silver print made directly from a negative. The word *surveillance* is larger than the other words, in black type on a white strip, pasted at a slight diagonal above the man's eyes. The phrase "is your busywork" is at the bottom of the image, in white type on a black strip. The words are a declaratory sentence. They are accusatory. "Surveillance" is associated with spying, sneakiness, furtiveness, unwholesome activities. "Busywork" is not something we want to be accused of doing—we have more important things to do with our lives. Someone is being accused by someone for something, and there is an urgency about the image.

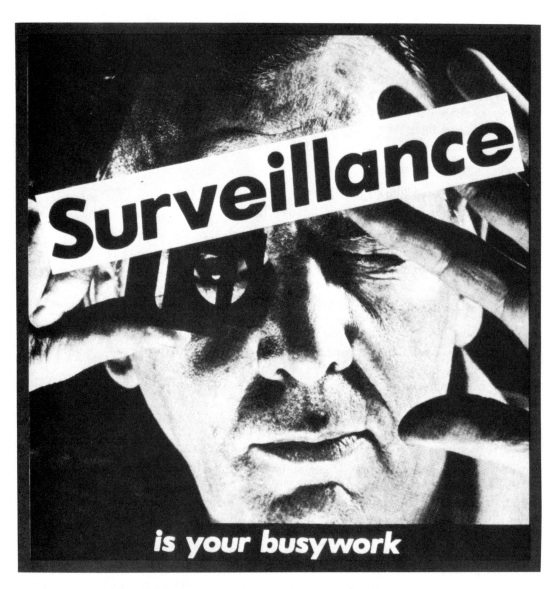

Barbara Kruger, *Untitled* ("Surveillance is your busywork"), 1983.

"Surveillance" and Original Context

Barbara Kruger was 38 and living in New York in her Tribeca loft when she made the "Surveillance" image. She was born in Newark, New Jersey, in 1945, into a lower middle-class, Jewish family. Her father was the first Jew hired by Shell Oil in Union, New Jersey, and the family was harassed by anti-Semitic phone calls during the year he was hired. She grew up in a black neighborhood, graduated from a competitive high school, and attended Syracuse University where she was a straight-A student. She returned home after her freshman year when her father died and enrolled in Parsons School of Design in New York where she had classes with Diane Arbus ("the first female role model I had who didn't wash floors 20 times a day"[12]). She also studied with Marvin Israel, an art director and designer who became her mentor. She lost interest in school after a year and began working for *Mademoiselle* magazine as a graphic designer and became its chief designer after a year. She began making fine art in 1969, quit *Mademoiselle,* but continued to work for Condé Nast publications as a designer on a freelance basis.

In the mid-70s Kruger joined a group called Artists Meeting for Cultural Change, and with the group read and discussed social and cultural theory by Walter Benjamin, Roland Barthes, Theodor Adorno, and other social critics of leftist ideologies. She socialized with a group of artists including David Salle, Ross Bleckner, Eric Fischl, Ericka Bleckman, Barbara Bloom, and Mat Mullican. Marcia Tucker included Kruger's art, then stitched decorative wall pieces, in the prestigious Whitney Biennial exhibition in 1973. Kruger began writing poetry and had her first poetry reading in 1974. She could have carved out a niche as a painter but was more intrigued and challenged by her writing than her art making.[13]

Kruger began photographing and combining her writings with her photographs around 1975. She eventually winnowed her texts to short phrases or a single word on top of a single photograph; for example, over a picture of a woman with folded hands, wearing a pristine wool sweater, she placed the word *perfect* (1980). She also stopped making her own photographs, and instead selected photographs from magazines and cropped and enlarged them. Most of the photographs she selects are posed or set up: "She does not work with snapshots, in which the camera itself suspends animation, but with studio shots, in which it records an animation performed only to be suspended."[14]

Kruger begins a set of new work with a "demi-narrative" in mind and selects photographs that might work with it. Once she has chosen her pictures she writes several different phrases, working from her notes, books, or a thesaurus. Writing the phrases and making them work in richly meaningful ways with the photographs is the hardest part for her. She plays with the words and pictures, relying on her experience and skill as a graphic designer. She crops, enlarges, and alters the contrast of the photographs in photostats and has the phrases set in different type sizes. After arranging a total image to her satisfaction, she sends it to a photo studio for enlarging and final printing. Her images are finally framed in bright red metal.[15]

In 1983 Kruger was again selected to participate in the Whitney Biennial and showed works similar to *Untitled* ("Surveillance is your busywork"), 1983. *Untitled,* 1981, for example, shows six men in tuxedos, with boutonnieres, laughing, as they pull at another man in a tuxedo. He appears to be laughing too. Where they are cannot be determined definitely, but it is probably a wedding reception, and he is probably the groom. "You construct intricate rituals which allow you to touch the skin of other men" is pasted over the photograph and to the right, in alternating white on black, and black on white segments, at slight diagonals.

Untitled, 1983, shows a short, clear glass with water, probably, and ten small pills on a cloth-covered surface, brightly lit from the above right corner. "You kill time" is printed over it, white letters on black strips.

Untitled, 1981, shows a baby's hand reaching for the finger of an adult hand. The photograph is contrasty, with an evident dot pattern, and starkly lit from the front. It is a close-up. The background is black. "Your every wish" is in small black type over the hands; "is our command" is in larger type at the bottom of the image. A different *Untitled,* 1981, shows the familiar image of a mushroom cloud after the detonation of an atomic bomb. "Your manias become science" is emblazoned across it. "Your" and "science" are black on white and larger than "manias become," which are white on black. The succinctness of the phrase, and the black and white pattern, are reminiscent of a blinking neon sign. We can read it as "your science / manias become" or "manias become / your science" as well as "your manias / become science."

Thus, on the basis of these other images done by Kruger around the same time as "Surveillance," we know that it is not an abnormality, not an idiosyncratic image, but part of a larger, consistent body of work. The other images inform this one and vice versa. They all bear the same typeface, in strips. But the photographic images are different from one another and not cohesive. She has images of an atomic explosion, an adult's hand and a baby's hand, a wedding reception, and a glass of water and pills. The photograph of the mushroom cloud is an image embedded in public consciousness. All of the photographs Kruger uses are somehow familiar. They are "appropriated" images, taken from mass culture. In pieces done in the mid-80s after "Surveillance," she uses the technique of plastic lenticular double images usually associated with kitsch religious icons. In these, one image is visible from one angle and another appears as the viewers shift the pieces or their angle of view. Kruger's images are similar to the "rephotographs" of Walker Evans's work by Sherrie Levine and to Richard Prince's rephotographs of magazine ads. Kruger is working in the 1980s, when postmodernist practice abounds, when many artists are using other images rather than making all images anew. Postmodernism questions the possibility and desirability of originality in art.

Kruger is very comfortable with mass media images. She says: "I grew up looking not at art but at pictures. I'm not saying it's wrong to read art-history

Barbara Kruger, *Untitled* ("Your manias become science"), 1981.

books. But the spectators who view my work don't have to understand that language. They just have to consider the pictures that bombard their lives and tell them who they are to some extent. That's *all* they have to understand."[16]

The phrases she writes, like the photographs she selects, also have a familiar ring to them. They sound like advertising, but they are more terse and biting. Kruger says her work is "a series of attempts to ruin certain representations" in language and images by her use of photographs and text. She wants her work to expose and condemn stereotypes and clichés in advertising and throughout culture. Postmodernist practice is politically motivated. The phrase "your manias become science" over the image of the mushroom cloud is overtly political, resonant with controversial social issues in the 1980s concerning atomic energy, nuclear warfare, and global nuclear disarmament. In the 1980s several women artists are feminist in their ideologies and their art making. Barbara Kruger is known by her contemporaries as a feminist artist and she acknowledges that she is a feminist, but she does not want to be tied to one feminist camp, saying "there are a multiplicity of readings of what constitutes feminism."

If we interpret the images as political and feminist, they become sharper. The wedding groom photograph, and the "you" in the phrase "you construct intricate rituals which allow you to touch the skin of other men," might now be read as an accusation by a feminist woman against men. Given that men are pictured, that they are in a ritual, and that men frequently exhibit fear of closeness with other men, it makes sense to interpret the image as accusing men. It is men, too, who have control of science and are responsible for inventing and using the atomic bomb. Probably it is they who are accused in the phrase "your manias become science" over the picture of the mushroom cloud. The "you" in the image of the pills and water with the phrase "you kill time" may be referring to women who kill time with sedating drugs, or the "you" may be addressing the pharmaceutical companies who make them, or the doctors, often male, who prescribe them for women, keeping women in a controlled state and contented by means of chemical sedation rather than through meaningful work.

Kruger intentionally uses her pronouns in slippery ways: "With the question of You I say there is no You; that it shifts according to the viewer; that I'm interrested in making an active spectator who can decline that You or accept it or say, It's not me but I know who it is."[17] When she lectures about her work, she is often asked what certain pieces mean, but she answers those questions of meaning generally and vaguely, placing the interpretive responsibility on the viewer. "Whenever they ask what a work means, I say that the construction of meaning shifts. And it shifts according to each spectator." She does admit, however, that she is "welcoming a female spectator into an audience of men." She also freely admits her desire for social change: "I want to make statements that are negative about the culture we're in," but she wants her images to be attractive "or else people will not look at them."[18] The changes she hopes for are toward "pleasure and tolerance."[19]

"Surveillance" and External Context

Barbara Kruger has placed her images in several different presentational environ-
ments and is acutely aware of the effect of external contexts on her work. She most
often places her work in artworld situations, usually presenting them in galleries
as fine art, under glass, in red metal frames, with expensive price tags. But she has
also made works for marquees in subways in New York and electric signage for
Times Square in Manhattan. In the winter of 1987 she placed eighty copies of a
photograph, a pigtailed little girl looking admiringly at a boy's muscle, with the
text "We don't need another hero," on billboards throughout England, Ireland, and
Scotland. She saturated Las Vegas with fifty prominent billboards of twelve
images. In 1985 she had "Surveillance is your busywork" enlarged for a billboard
and displayed it in Minneapolis. "Your manias become science" has been reduced
and printed on matchbook covers. Sometimes she uses newspaper ads to deliver
her messages, and several of her images are available as postcards; others are
printed on T-shirts and sold in boutiques and department stores.

About the various means she uses to distribute her work, Kruger says: "The
more visible I become in the artworld, the easier it is for me to place images
outside the artworld in secular sites." She adds: "Why just do one thing?...Why
just do posters? Or why just blow up pictures and put them in red frames for
galleries? Why not do posters, do billboards, do the galleries?"[20]

Kruger sometimes targets very specific populations for her messages, and
when she does, she may make significant changes to an existing piece. She has
displayed "Your manias become science," for instance, in subways, and translated
the phrase into Spanish. When she did, she changed the pronouns so that in
Spanish "Your manias become science" reads as "*their* manias become science."
This switch is an important clue to the meaning of this piece and her others. It is
not Hispanics riding the subways of New York who possess the science and tech-
nology to militarily dominate the world. The Hispanic reader is addressed by the
piece, but clearly it is not the Hispanic reader who is being accused.

The question of who is addressed, and accused, by her statements, and
particularly by her pronouns, is an essential question in viewing her work. Lynn
Zelevansky writes in *Artnews* that "the voice generally seems to belong to a
woman commenting bitterly on a male-dominated society."[21] About Kruger's use
of language Carol Squiers writes in *Artnews*: "The words strike out at you. . .
provoking a variety of visceral responses—fear, disgust, denial. But the question
remains, are you the victim or the victimizer? The position of the viewer remains
ambiguous, shifting between gender roles and power positions, alternately active
and passive, receptive and rejecting."[22] Craig Owens, writing in *Art in America,*
agrees: Her particular uses of pronouns force the viewer "to shift uncomfortably
between inclusion and exclusion."[23]

As an artist Kruger has chosen to display her work in several different
external contexts, but others have also made choices about where her work

belongs and have placed it in presentational environments of their choosing. Knowledge of some of these external contexts adds to our understanding of her work, because by knowing these we gain information about how others in the art world understand her work and how they situate it for the public and thus influence how it is understood by those who see it. Annina Nosei showed Kruger in 1981 in a group show entitled "Public Address" with Jenny Holzer, Mike Glier, and Keith Haring. Hal Foster chose to unite and compare Jenny Holzer and Barbara Kruger in a feature article for *Art in America*.[24] He understands both artists to be addressing concerns about mass media and the artworld through uses of language. Of both of them he says, their "images are as likely to derive from the media as from art history, and whose context is as likely to be a street wall as an exhibition space." He sees both artists using language as a target and as a weapon. Both are "manipulators of signs more than makers of art objects—a shift in practice that renders the viewer an active reader of messages more than a contemplator of the esthetic."

Le Anne Schreiber writes in *Vogue*: "Kruger has been building a reputation as a sharp-edged, sharp-tongued, critic of the consumer society." Once a graphic designer, "she now uses her skills to unmask the hidden persuaders rather than to assist them."[25] Schreiber adds that Kruger "is the sworn enemy of cliché and stereotype, of those culturally reinforced images that tell us who we are and what we want." Lynn Zelevansky adds that "Kruger is one of a number of artists who quote commercial art, an inversion of the traditional relationship in which advertising utilizes the conventions and imagery of fine art because such connoisseurship denotes wealth, sophistication and intelligence."[26]

In an *Artforum* review of a 1984 show Kruger had at Annina Nosei Gallery, critic Jean Fisher contextually places Kruger's work in an area already mapped out by such artists as John Baldessari, Hans Haacke, and Victor Burgin, who were working in the 1970s with the relationship between word and photographic image. Fisher credits Kruger with adding feminist concerns, specifically concerns about inequitable divisions of labor according to gender.[27] In an *Artnews* review of another Annina Nosei Gallery exhibition two years later, John Sturman writes that "Kruger has become one of the leading feminist exponents of a form of contemporary photography that is grounded in the principles of mass communication and advertising."[28]

Fisher claims that Kruger's use of boldface type over images is reminiscent of design rooted in Russian productivism and that her use of red frames reinforces the connection and suggests that the work is in the tradition of socialist propaganda.[29] Anne Hoy also thinks Kruger's style uses "the devices of Socialist propaganda to counter what she considers capitalist ideology, one agitprop against another,"[30] and that it evokes the photo collages John Heartfield made for the Communist workers' paper *AIZ* in the 1920s, and Soviet posters of the 20s and 30s.

Two critics specifically mention Kruger's adroit use of humor. Shaun Caley, in *Flash Art,* writes: "The pleasure of Kruger's text is the joy of the one-liner

social commentary that throws the carnivalesque into perspective and capitalizes with a just amount of cynicism on the game of exploitation."[31] Carol Squiers thinks that Kruger's humor is black humor: "Although Kruger's work is always leavened by and sometimes dependent on humor for its punch, it is usually humor of the blackly corrosive variety."[32]

Kruger was included in "Playing It Again: Strategies of Appropriation" in 1985 along with several other artists who use images from the mass media to critique the daily onslaught of images created by those who control film, television, newspapers, and advertising. Her work was also selected for Documenta 8 in Kasse, West Germany, in 1987, by curators who wished to rescue all art from mere self-involvement: "Neo-Expressionism was about the relation of the artist to himself. Documenta 8 is about the relationship of art to society."[33] Documenta 8 was curated to be full of work with social themes, art which is socially engaged, and Kruger's work is seen by the curators to be an important exemplar of such socially engaged art. Anne Hoy includes Kruger in her book *Fabrications: Staged, Altered, and Appropriated Photographs*, situating Kruger in the section "Appropriated Images and Words" along with such artists as Sherrie Levine, Richard Prince, Vikky Alexander, Sarah Charlesworth, and Victor Burgin. About these artists Hoy states that "their source remains mass culture and the power structure at its core."

Hoy also states that the appropriated photographs of artists such as Kruger, Levine, and Prince have generated some of the most complex and challenging critical writing we have on photography to date. In discussing Kruger's work in *Artnews,* critic Hal Foster refers to Friedrich Nietzsche, Bertolt Brecht, Walter Benjamin, and Roland Barthes, and in a feature article about Kruger in *Art in America,* Craig Owens appeals to the ideas of Jacques Lacan, Emile Benviniste, Roman Jakobson, Barthes, Michel Foucault, and Sigmund Freud. By appealing to the work of such scholars to make Kruger's work more understandable, critics Foster and Owens place her work in a larger intellectual arena and into an external context of progressive European thought.

BARBARA KRUGER'S *UNTITLED* ("SURVEILLANCE"), 1983, AND THE CATEGORIES

We will now consider how Kruger's "Surveillance" fits in the six categories—descriptive, explanatory, interpretive, ethically evaluative, aesthetically evaluative, theoretical—and in which categories it fits best on the basis of what we have learned by examining its internal, original, and external contexts.

Descriptive Photographs

Although "Surveillance" shows a man from close range, it is not like an identification photograph, a medical X-ray, or a photomicrograph. The image of the man

was probably not originally made to accurately describe the man or whatever he is engaged in doing. The way Kruger uses the image is not particularly descriptive either: She coarsens the image by adding contrast to it, severely crops it, and covers part of it with the word *surveillance*. The photograph in "Surveillance" does describe, however, as do all photographs. It describes the man, portions of his hands, and the lupe he is looking through. It describes frontally by means of harsh lighting. And Kruger's use of the photograph is in a sense descriptive: She presents to us an image in circulation in the 1950s. She calls its qualities to our attention by selecting it, cropping it, labeling it with her phrase, framing it, and distributing it. But certainly this image is much more than a value-neutral description.

Explanatory Photographs

The text that Kruger uses, "Surveillance is your busywork," is not informational. The phrase sounds neither scientific nor objective but instead emotional and angry. Even though the man in the photograph might be doing something scientific or technological, the image of his doing it, especially with the phrase, is not explanatory in nature. It does not look like a Muybridge animal-locomotion study nor like a Bill Owens *Suburbia* photograph, even though both *Suburbia* and "Surveillance" use pictures of people and words. In short, the image declares and accuses rather than explains.

Interpretive Photographs

"Surveillance," like all of Kruger's images, is her interpretation of the way the world is. It represents her world view, her individual way of encountering and reacting to and picturing her experience in the world. It is her subjective view in her personally refined and highly identifiable style. It is clearly meant to persuade us to see the world as she does, and it uses photographic and linguistic rhetoric to do so. Although "Surveillance" is subjective and interpretive, it is informed by her knowledge of and experience in the world, her knowledge of art and political theory, and it makes a claim to truth. Because it is an interpretive image it asks to be interpreted, thought about, and considered seriously, and not to be dismissed as "just her opinion."

Ethically Evaluative Photographs

There is a strong moral tone to the language in the image and negative connotations in the photograph of the man. The photograph is not at all flattering: It is spooky, in harsh light and deep shadows. Someone is being accused by someone of doing something wrong. "Surveillance is your busywork" is an ethically

evaluative statement, a moral condemnation. The words and image mesh, rein-
forcing the condemnation.

Given the political nature of Kruger's work and her feminism, it seems likely
that this image is directed at men, particularly white men who have and exert
power over other people's lives. This image asserts that they control others
through surveillance. Because of the photographer's lupe, and the lighting that is
probably from a light table, photography is the suggested means of their surveil-
lance.

Surveillance is not a wholesome activity. It is sneaky business, a defensive
and offensive activity directed at people who are declared enemies and suspect.
Surveillance is usually engaged in by the military and police agencies and by those
who have a lot of money, merchandise, and property. These are usually men,
privileged by race, gender, and class. This image accuses them of sneakily watch-
ing over others to protect and maintain their privilege and status.

The surveillance that Kruger is addressing might also be men's voyeuristic
surveillance of women for sexual titillation and gratification. Photography is
widely used for pornography, the mainstay of *Playboy, Penthouse,* and other
magazines, and for print and television advertising images that often exploit
women. The man in the image could be a picture editor for a magazine or an art
director of an ad agency.

Aesthetically Evaluative Photographs

In "Surveillance" Kruger uses a photograph that is harshly lit, visually compact,
shot from a close range which reveals stubbles of whiskers and pores of skin. It
is not an appealing photograph of appealing subject matter.

Aesthetically evaluative photographs are sometimes made to comment
negatively on the lack of aesthetic appeal in the world. This image by Kruger
might in part be negatively commenting on the photograph of the man in "Surveil-
lance," and perhaps on mass media, journalistic photography of the forties and
fifties. Because she so freely reproduces her work in so many different graphic for-
mats, from matchbooks to billboards, and widely circulates them in large num-
bers, we can infer that the precious, one-of-a-kind, classical "fine print" is not a
criterion of hers for her art. Because for her pieces she chooses photographs
already existing in magazines and other sources, we can also infer that the
originality of her photographic vision is not at issue. In her case it is not "the
photographer's eye" that is paramount but rather the artist's mind. Most photo-
graphs that fit comfortably into the aesthetically evaluative category, such as
much of the work of Edward Weston and Ansel Adams, exhibit concern for
originality and fine printing and the photograph as a precious object, archivally
processed, matted, framed, and under glass. Clearly Kruger, with her T-shirts and
subway signs, is not concerned with such issues. In short, "Surveillance" does not

fit well within this category, and this category does not inform us much about this image except to help us determine what the image is not about.

Theoretical Photographs

All images are about other images in the sense that images emerge from within a tradition. "Surveillance," like all postmodern images, is more directly about other images. It quotes another image, appropriates it, and then transforms it by cropping, contrast, reproduction, and especially by the addition of text. "Surveillance" includes a photograph of an older photograph made by a photographer, probably anonymous, other than Kruger. Kruger's "Surveillance" is about representations generally and about photographs. Her use of others' photographs asserts again the postmodern belief that there are enough images in circulation already and that these need commentary. Kruger comments particularly on non-art images drawn from popular media.

"Surveillance" also comments negatively on the use of photography as a means of surveillance. By using the photograph of the man with the photographer's lupe, Kruger, along with others,[34] targets photography as a means of control, intimidation, domination, and voyeurism. The world is spied upon by satellites with cameras; mug shots document criminals; suspected subversives in Third World countries are surreptitiously photographed and their pictures filed for future reference; people in protest groups in street demonstrations are frequently photographed by police agencies; cameras patrol the aisles of department stores and the lobbies of banks; and when we write a check in a discount department store we are likely to be photographed before the check is accepted. "Surveillance" connotes these practices.

THE INTERPRETIVE PROCESS: A SUMMARY

The process of interpreting photographs is complex, and there is no one way critics use to arrive at their understandings of images. In Chapter 3, for example, several general approaches or perspectives toward interpretation were mentioned with examples quoted from critics: psychoanalytic, formalist, semiotic, feminist, Marxist, stylistic, biographical, intentionalist, and technical. Each of these approaches has advantages and limitations. This list is not exhaustive, and some of these approaches are combined by critics. Each of them could be tried to see how they fit an image or how comfortably they fit the critic. What is most important to remember is that interpreting a photograph is a matter of building a reasonable understanding based on demonstrable evidence. Good interpretations are not willy-nilly responses, nor are they dogmatic pronouncements. They are reasonable arguments built by critics, and they are always open to revision. Some interpretations are better than others because they better fit the photograph, offer greater insight, and are more compelling. Because there are so many critics with

so many world views and ideological persuasions, there will be multiple interpretations that are reasonable and compelling, even though different. Our lives are enriched by diverse interpretations of the same photograph.

In Chapter 4, we considered photographs according to the categories of descriptive, explanatory, interpretive, ethically evaluative, aesthetically evaluative, and theoretical. These categories were introduced to emphasize that not all photographs are made as art nor presented as art and should not be interpreted solely as aesthetic objects. The categories are also a means of interpretation: If we use the categories, we have to consider how a photograph is functioning and what it is about. Placing a photograph in one or more categories demands that we interpret the photograph, not merely label it.

In this chapter, the importance of considering contexts—internal, original, and external—was discussed with the example of the Doisneau photograph and its various placements and uses and misuses. These three contextual sources of information were used to consider an image by Barbara Kruger, and based on the information gathered from these contexts, her "Surveillance" image was placed in each of the categories to further determine how it functioned and what it might mean. The interpretive, ethically evaluative, and theoretical were the most helpful in understanding "Surveillance." The consideration of external and original contexts requires that we look beyond what is shown in the photograph. These contexts also reinforce the principle that interpretation is both a personal and a communal endeavor: It is usually possible and always wise to consider the views of other knowledgeable people when putting forth our own interpretations. Ultimately, it is a community of people knowledgeable about art and photography who formulate the meanings of images. In the short term, a critic is often the first one to formulate a meaning about an image, but in the long run, interpretation is a collective endeavor that includes the thoughts of a variety of people working from within a diverse range of perspectives.

6
EVALUATING PHOTOGRAPHS

When critics criticize photographs they sometimes but not always judge them. When critics do judge photographs, they usually praise them but sometimes condemn them. The terms *evaluation* and *judgment* are synonymous. When critics evaluate an artwork they make statements of appraisal, stating how good it is or isn't. The following several examples of statements from published criticism are clearly judgmental.

EXAMPLES OF JUDGMENTS

Irving Penn is "a major talent, by most if not all standards, and at least arguably a genius, a maker of some of the most awesomely handsome photographs in the history of the medium." In Penn's photographs, "there is more pure sensual pleasure per square inch than can be found in the work of any other living photographer" and "anyone fortunate enough to see [his photographs] will find among them the most beautiful physical entities photography can produce" (Owen Edwards, *Saturday Review).*[1]

Irving Penn's "imperial eye can turn African villagers into caricatures and, when he transforms a motorcyclist from the Hell's Angels into a delicate study in gray, the eye is seduced—but the mind gags" (Mark Stevens, *Newsweek).*[2]

Diane Arbus is "one of the most remarkable photographic artists of the last decade." And she is "as rare in the annals of photography as in the history of any other medium—who suddenly, by a daring leap into a territory formerly

96

regarded as forbidden, altered the term of the art she practiced" (Hilton Kramer, *New York Times Magazine*).[3]

Arbus's work "has had such an influence on other photographers that it is already hard to remember how original it was" (Robert Hughes, *Time*).[4]

Arbus's work "shows people who are pathetic, pitiable, as well as repulsive, but it does not arouse any compassionate feelings.... The insistent sameness of Arbus's work, however far she ranges from her prototypical subjects, shows that her sensibility, armed with a camera, could insinuate anguish, kinkiness, mental illness with any subject" (Susan Sontag, *On Photography*).[5]

"But clearly [Gary] Winogrand made not just good pictures; he made extraordinary ones" (Andy Grundberg, *New York Times*).[6]

"[Henri] Cartier-Bresson's fame is based on four decades of incomparable camera reporting.... [His] genius lay in his recognition that unretouched reality was already tractable enough, that the world was most intoxicating when served straight up" (Richard Lacayo, *Time*).[7]

Cindy Sherman "is the first artist working in the photographic medium to have fully infiltrated the 'other' art world of painting and sculpture.... She has accomplished what other photographers have been pursuing for a century— true parity with the other two arts" (Lisa Phillips, *Cindy Sherman*).[8]

"Not all of [Sherman's] images are successful" (Deborah Drier, *Art in America*).[9]

"[Robert] Heineken, one of the most important and influential photographers in America today..." (Mark Johnstone, *Contemporary American Photography*).[10]

"Heineken has consistently failed to embody his concerns in anything but superficial ways" (Jonathan Green, *American Photography*).[11]

JUDGMENTS AND REASONS

A judgment is a *what* that demands a *why*. Judgments, like interpretations, depend on reasons. Judgments without reasons are not particularly beneficial. To declare something "good" or "bad," "original" or "remarkable," without giving reasons as to why it is thought to be so is merely to offer a conclusion, and however well founded or thought out that conclusion might be, it is not very revealing or helpful if the reasons behind it are not offered in its support. The positive and negative conclusions about the work of various photographers cited above have been

quoted without the reasons the critics offered to support their judgments. But the critics who wrote them do have reasons, some of which are provided below.

When Hilton Kramer declared Diane Arbus to be "one of the most remarkable photographic artists," he offered several reasons, one of which was that Arbus invited her subjects to participate in her photographs and thus they "face the camera with patience and interest and dignity; they are never merely 'objects.'" Robert Hughes also provides several reasons supporting his admiration of Arbus's photographs: Her work is "very moving," and "Arbus did what hardly seemed possible for a still photographer. She altered our experience of the face."

Nevertheless, there is serious disagreement on Arbus's work. In a review of the same exhibition that Kramer and Hughes praise, Amy Goldin in *Art in America* specifically derides their views and claims that "for us her people are all losers, whether they know it or not.... Her subjects must not seem to feel too much, lest they destroy the delicate superiority we gain from knowing more of their vulnerability than they do. Nor can they be heroic; we must admire ourselves for respecting them."[12] Susan Sontag is also especially negative about Arbus's work and devotes a whole chapter to it in her book *On Photography*. Sontag argues that Arbus makes everyone look the same, that is, monstrous, and that she takes advantage of their vulnerability and their compliance, "suggesting a world in which everyone is an alien, hopelessly isolated, immobilized in mechanical, crippled identities and relationships."

In supporting Cindy Sherman's work, Lisa Phillips argues that Sherman's use of photography for her content is an apt match: "To Sherman the secondary status of photography in the art world forms a perfect corollary to the status of women in a patriarchal society, and she uses each situation to question our assumptions of the other." Deborah Drier also admires most of Sherman's work but expresses reservations about two of them in Sherman's 1985 exhibition at Metro Pictures gallery in New York: "the bearded lady is saved from cliché only by the evidence of her wretchedness and the disgust engendered by the most horrid orifices erupting near her eye, and I could have lived without the girl-into-Miss Piggy trick." In an introductory catalogue statement, the work of Robert Heinecken is praised because it "simultaneously questions and expands our notion of 'what is a photograph.'" But Jonathan Green rejects the work as "simplistic" and claims that in deviating from straight photography "Heinecken lost his way in a maze of pictorial alternatives."

In important respects, critical judgments or evaluations are similar to interpretations or explanations. Both are statements that need reasons in their support; both are arguments that require evidence. Judgments without reasons are similar to opinion polls: They tell us that some people hold a certain position, but they fail to reveal why. If we are given reasons for judgments, we are better able to agree or disagree with them and thus further our own thought, discussion, and knowledge about photographs, and deepen our understanding and appreciation of them.

Also, like interpretations, judgments are neither definitively nor absolutely

right or wrong. Rather, judgments, like interpretations, are more or less convincing, persuasive, and compelling depending on how well or poorly they are argued.

JUDGMENTS AND CRITERIA

Complete and explicit critical judgments entail three aspects: *appraisals* that are based on *reasons* which are founded in *criteria*. Hilton Kramer's statement that Arbus is "one of the most remarkable photographic artists of the last decade" is an appraisal. Statements of appraisals are about the merits of the work being judged, that it is "remarkable," "strong" or "weak," "good" or "lacking." Reasons are statements that support an appraisal. One of the reasons Kramer provides for his positive appraisal of Arbus's work is that she gave her subjects dignity and never reduced them to objects.

Norms are rules or standards for greatness upon which appraisals are ultimately based. One of Kramer's criteria for judging Arbus's work extraordinary is that it changed the history of the medium: She effected "a historic change in the way a new generation of photographers came to regard the very character of their medium." In other words, Kramer is arguing that an artist is great if, among other things, her work positively affects the work of those around her and after her; Arbus's work has done this, and therefore her work is great.

Critics do not always, however, provide arguments for their judgments. Evaluations, particularly positive evaluations, are sometimes assumed to be obvious and not explicitly argued for. In a review in *Newsweek* of an exhibition by Henri Cartier-Bresson, Douglas Davis[13] expends little effort defending the greatness of Bresson's work. He assumes that we are willing to accept its greatness and writes to give us more information about the man and his work. But he clearly implies positive evaluations throughout the review by using such phrases as "the king of photographers," "the master," and "his magnificent pictures."

Criteria are usually based in definitions of art and in aesthetic theories of what art should be. In published and casual art criticism it is easy to find statements of appraisal. In casual art criticism, appraisals are abundant but reasons are rare and criteria rarer still. In published art criticism, reasons are usually offered but criteria can be difficult to locate. Sometimes they are hinted at or suggested, but it is not often that critics explicitly state their criteria. It is easier to find clear, though often complex, criteria in the writings of aestheticians, artists, and critics attempting to define what art is or what art should be. More often than not, in published criticism, criteria are implied.

In a *New York Times* review of a 1985 exhibition of then new work by Duane Michals, critic Gene Thornton offers clear judgments of Michals's photographs. Thornton opens his review by claiming that the work Michals exhibited was "as strong and moving as anything he has ever done."[14] Thornton was especially impressed with a sequence entitled *Christ in New York*. Reasons for his praise of

Duane Michals, *Christ in New York*, 1985.

Michals' work and this sequence in particular come later in the review. Thornton explains that picturing Christ as a contemporary person is difficult and that Michals has done it convincingly, so much so that his visualization is the "most convincing one" Thornton knows. Thornton also praises Michals for his lyrical use of words accompanying his photographs. But Thornton's major reason for lauding Michals's work, and especially his sequences, is the quality of Michals's ideas: "Each was the visualization of a good idea, and good ideas are few and far between, especially good ideas that can be expressed in pictures." Thornton's review, then, offers clear statements of appraisal, that Michals is very good at what he does; and reasons for the appraisal, namely, that he works with difficult subjects convincingly, that his use of text is effectively poetic, and especially that his photographs are based on good ideas. Thornton never explicitly states criteria for his positive judgments of the work, but an implied criterion is that for a photograph to be effective it needs to be based on a good idea. As a critic writing an evaluative review, Thornton has done his job. He has provided clear judgments and has supported them with reasons based on implied and discernible criteria.

DIFFERENT CRITERIA

Critics judge photographs by many different criteria, most of which can be grouped into clusters derived from common theories of art.

Realism

Realism is one of the oldest theories of art, upheld by the ancient Greeks, backed by the authority of Plato and Aristotle, rejuvenated in the Renaissance, and upheld later throughout the history of photography. In aesthetics, realism is also referred to as "mimesis" and "mimeticism." In his exhibition and accompanying book *Mirrors and Windows,* John Szarkowski contrasts the realist tradition ("windows") in art and photography with the expressionist tradition ("mirrors"). He states that the basic premise of realism is that "the world exists independent of human attention, that it contains discoverable patterns of intrinsic meaning, and that by discerning these patterns, and forming models or symbols of them with the materials of his art, the realist is joined to a larger intelligence."[15] For the realist, because the world is the standard of truth, and because it is incomparably beautiful, the most noble goal of the artist is to attempt to accurately portray the universe in all its variations.

Paul Strand and Edward Weston are two historically prominent photographers who advocated realism in photography. Strand believed that the photographer ought to have "a real respect for the thing in front of him," namely, reality, and that "the very essence" of photography is an "absolute unqualified objectivity."[16] Weston agreed: "The camera should be used for the recording of *life,* for rendering the very substance and quintessence of the *thing itself,* whether it be

polished steel or palpitating flesh.... I feel definite in my belief that the approach to photography is through realism."[17]

Life magazine reaffirmed the primacy of realism in photography throughout its long and influential history. Henry R. Luce, founder and publisher, introduced the first issue of *Life* (November 23, 1936) with this statement:

> To see life; to see the world, to eyewitness great events; to watch the face of the poor and the gestures of the proud; to see strange things—machines, armies, multitudes, shadows in the jungle and on the moon; to see man's work—his paintings, towers and discoveries, to see things thousands of miles away, things hidden behind walls and within rooms, things dangerous to come to; the women that men love and many children; to see and be instructed.

Realism is also upheld as a criterion by contemporary thinkers. In *The Photographer's Eye,* Szarkowski writes: "The first thing that the photographer learned was that photography dealt with the actual; he had not only to accept this fact, but to treasure it; unless he did photography would defeat him."[18]

Hilton Kramer summarizes realistic criteria in this statement:

> What we admire in the great modern photographers is, more often than not, the quick pictorial eye that wrests from this heterogeneous public scene an arresting conjunction of detail.... It is essential that the subject be "caught" from the outside, trapped, so to speak, in a given instant that can never be repeated. In that unrepeatable point in time, the photographer composes his picture, the quickness of his eye and the lightning sensitivity of his emotions joined in the flash of the shutter, and from that moment the reality of the subject inheres in the composition, for it can no longer be said to exist "out there."[19]

Traditional photographic realists also advocate certain techniques as proper and reject others. Realism is closely associated with "straight photography," some of the principles of which were articulated by Sadakichi Hartmann in 1904:

> Rely on your camera, your eye, on your good taste and your knowledge of composition, consider every fluctuation of color, light and shade, study lines and values and space division, patiently wait until the scene or object of your pictured vision reveals itself in its supremest moment of beauty.[20]

Both Strand and Weston advocated realistic criteria and the straight approach in making photographs. Strand held that the photographer should express reality "through a range of almost infinite tonal values which lie beyond the skill of human hand.... without tricks of process or manipulation [and] through the use of straight photographic methods."[21] Weston derided photographs that relied on soft focus (what he called "dizzying out of focus blurs"), textured printing screens and papers, and handworked photographs as "photo-paintings" and "pseudo-paintings."[22] Minor White and Ansel Adams continued the straight, realistic

tradition in photography they inherited from Strand and Weston. White wrote: "I have heard Edward Weston say that he strove to eliminate all accidents from his work and I copied his striving.... I now see like a lens focused on a piece of film, act like a negative projected on a piece of sensitized paper, talk like a picture on a wall."[23] Dorothea Lange had these words, quoted from the empirical philosopher Francis Bacon, hung on her darkroom door: "The contemplation of things as they are, without substitution or imposture, without error or confusion, is in itself a nobler thing than a whole harvest of invention."[24] Ansel Adams devised the zone system of exposure and development to enhance the abilities of the straight photographer.

Expressionism

Expressionism, or expressivism, is also time-honored in photography but is not as old as realism in the history of art theory. Its basic premise is a respect for the individuality of the artist and the potency of the artist's inner life as vividly expressed in visual form. Expressionists believe the artist's intense experience is the basis of art making and that viewers should judge art according to the intensity of the feelings it provokes in them. They emphasize the artist rather than the world, and for expressionists, intensity of expression is more crucial than accuracy of representation.

The term *expressionism* is more common in the literature of art and aesthetics than in photography. The term *pictorialism,* however, is common in photography, and the pictorialist movement in photography fits within expressionistic criteria. Pictorialism preceded straight photography, which was a reaction to pictorialism. Pictorialists upheld photography to be art and strove to have it as honored as painting. In their struggle, they often mimicked the subject matter and stylistic conventions of the paintings of their day. Pictorialist images often utilized soft-focus, textured paper, hand touching with brushes, allegorical stories, costumes, and props, and sometimes were collaged images made from several negatives. The end was art and the means were whatever the photographer could use to attain that end. C. Jabez Hughes stated the pictorialist position in 1861:

> [The] photographer, like an artist, is at liberty to employ what means he thinks necessary to carry out his ideas. If a picture cannot be produced by one negative, let him have two or ten; but let it be clearly understood, that these are only means to an end, and that the picture when finished must stand or fall entirely by the effects produced, and not by the means employed.[25]

Many pictorialists were particularly influenced by the paintings of Turner, Whistler, Degas, and Monet. The pictorialist tradition includes such historically influential photographers as Alvin Coburn, F. Holland Day, Frederick Evans, Gertrude Käsebier, Alfred Stieglitz, Edward Steichen, and Clarence White. Stieglitz championed the movement in *Camera Work* and Gallery 291. Pictorialism

declined by the mid-1920s and was largely overtaken by the "straight" aesthetic, but interest in pictorialist aesthetics and techniques ("manipulated photographs") emerged again in the 1970s, and the tradition vigorously continues today.

Formalism

Formalism is an aesthetic theory of this century. It is closely associated with modernism and is rejected by postmodernists. Formalism insists on the autonomy of art, that is, "art for art's sake," and on the primacy of abstract form rather than references to the physical or social world.

Formalism is an aesthetic philosophy, a theory of art—it should not be confused with a concern for form in art. All art, realistic and abstract, representational and nonrepresentational, has form. All artists, whether they be realists, expressionists, postmodernists, or of some other aesthetic persuasion, are concerned with form. Both straight and manipulated photographs have form. Expressionists want form that is vividly engrossing; realists strive for form that is consistent with immutable laws of nature; instrumentalists seek form that will effect social change.

The theory of formalism upholds the sovereignty of form and considers subject matter and references to religion, history, and politics aesthetically irrelevant, or "nonartistic" concerns. Art should be judged by its own criteria, that is, by whether or not it embodies "significant form." Roger Fry and Clive Bell,[26] the originators of formalism in the 1930s, unfortunately did not, perhaps could not, specify criteria for formal excellence. Their influence was in denial: Art should not be judged by its narrative content, historical references, psychological associations, emotional connotations, or imitation of objects and surfaces.

Although formalism supports abstraction, nonrepresentational imagery, and minimalist art, it is not limited to these. Representational painters such as Poussin and Cézanne are highly regarded by formalists because of their harmonious organization of trees, hills, or figures. That the subject matter happens to be fruit in a bowl or a sun-bathed hillside is not of interest. If Picasso's *Guernica,* for example, is to be honored, it is because of its superb formal organization; its references to the horror of war and the suffering of victims are aesthetically irrelevant.

Formalism and modernism gave rise to concern for the individuality of media, the uniqueness of a medium, and the distinct visual contributions different media could make. Straight photography came of age during the period of formalism and modernism and in turn influenced it. Edward Weston, for example, was concerned about identifying what the medium of photography did best, or did uniquely, and then made photographs according to these distinctions. *Group f/64,* founded in 1929 by Weston and including Ansel Adams and Imogen Cunningham, strove to make pictures that were "photographic" rather than "painterly." Thus, these photographers abhorred handwork and soft focus and championed crisp focus with a wide depth-of-field.

Formalism also influenced art criticism. As references in artworks to real-world considerations were aesthetically irrelevant, criticism that relied on history or biography or the psychology of the artist was also eschewed as aesthetically irrelevant. Context was ignored. In *Aperture,* founded in the 1950s by Minor White, photographs were presented as the sole matter on pristine white pages; information about photographer, title, date, and so forth, was put in the back of the magazine so as not to distract from the image itself. The art object itself, and only the art object, was the locus of critical attention. Formal description of the object itself, in painstaking detail, became paramount in art criticism.

Instrumentalism

"It was never our intention to curate an exhibition on the basis of conventional criteria—that is, work selected as *rarest, most unique, formally most inventive,* or *technically most polished.*"[27] This statement, based in an instrumentalist view of art, is from an exhibition catalogue, *AIDS: The Artists' Response* by Jan Zita Grover and Lynette Molnar, the curators of the exhibition of the same name. Instrumentalists reject the notion of art for art's sake, and instead embrace art for life's sake. They are concerned with the consequences of art. Instrumentalist criteria hold that art is in service of causes that go beyond art itself, goals larger than "significant form," originality, and unique artistic expression. Artwork made about AIDS has generated debate that centers on the conflicting criteria for art and illustrates how instrumentalist criteria operate in judging art.

Michael Kimmelman states an instrumentalist criterion in a *New York Times* article about art about AIDS: "The goal is not to produce museum masterpieces but to save lives, by whatever means at an artist's disposal."[28] Kimmelman sees several artistic shortcomings in some activist art about AIDS: Some of it is "dictatorial," and it can be simple-minded and "condescending" and "even counter-productive in its eagerness to provoke," and most of it will not last except as a relic of an era. But he defends the work by arguing that "most of these works don't pretend to be great art in the way traditional art historians use that phrase. To be heard above a roar of misinformation and in the face of so much indifference, shouting may be necessary."

Instrumentalist criteria play themselves out in reaction to Nicholas Nixon's photographs of people with AIDS exhibited in 1988 at the Museum of Modern Art in New York. Nixon photographed the final months of life of several AIDS patients. The photographs were clearly meant to elicit sympathy: "I hope my pictures humanize the disease, to make it a little bit less something that people see at arms length."[29] For the most part his photographs were received positively by critics. But they also produced very hostile reactions on instrumental grounds from activist critics. One stated that "personally, I think the only proper response to these photographs is to walk into museums and rip them off the walls."[30] Those who attacked the Nixon photographs objected that they made people with AIDS

look like freaks, and sickly, helpless, fatalistic victims, barely human. Robert Atkins, a critic for the *Village Voice*, bitterly complains about photojournalism's penchant for the exotic and melodramatic. If an editor of a popular magazine has a choice between using a photograph of a person with AIDS shopping in a supermarket or a photograph of a person with AIDS being fed intravenously in the hospital, the editor will likely choose the more dramatic hospital photograph because it will sell more magazines. Thus, Atkins argues, we have received mostly "negative" rather than "positive" images of people with AIDS.[31] During Nixon's Museum of Modern Art exhibition, gay activists distributed leaflets that demanded images of "vibrant, angry, loving, sexy, beautiful" people with AIDS, "acting up and fighting back."

Instrumentalist criteria, then, encourage an examination of art based on social, moral, and economic purposes of art, how art is used in society, and its consequences. Instrumentalist criteria insist that art is subservient to, rather than independent of, social concerns.

Other Criteria

The preceding criteria are not exhaustive. Critics use others, such as craftsmanship, originality, and good composition, but these are usually subsumed by the larger clusters of criteria just identified. Originality, for example, might not be particularly important to an instrumentalist critic who is interested in raising consciousness about sexism and racism in society: If the image is effective in improving society, whether it is derivative or original will likely be considered irrelevant. Craftsmanship is a time-honored criterion, and one that seems easy to apply, but a well-crafted image for an expressionist might be different from a well-crafted image for a realist: A "dizzying out of focus blur" for Edward Weston might be a dynamic, innovative expression for Duane Michals. A good print for a formalist might be a waste of silver for an instrumentalist because the photograph lacks social content. A feminist critic would likely reject a photograph that encourages violence toward women no matter how well composed, well crafted, or original the image.

CHOOSING AMONG CRITERIA

Each of these sets of criteria is appealing, and deciding among them is difficult. There are some alternatives. We can let the work influence the criteria by which it will be judged. Such a decision presumes an interpretation, and based on our understanding of an image, we would choose criteria that are most favorable to the image. A formalist image would be measured against formalist criteria, a realistic image by mimetic standards. This is a pluralistic acceptance of art. Such a stance gives primacy to the art and keeps viewers open to a variety of artforms. But some

types of art may be unacceptable to some critics, and a viewer might want to adhere more rigorously to a particular set of criteria that are consistent with his or her aesthetic or moral beliefs. The pluralist runs the risk of being wishy-washy.

We can accept a particular set of criteria and apply them to all art, whether the criteria fit the art or not. The risks here are dogmatism and rigidity of experience. The risk of a very narrow range of acceptance is particularly great for a naive viewer who has not had much exposure to the variety of artforms. If a viewer adheres strictly to a set of realistic criteria, for example, much art of the world and of our times will be dismissed.

A viewer who has carefully and thoughtfully sampled many kinds of art, however, may want to champion certain kinds of art and dismiss others. Some activist critics, including feminists and Marxists, take an informed and narrow stance about art they critically uphold and art they vehemently reject.

We can mix criteria and insist that an expressionist image adhere to certain nonnegotiable formalist criteria, for example. But some criteria are incompatible, even contradictory. It would be logically inconsistent to adhere to both formalism and instrumentalism: Art is either autonomous or heteronomous, transcendent or subordinate to other values.

Different criteria illuminate different aspects of a work of art. All of the preceding criteria can be applied to a single photograph in order to draw attention to its different aspects. Trying different criteria can also broaden our critical perspective, allowing us to see an image from multiple points of view. By knowing different criteria, we have more standards of excellence to apply to photographs and through them we may find more to appreciate in a photograph.

DIFFERING JUDGMENTS

Because there are different criteria for judging art, inevitably there are different judgments of the same work of art. Major exhibitions and new showings of prominent photographers' work receive multiple evaluations from a variety of critics. Sometimes critics agree that the work is good, but they may find it good for different reasons and by different criteria. Sometimes critics disagree over the worth of the work, with some upholding it and others rejecting it. This can happen when critics use different criteria to judge the same work and when critics hold the same criteria but differ in their decisions about how the artwork holds up to scrutiny under those criteria.

Different evaluations of the same exhibition are interesting to read and compare because they show that critics' evaluations of the same work can vary, sometimes considerably. The different reasons that critics offer in praising or faulting an exhibition are valuable and stimulating because they give us several alternative viewpoints to consider in forming our own critical decisions about the work in question.

JUDGMENTS ARE ARGUMENTS

Critical judgments, like interpretations, are arguments. Evaluating a photograph or an exhibition requires formulating arguments. Not all judgments are equal. Judgments, like interpretations, are more or less convincing depending on how they are argued. Judgments are not so much right or wrong as they are reasonable, convincing, or enlightening. Critical judgments themselves can be judged according to whether or not, and how well, they increase our understanding and appreciation of artworks. Evaluative arguments are always open to dispute and invite counterarguments. Seeing how critics differ in their appraisals of an artwork is one of the aspects of criticism that makes it interesting and informative.

That critics disagree, however, does not warrant the claim that evaluative judgments are totally subjective and are "mere opinions," or that all critical appraisals are equally legitimate. Critical judgments are arguments with reasons, and these arguments can be looked at objectively and then be evaluated. We can choose among judgments, reasons, and criteria, and agree with some and disagree with others in reasoned ways. The most convincing judgments are better grounded and better argued.

REAPPRAISALS

Judgments, like interpretations, are not conclusive, definitive, and final pronouncements. Judgments can and do change. "The Family of Man," a major exhibition that traveled internationally, was curated in 1955 by Edward Steichen of the Museum of Modern Art in New York. It is the most successful photography show in history if measured by attendance and audience appeal, and it was generally unchallenged by critics in its time. More recently the show has been written about extensively, reappraised, and harshly judged by several writers including John Szarkowski,[32] Allan Sekula,[33] and Jonathan Green.[34] In 1984 Marvin Heiferman curated a new show, "The Family of Man: 1955–1984," at P.S.1 in New York. This new show was based on the original 1955 exhibition and rebuked it. Heiferman's exhibition was visual art criticism of Steichen's exhibition.

"Revisionist" history and criticism are about revising past interpretations and evaluations of works. Some historians and critics are deeply concerned that art by women, for instance, has been unfairly ignored or given too little critical attention. These historians and critics are attempting to right the wrongs of the past scholarship by rediscovering lost work, reinterpreting it, and reevaluating it, showing that it deserves a more prominent place in history.

JUDGMENTS AND PREFERENCES

Critical judgments are different from preferences. Preferences do not require reasons, and preferences are rarely disputed. Critical judgments, however, do

require reasons and do invite counterargument because their consequences are important. Also, statements of preference tell us more about the person making the statements than about the object in question. When engaging in criticism we are seeking to find out about the art object and not about the persons engaging in criticism. More bluntly, whether someone *"likes"* the photograph is not particularly relevant; what is relevant is whether or not someone thinks it is good, or bad, and for what reasons.

Strategically, it can be beneficial to begin to formulate our judgments of photographs based on strong, immediate responses of liking or disliking them. Carrie Rickey, an art and film critic, chooses, when she can, to write only about works which she feels passionately about. She uses her strong personal reactions to films or art as motivation to write, but she transforms these reactions into argued positions. To engage in responsible criticism we need to transform preferences into judgments that are based on more than personal likes and dislikes. A strong, personal, positive or negative reaction to a photograph can be critically valuable if we decipher reasons for reactions, try out the reasons, and begin to posit criteria for what we consider to be good in a photograph.

The distinction between preferences and values can be personally liberating because the distinction allows us to dislike certain things even though it is understood that they are good; and to like and enjoy certain things even though it is understood that they are not particularly worthwhile from a critical standpoint. John Corry utilized the distinction between preference and value in his review of *Hollywood Wives* for the *New York Times*. From the outset he refers to this made-for-television movie based on a best-selling novel as "trashy" but also admits that "this critic enjoyed it."[35] He says it is not the kind of movie one would recommend to friends but that "everyone watches stuff like this, anyway, and then pretends they haven't seen it." In his review he thoroughly explains the movie's flaws, but with some sarcasm he humorously concludes that "trashy fun is trashy fun, and if you want to be uplifted you can always read a book." As an informed critic, Corry knows the difference between the value of quality drama and his occasional preference for the fun of enjoyable entertainment, and in this case opts for the latter.

INTENTIONALISM AND JUDGMENTS

The flawed critical method of "intentionalism," discussed earlier in relation to interpretation, also comes into play in evaluation. A critic can evaluate a photograph according to whether or not it meets the intent of the photographer: If the photographer tried to do "x," and succeeded in doing "x," then the photograph is good. But this is a weak method of critical judgment. As was said earlier, photographers do not always make public their intents. Also, because a photographer makes a photograph that matches his or her intent does not make it a good photograph. The intent itself may be weak. There are also cases when a photographer

tries to make one kind of picture but ends up with another that may be as good as or better than the photograph intended.

It is beneficial for photographers to carefully consider what it is they intend to express and to consider whether they have achieved their intents and whether their intents are worth achieving; and it is appropriate for teachers to critically consider students' intents. But critics ought to work with the images photographers make and not the minds of the makers.

THE OBJECTS OF JUDGMENTS

The objects of critics' judgments are individual photographs, portfolios, exhibitions, the entire life work of a photographer, movements, styles, and historical periods. Critics usually criticize new work but occasionally reevaluate older work that has already received critical attention, especially when it is presented in a new exhibition.

Whenever possible, critics work with original objects and not reproductions. Some photographic works printed in offset that look like reproductions, are not. Tony Mendoza's *Stories,* for example, is a book, and critics have properly evaluated it as a book, not as a bound set of reproductions. If the photographs from the book are exhibited, then they become the objects for judgment. Similarly, *The Deerslayers* by Les Krims is a limited edition, offset portfolio, not a set of inexpensive reproductions substituting for more expensive, original silver prints. The offset folio ought to be judged as an offset folio. It would be inappropriate and unfair, however, to critically appraise photographs made for exhibition on the basis of reproductions.

JUDGMENTS OF ROBERT MAPPLETHORPE'S WORK

In the summer of 1989, the photographic work by Robert Mapplethorpe became the center of major political turmoil of national consequence for the arts. The Corcoran Gallery of Art in Washington, D.C., canceled its scheduled exhibition of "Robert Mapplethorpe: The Perfect Moment," a large, retrospective, touring show of the late photographer's work. Mapplethorpe had died of AIDS the previous March. The exhibition of Mapplethorpe's photographs was organized by Janet Kardon of the Institute of Contemporary Art in Philadelphia and was partly financed by funds from the National Endowment for the Arts. The decision to cancel the Mapplethorpe show came amidst some furor over another piece of art financed by the National Endowment and exhibited in North Carolina—a photograph titled *Piss Christ* by artist Andres Serrano, a Cibachrome of a plastic crucifix submerged in the artist's urine.[36] There was also political controversy of national attention the previous winter when an art student at the School of the Art Institute of Chicago exhibited a piece in the school's gallery that was understood by many to desecrate the American flag.

Robert Mapplethorpe, *Embrace*, 1982.

The budget of the National Endowment was scheduled for congressional review during the time the Mapplethorpe exhibition was scheduled for view. Republican Senator Jesse Helms of North Carolina, Republican Senator Alfonse M. D'Amato of New York, and Republican Representative Dick Armey of Texas opposed the exhibit and questioned whether art that is considered blasphemous or pornographic by some should be supported with government money. About her decision to cancel the exhibition, the director of the Corcoran, Dr. Christina Orr-Cahall, stated: "We were just in the wrong place at the wrong time....We had the institutional responsibility to decide if this was the right environment in which to present the show."[37]

A group of conservative Republicans attempted and failed to eliminate or slash the National Endowment's budget. The Democratic leadership eventually came up with a carefully designed slap on the wrist for the Endowment by cutting its budget by $45,000, the amount previously given to the agencies involved with the Mapplethorpe and Serrano projects. On Wednesday, July 26, 1989, after the Corcoran's decision to cancel the Mapplethorpe exhibit, Senator Helms introduced legislation to bar federal funding of "obscene and indecent" art, and his bill eventually passed. About the controversy, Schuyler Chapin wrote, "Congress, art critics, enraged civil libertarians, religious fanatics, pro- and anti-censorship groups—all are having a field day, leaving the arts communities in defensive positions."[38]

On two consecutive Sundays, the *New York Times* published two opposing articles about the controversy, the first by Hilton Kramer,[39] who argued against government funding of art like that of Mapplethorpe's. The following Sunday, Grace Glueck [40] defended the funding of Mapplethorpe's work, and work like it, and opposed the Corcoran's cancellation of the exhibition.

In the following pages, Kramer's and Glueck's arguments are presented for and against the Corcoran's decision to cancel the Mapplethorpe exhibit. We will also consider various critics' judgments of Mapplethorpe's work, looking for reasons for their judgments and the implicit or explicit criteria on which they based their judgments.

Kramer is dramatic in his refusal to even describe the work in the show: "I cannot bring myself to describe these pictures in all their gruesome particularities, and it is doubtful that this newspaper would agree to publish such a description even if I could bring myself to write one." Clearly, his lack of description is a negative judgment of the work—he suggests that it is too disgusting to merit the dignity of language. Glueck has less difficulty in describing the contents of the exhibition:

> The Mapplethorpe show is a retrospective of the artist's work that contains images depicting homosexual and heterosexual erotic acts and explicit sado-masochistic practices in which black and white, naked or leather clad men and women assume erotic poses. Along with these photographs are fashionable portraits of the rich and trendy, elegant floral arrangements and naked

children—images that might not necessarily be considered indecent if viewed singly but that in this context seem provocative.

Other potentially offensive pictures that neither mention in detail are a man urinating into another's mouth, a close-up of a fist and forearm penetrating an anus, the handle of a bull whip protruding from the artist's rectum, and a close-up of mutilated male genitals. Glueck admits that some of Mapplethorpe's photographs are offensive: "Homosexuality is a subject that has deep emotional resonance for many people. For some, the show was certainly distasteful." But she argues that art is sometimes "hideous, even depraved," and cites Goya's painting of cannibalism and Picasso's explicitly erotic paintings and etchings, all of which are firmly enshrined as art. She asserts that the public does not want to be "saved" from viewing them, and likewise, that the public should not be "saved" from viewing Mapplethorpe's work.

In defending Mapplethorpe's work, Glueck adheres to expressionist criteria: "Artists are important to us, among other reasons, because of their ability to express what is deep or hidden in our consciousness, what we cannot or will not express ourselves." She argues that his photographs are art by appealing to an institutional definition of art, namely, it is art because those who know about art honor it as art: "Whatever one thinks of Mapplethorpe as an artist—and there are critics on both sides—his images are intended as art, presented as such and are judged to be art by those qualified in such matters. They have been chosen by well-established art institutions." Finally, she argues that "museums are traditionally the neutral sanctuaries—entered voluntarily by the public—for this expression. What we see there may not always be esthetic, uplifting, or even civil, but that is the necessary license we grant to art."

Kramer, however, strongly objects to the use of taxpayers' money to support art that flaunts standards of decency and civility: "Or, to state the issue in another way, is everything or anything to be permitted in the name of art? Or, to state the issue in still another way, is art now to be considered such an absolute value that no other standard—no standard of taste, no social or no other standard—is to be allowed to play any role in determining what sort of art it is appropriate for the Government to support?" He clearly is rejecting the autonomy of art. He also supports the public's right to have strong influence in decisions about art that is supported by their taxes. He argues that there was no public outcry about the exhibition of Mapplethorpe's photographs in private commercial galleries, but there was when taxpayers' money was to be used in their public display.

He identifies what he finds so offensive about some of the Mapplethorpe photographs. For Kramer, it is not that they depict male nudity. He asserts that no one has made a fuss about Minor White's male nudes on display at the Museum of Modern Art. What he finds so offensive in Mapplethorpe's images is "so absolute and extreme a concentration on male sexual endowments that every other attribute of the human subject is reduced to insignificance. In these photographs,

men are rendered as nothing but sexual—which is to say homosexual—objects." But for Kramer, these are not the most troubling: "That dubious honor belongs to pictures that celebrate in graphic and grisly detail" a sadomasochistic theme. "In this case, it is a theme enacted by male homosexual partners whom we may presume to be consenting adults—consenting not only to the sexual practices depicted but to Mapplethorpe's role in photographing them." Kramer also finds it extremely offensive that Mapplethorpe made these pictures as a sympathetic participant.

Kramer argues that "to exhibit photographic images of this sort, which are designed to aggrandize and abet erotic rituals involving coercion, degradation, bloodshed, and the infliction of pain, cannot be regarded as anything but a violation of public decency." He goes on to argue that the images are pornography, and as such, have a right to exist, but belong in a private, not a public, realm. He also grants them the status of art: "I know of no way to exclude them from the realm of art itself. Failed art, even pernicious art, still remains art in some sense." He argues that "not all forms of art are socially benign in either their intentions or their effects," and when the government supports this kind of art, opposing citizens have a right to be heard, not to deny artists freedom of expression, "but to have a voice in determining what our representatives in the Government are going to support and thus validate in our name."

The *New York Times* published several letters of response to the articles by Grace Glueck and Hilton Kramer. One response defending Mapplethorpe's photographs was from Veronica Vera, an artist and a model in one of the sexually explicit photographs in the exhibition: "I see them as debunking the whole idea of pornography—helping society to get rid of that self-hating concept that ghetto-izes sex, that implies that some parts of our sexuality are too unspeakable to mention, too private to be public."[41] Two arts administrators wrote: "Attempts to insure that artwork supported by public funds conforms to the beliefs held by some deny the cultural plurality of our country and infringe on the freedom to express different views through artistic creation."[42] Many of the letters objected to any censorship of the arts, but others applauded the Corcoran's decision and Kramer's position.

Most published criticism in 1988 and 1989 of Mapplethorpe's photographs was positive, with some reservations. Kay Larson,[43] writing for *New York Magazine,* doesn't hesitate to describe Mapplethorpe's images: "Some are very hard to look at: men in leather and chains, sometimes hung upside down, often subjected to grim and tortuous sexual indignities." She cites one particular example of a difficult photograph: "*Man in Polyester Suit* is the kind of picture you could warn your children against: Out of an anonymous, unzipped fly comes a brutally surprising penis, like the life force erupting in the midst of a Victorian garden party." In addition to acknowledging the troublesome nature of the photographs, she puts her emotional reactions into language: "The shock of Mapplethorpe's

Robert Mapplethorpe, *Tulips,* 1983.

images is a belly flop into dark ice water. You reexperience the sexual uproar and physical mystery usually concealed behind the zipper."

Before explicitly praising the photographs, which she eventually does, Larson offers her interpretation of them. She puts them in a context of other photography, social documentary photography, and formalist photography: "He's an unsparing observer of the lower depths, like Weegee; he's a classicist enraptured with perfect form, like Edward Weston." Her main interpretive claim, however, is that Mapplethorpe aestheticizes all that he sees: "A Mapplethorpe photograph is a voluptuous visual experience, an ecstasy of details, from the erotic terrain of dark belly skin to the hair on the stem of a swollen, testiclelike poppy bud." She explicates further: "Mapplethorpe pursues a state of ferociously aestheticized desire—directed not just at men he is interested in but at all beautiful surfaces, whether skin or marble. Love, which might make room for the less than beautiful, is not part of this horizon." Ultimately she praises the work because "he has caught the spirit of his times with uncanny accuracy and crushing honesty."

Stephen Koch's[44] understanding of Mapplethorpe's photographs is consistent with Larson's. Writing in *Art in America,* Koch explains that "Robert Mapplethorpe is an esthete…. Mapplethorpe is devoted to artifice: he brings an exceptionally gifted graphic intelligence to his photographs in order to render what he sees as part of a kind of esthetic utopia, formed from his own tastes and identity." Koch accepts the work as "phallus worshipping, homosexuality, transvestism, sadomasochism, racial fetishism," and explains that

> from flowers to phalluses to whips and chains and unhappy Manhattanites trussed up on torture racks, Mapplethorpe carries his audience step by probing step deeper into his utopia of anonymity, testing not only the audience's willingness to follow, but also the power of his own exceedingly elegant graphic imagination to reconcile the audience (and his own eye as an artist) to the shameful and nasty preoccupations which rule in that realm.

Most of Koch's feature article on Mapplethorpe's work is interpretive rather than judgmental, but the article is clearly complimentary. Koch praises the work because it elegantly and convincingly pursues a utopian aesthetic world and because Mapplethorpe is working within an artistic tradition with other aesthetes and "holds an important place in that company."

Stuart Morgan[45] has also written a mainly interpretive article in *Artforum* on Mapplethorpe's work. It, too, is positive and complimentary, but in it he expresses reservations:

> Harder to tolerate is the easy passage from, say, flowers to people. We accept that flowers are placed in pots, but what are we to make of an event such as the pose of a nude male on a pedestal, like an object?… a procession of comparatively unknown young men, often black, whose relationship to the

photographer and to the web of other sitters brings up issues of power, of master and slave. This is the aspect of the work that has bothered viewers more than any other; the black man posed as an object, a person who serves the purposes of another.

Andy Grundberg[46] provides a characteristically reserved overview of Mapplethorpe and the controversy surrounding his imagery, but Grundberg, too, is ultimately positive in his appraisal. In a 1988 *New York Times* review of Mapplethorpe's exhibition at the Whitney Museum of American Art, Grundberg places Mapplethorpe's work in historic context: "Like scores of photographers before him—Lewis Hine, Brassai, Weegee—Mr. Mapplethorpe chose to depict a subculture seldom photographed before, or at least seldom seen in the contexts of fine-art photography. In his case, the subculture is a sado-masochistic, male homosexual one." Grundberg also provides some recent historical context: "Roundly condemned 10 years ago as unsuitable viewing for adults, much less children, it has since been admired, collected and valorized by Susan Sontag, Holly Solomon, the late Sam Wagstaff, and other influential cultural figures." Grundberg especially admires Mapplethorpe's mastery of the photographic surface and manner of presenting subject matter: "The conjunction of perfect technique and perfect form gives his photographs a rarefied beauty that would seem anachronistic were it not for its obvious contemporary appeal."

Grundberg provides other critics' views in his own review by citing the essays from the catalogue that accompanies the Whitney exhibition. Grundberg presents Richard Marshall's understanding that equates Mapplethorpe's vision with abstract, formal considerations and idealized beauty; Ingrid Sischy credits the photographer with transgressing borders and foraging in areas of renegade subject matter; and Richard Howard persuades us that Mapplethorpe balances forces that uplift with those that pull down. Grundberg agrees with Sischy's "observation of the disruptive power of Mapplethorpe's work.... His pictures do serve to rupture the conventions of polite esthetic discourse." But he finds it difficult to accept that Marshall "can manage to talk about pictures of men bound in leather and chains in purely formalistic terms."

Thus, Grundberg provides some criticism of the criticism of Mapplethorpe as well as adding to that criticism by concluding that Mapplethorpe is about style, that style has its own substance, and that Mapplethorpe has shown us that "the world is comprehensible through the mediation of taste but not by the imposition of moral values. This is the real and quite remarkable message of his pictures, and it makes them central to the issues of our times."

In another article, following the furor over Serrano's photograph and the Corcoran's cancellation of the Mapplethorpe exhibition, Grundberg took a stronger position and wrote in the *New York Times:* "Mr. Serrano's now-notorious image of a crucifix floating in a field of yellow can be interpreted as an attempt at exorcising the artist's Roman Catholic upbringing.... It is a work of art in part

because it is so uncomfortable to look at, and because it bears the stamp of authentic conflict."[47] He defended Mapplethorpe's work this way: "[His] work is predicated on trespassing the boundaries of conventional mores. That trespass is, one could say, the ultimate subject of his art, and it makes even his most unsettling images something more than pornography."

CONCLUSION

Judgment presupposes interpretation, and interpretation presupposes description. We need an understanding—hopefully a defensible and convincing understanding—of what a photograph is about before we judge it. This does not mean, however, that the process of judgment can never be the starting point. It is counterintuitive and somewhat unnatural to walk into a gallery and to describe, and describe only, before we form a judgment. It is more likely that we first judge whether or not we even want to take the time to carefully describe and interpret the work. But a judgment without the benefit of an interpretation is irresponsible.

Ratings without reasons are also irresponsible. Many judgments are tossed about casually in conversation with passion and finality but with no reasons provided or requested. Responsible judgments can and should be argued, not pronounced.

Critics write persuasively, perhaps especially when they are trying to convince us of the worth or worthlessness of an artwork or an exhibition. If we really love something, or someone, we would usually like to convince others important to us to share our positions, or at least understand and accept them. Passionate critical writing can be very good critical writing, and very engaging to read.

Finally, issues of theory overlap with issues of critical judgment because criteria for judging art are so tightly linked to theories of art, or what one believes art is or should be. If a critic is arguing about whether the government should fund "offensive art," he or she is probably engaged in theorizing about art and the role of art in society rather than, or in addition to, judging the art in question. Theory is the topic of the next chapter.

7
THEORY:
IS IT ART?

Perhaps this chapter should have been the second of the book, before Description, rather than the last. It is here because the book proceeds from simpler to more complex critical procedures in the order of describing, interpreting, evaluating, and then theorizing. This sequence is also suited to teaching criticism. Theory, however, pervades all of art criticism and all of art teaching, art making, and art exhibiting.

In a review of a Cindy Sherman exhibition, Eleanor Heartney wrote in *Afterimage:* "These days, we seem to prefer our art obedient to theory. Cindy Sherman's rise to fame has been inextricably linked to the ease with which her work could be assimilated into a feminist-poststructural framework."[1]

If this is true today, it is likely true of photography in the past, but under different rubrics, terms, and theories. Alfred Stieglitz exhibited in Gallery 291 and published in *Camera Work* those photographers whose work fit his theory of photography and political agenda for photography.

In a feature article discussing recent photographic work, Richard Woodward wrote in the *New York Times Magazine*: "It isn't clear anymore how photography should be valued or looked at, where within our museums it should be exhibited— even what is or is not a photograph."[2] This is also true of the past, with debates raging in the late 1800s about the status of photography as art or not art, and in the 1920s with Edward Weston accusing pictorialist photographers of making "pseudo-paintings" instead of "photographs."[3]

In an intentionally ironic twist, Woodward titled his article "It's Art but Is It Photography?" This is ironic because the debate has shifted, come full circle: With the acceptance of photography into museum collections, and with its economic

value rising rapidly since the 1960s, the question about whether photography is art eventually became irrelevant.

With the work of such artists as the Starn Twins, which combines photographs with cellophane tape in constructions of large wall pieces, and has been exhibited and accepted as art, the question in the late 1980s shifts to "Is it photography?" The Museum of Modern Art in New York has yet to give an exhibition to John Baldessari, Gilbert & George, David Hockney, Robert Mapplethorpe, Richard Prince, Laurie Simmons, William Wegman, Joel-Peter Witkin, Cindy Sherman, Barbara Kruger, Sherrie Levine, or the Starn Twins. These artists have had widespread support in other museums but have not been sanctioned by the Department of Photography at the Museum of Modern Art. For the Museum of Modern Art, presumably, the work of these people may be art, but not photography. Or if photography, not the type supported by the theory that underpins the large and extremely influential collection of photographs of the Museum of Modern Art.

Other consequences of theoretically defining something as art rather than photography are directly related to the economics of the art market. Charles Desmarais, former director of the California Museum of Photography in Riverside, California, says, "I'm not sure why it is that when you call yourself a photographer you charge $300 for a picture, but if you're an artist it's O.K. to ask $3,000 or $30,000."[4] David Hockney's large photo collages, sometimes produced in editions of twenty, are priced between $10,000 and $60,000. A Barbara Kruger billboard piece sells for $30,000. The Starn Twins can earn $50,000 for a photograph. Hockney is known as a painter; Kruger and the Starns are promoted by their galleries as artists, not photographers. Their prices for single images are well above the price of a single photograph by living photographers, which are much closer to the $300 figure.

A different definitional dispute arose in the late 1970s when the New York City Public Library took a look at all its books containing photographs and discovered several books that were illustrated with old photographs by now famous photographers. These books were catalogued under various topics, such as history, geography, and science. The administration formed a new department of photography and appointed a librarian to oversee the department. Books on the Civil War that contained photographs by Timothy O'Sullivan and Alexander Gardner, and books on Egypt with photographs by Beato, have all been recatalogued under the single category of "photography."

Douglas Crimp wrote an essay objecting to the recataloguing.[5] He argued that the decision was a misguided one in that it was based on the new economic value photographs received because of their newly acquired status as high art. Crimp argues that recataloguing the books under "photography" changes the content of the books from history and geography and science to art and to photography. He fears that an accurate understanding of the books will be befuddled by

their new label and that their contents will now be restricted to a limited understanding of them as aesthetic objects: "What was Egypt will become Beato, or du Camp, or Frith; Pre-Columbian Middle America will be Desiré Charnay; the American Civil War will now be Alexander Gardner, Timothy O'Sullivan, and others...the horse in motion will be Muybridge, while the flight of birds will be Marey...urban poverty and immigration become Jacob Riis and Lewis Hine." His argument is theoretical, having to do with a definition of photography. He is arguing against defining, in words and in practice, all photographs as "art."

Theory also affects the teaching of photography in colleges and universities. It largely determines where departments of photography are located (within departments of journalism, engineering, or art) and whether photography is offered separately or in conjuction with printmaking, or painting, or film and video. Theory also determines, in part, whether photography is taught as art, or as journalistic communication, and whether commercial photography is included, and whether the history of photography is taught as part of art history, through history of art departments, or apart from art history and by its own photography faculty.

AESTHETIC THEORY

Aesthetic theories apply to art, its making, and its distribution in society. Aesthetic theory most prominently attempts to define what art is. When writers theorize about photography, they generally attempt to define what photography is, that is, what it should be. Most definitions of art try to persuade us to view art in a certain way and to make certain kinds of art. New definitions are often put forth in reaction to prior definitions.

Definitions of art may be given in a sentence. In a catalogue essay to an exhibition, Max Kozloff writes: "A photograph, with its two-dimensional surface, is the inert, flattened light trace of certain external maneuvers that once occurred."[6] He offers this definition of photography, but almost in passing, in his development of another thought.

Allan Sekula opens an article with this sentence: "Suppose we regard art as a mode of human communication, as a discourse anchored in concrete social relations, rather than as a mystified, vaporous, and ahistorical realm of purely affective expression and experience."[7] His definition is clearly persuasive. That is, he wants the reader to accept photography as a "mode of communication anchored in concrete social relations." His definition of photography is in opposition to a definition of photography as art, which he dismisses as "mystified, vaporous, and ahistorical affective expression." In the remainder of his article, "Dismantling Modernism, Reinventing Documentary (Notes on the Politics of Representation)," Sekula explains his definition, argues for its acceptance, and offers examples of photography that fit within it.

Some definitions of art, or photography, take the length of a book to fully explicate. Such books are Aristotle's *Poetics,* Arthur Danto's *Transfiguration of the Commonplace: A Philosophy of Art*, and Roland Barthes's *Camera Lucida: Reflections on Photography.*

Writers who theorize about photography are not inquiring about a particular photograph, although they use particular photographs for examples. They are exploring photography in general, attempting to answer how it is like and how it is different from other forms of picturing. They are contributing to what Andy Grundberg calls "theoretical criticism." The longstanding questions that have received many different answers are typical theoretical questions: What is photography? Is photography art? What are the consequences of calling photography "art"? Is photography different from painting? Does photography get us closer to reality than painting does? What does photography do best?

Theories can also be partial, incomplete, and fragmented. We move through the world with such theories and may not be cognizant of them until questioned about them. Such theories are probably better understood as assumptions about reality, life, art, photography, and so forth. Whether consciously held or not, they affect how we make photographs and how we understand them. The theories of our teachers, whether fully developed or a loosely held set of assumptions, certainly influence the way they teach about photography, the way we learn about photography, and the kinds of photographs we are encouraged to make.

THEORIES AND CRITICS

When criticizing a particular exhibition or the work of a photographer, critics sometimes interject theoretical points. For instance, while reviewing the work of Irving Penn, Owen Edwards writes: "The purpose of the still life is to allow us time to contemplate the beauty of objects by holding them aloof from time."[8] Edwards's statement is theoretical because it is a large claim about a group of images, still lifes. He is attempting to elucidate all still lifes by stating what he thinks is their purpose.

In the opening paragraph of a review of the photographs of John Coplans, Andy Grundberg states: "Unlike other methods of representation, including drawing and painting, photography cannot claim to be an art of line, stroke, or touch."[9] His claim is theoretical. It is about photography in general, as a means of representing. He distinguishes photography from painting and drawing. Grundberg states the claim in the service of his review of Coplans's photographs and he builds on the claim throughout the review, partly as a literary device and partly as a means to illuminate the photographs of Coplans's that he is considering.

Sometimes critics set out to write more fully developed theory. A. D. Coleman, whose definition of photography criticism is "the intersection of photographs with words," wrote the influential theoretical article in 1976 entitled "The Directorial Mode: Notes Toward a Definition." His article is theoretical

because his purpose is to define an approach to photography, one that he termed "directorial." In addition to recognizing this mode of working, naming it, defining it, and identifying its practitioners, Coleman discusses how directorial photography differs from other ways of working photographically and its relation to differing theories of photographic art. This article and the ideas in it are now established and may seem self-evident, but weren't until Coleman specified the genre in his writing.

Some critics consistently write from a theoretical point of view because they are more interested in photography generally than in individual photographs or individual photographers. They seek to know about photography as a cultural phenomenon and to understand how photographs are used in a society and how they affect the society. Allan Sekula's writings about photography are critical and historical investigations consistently dealing with theoretical problems he identifies and addresses from a particular concern, namely, "a concern with photography as a *social practice*" (Sekula's italics).[10]

Recently, photography theory has increasingly come from outside of the photographic community. Susan Sontag and Roland Barthes are two writers who have contributed significant literature to the field of photography although neither of them are trained in photography. Sontag's *On Photography* is an observer's view that is extremely critical of photography. Aestheticians are writing about photography more frequently than in the past,[11] and writers in the psychology of art such as Rudolph Arnheim and E. H. Gombrich are also contributing literature on photography. Both Arnheim and Gombrich are concerned, from a psychological perspective, with theorizing about how photographs mean, how they communicate, and how viewers decipher and understand them.

THEORIES AND PHOTOGRAPHERS

Photographers sometimes write theory. Edward Weston, Paul Strand, and August Sander are notable examples of prominent photographers who have written theoretical pieces that define what photography is and what it does best. Weston and Strand pointedly implemented their theories in their photographs and significantly influenced all the photography that followed. Victor Burgin, Martha Rosler, and Allan Sekula are three contemporary photographers who write theory, reflect their theories in their work, and influence other image makers through their writing, exhibiting, and teaching.

THEORIES AND HISTORIANS

All historians of photography are influenced by their theories of photography—by their assumptions of what a photograph is, which photographs are the most important to consider, and which should be ignored. Beaumont Newhall has been

faulted by others[12] for too narrow a view of photography and for diminishing the contributions of those who favored approaches to photography other than the straight approach. Jonathan Green built his history, *American Photography,* around a theoretical question: What is American about American photography?

THEORIES AND CURATORS

As a curator of photography in a prestigious institution, John Szarkowski has influenced theory about photography in many ways: by offering shows to certain photographers and not others, by choices of which photographs to purchase for the museum and which to accept from donors, and by conceptualizing, organizing, and circulating several exhibitions. His major exhibitions have included catalogues of the work in the exhibitions and essays explaining and defending his views of photography.

One such exhibition and catalogue of the same name is *The Photographer's Eye,* introduced in 1966. The exhibition is an attempt to provide in language, and by means of photographic examples, a definition of photography. In *The Photographer's Eye,* Szarkowski investigates what photographs look like and attempts to explain why they look the way they do. His concerns are with photography in general, and he uses individual photographs to explicate and illustrate his understanding of photography. In the introductory essay to the catalogue, he seeks to decipher how the medium of photography differs from other media. He identifies five distinguishing characteristics of the medium: "the thing itself," "the detail," "the frame," "time," and "vantage point."

In the essay, Szarkowski's major claims are that photography is best when it deals with the actual ("the thing itself"), even though the photographer's picture is very different than the reality from which it was made. He argues that photographs are very adept at giving us isolated fragments ("the detail"), and elevating them to symbols, but not very good at telling stories. The central act of photography is one of selecting ("the frame"), that is, choosing and eliminating what will be in the photograph. He identifies the medium as inherently time related ("time"): "Uniquely in the history of pictures, a photograph describes only that period of time in which it was made." Finally, photography has taught us to see from the unexpected view ("vantage point").

Szarkowski's attempt at defining photography as a unique medium, however, is seen by his critics as a modernist attempt, and they reject such attempts in favor of postmodernist theory.

Two more recent exhibitions with different themes are other examples of curatorial theorizing: "Cross-References: Sculpture into Photography" and "Vanishing Presence."

"Cross-References: Sculpture into Photography" is an exhibition of international scope featuring the work of Bernard Faucon of France, Ron O'Donnell of

Scotland, Boyd Webb of England, and Americans James Casebere, Bruce Charlesworth, and Sandy Skoglund. The exhibition is curated by Elizabeth Armstrong, Marge Goldwater, and Adam Weinberg and shown at the Walker Art Center in Minneapolis and at the Museum of Contemporary Art in Chicago. All the works in the exhibition were new pieces commissioned by the curators. The theoretical thrust of the exhibition is imagery created by artists for the camera. Each of the artists makes large-scale, room-size constructions, which they usually destroy after photographing them. Their imagery has been influenced by film, television, and literature.

In the introduction of the catalogue accompanying the exhibition, the curators state: "These artists have little interest in photography as documentation of visual fact; rather, they prefer to arrange events to create their own realities... By fabricating their own subject matter, these artists maintain an unusual degree of control over the resulting photographs."[13]

For the exhibition, Bernard Faucon created a large, clear, sealed glass case partially filled with white granulated sugar. The piece is entitled *The Wave of Snow*. The curators make explicit Faucon's suggested parallels between the crystals of sugar in the sculpture and the crystals of silver on a sheet of photographic paper: "The crystals of sugar in *The Wave of Snow* constitute a *tabula rasa*, a blank sheet of photographic paper." The sculpture, like the photograph, is also frozen, immutable and timeless. "It is a container that holds its subject sealed off, separated from the world like a photograph in which everything must be enclosed in a square piece of paper."

This exhibition is a good example of theory influencing practice and practice being clarified by theory. The curators identified and defined a conceptual direction in photography, selected representative artists who they thought were working in a similar manner, and commissioned new works that illustrated the curators' concepts. This conception of photography owes its debts to Coleman's theory of directorial photography, and furthers it.

"Vanishing Presence" is a traveling exhibition organized by Adam Weinberg for the Walker. It gathers photographs already made, rather than photographs commissioned specifically for the exhibition as in "Cross-References." The exhibition is guided by a conception of photography that contradicts what is traditionally considered good photography, that is, crisp and sharply focused images of decisive moments. It includes the photographs of twelve artists: Dieter Appelt, Bernhard Blume, Mary Beth Edelson, Joseph Jachna, William Klein, Ralph Eugene Meatyard, Duane Michals, Lucas Samaras, Michael Snow, Patrick Tosani, Anne Turyn, and Francesca Woodman.

The photographs in "Vanishing Presence" utilize a variety of techniques to blur reality and distort time by photographically expanding it and making it indecisive, implying continuous flow rather than frozen segment. In his catalogue essay, Weinberg writes:

They are evolutionary images and their subjects are vaporous. They do not describe parcels of time corralled in a frame and clearly denoting the past. They are pictures suspended in the perpetual process of becoming and concerned with change itself. They urge us to consider the experience of time not as interchangeable, digital segments but as a continuous, disturbing, overwhelming, and wondrous whole. These photographers have used ghost images, blur, lack of focus, and other intrinsically photographic means to free themselves from the chains of photographic exactitude and to shake up our pedestrian and complacent views of reality.[14]

According to Weinberg, the images in this exhibition are counterpointed by mainstream photography: "Beginning with Stieglitz, American photographers favored a transcriptive approach to the medium, that is, photography's capacity to represent all the minute details of a subject exactly as they appear before the lens." The images selected for "Vanishing Presence," however, "seek to free the mind—and the camera—from rational control and, most importantly, to evoke other levels of visual reality."

Theorizing is involved in both of these shows. The curators of "Cross-References" and "Vanishing Presence" considered how photography was being defined or had been defined, and then sought to expand these definitions with new work and new considerations that the work made apparent. The steps they take in making theory are several: They articulate existing definitions of the medium, decide that they are too narrow, expand them with new examples, and put forth a broader definition or conception of what photography is and how it should be considered.

A SURVEY OF THEORETICAL POSITIONS

Theoretical positions about photography are abundant today, much more so than in the past. The positions are multifaceted, complex, full of specialized terms, and often difficult to understand. They are interesting in themselves as ideas and are very important because they directly affect the photographs we make and see and how we receive them. The following pages offer an overview of the major theoretical positions affecting photography today.

Realism or Conventionalism

Does photography get closer to the truth than do painting and other forms of representation? This question, around which theory has been recently built, receives different answers. This debate is sometimes called the "ontological" debate, that is, having to do with the ontology of the photograph, its philosophic nature or being. The differing answers can be grouped into two major camps, "realism" and "conventionalism." Photography grew up with claims of having a

special relationship to reality. In 1839, the year the invention of the fixed photographic image was announced, Dominique François Arago, claiming the invention for France, promoted photography on the basis of its "exactness," its "unimaginable precision," and faithfulness to reality.[15] Daguerre himself wrote that "art cannot imitate [the daguerreotype's] accuracy and perfection of detail,"[16] and Edgar Allan Poe, an early enthusiast of the medium, wrote "the Daguerreotype plate is infinitely (we use the term advisedly) is *infinitely* more accurate in its representation than any painting made by human hand."[17] He also attributed to photography "a more absolute truth," than ever before possible with pictures.

Jacob Riis and Lewis Hine made photographs in the cause of social reform and knowingly used the medium to give their writing more credibility. Hine stated that "the average person believes implicitly that the photograph cannot falsify," but he was quick to add that "you and I know [that] while photographs may not lie, liars may photograph."[18] Although Hine knew that photographs could lie, he also knew that the photograph was more persuasive and effective than the journalistic illustrations common in the early 1900s. Paul Strand, a student of Hine's, believed in the realism of photography, but took the idea into an aesthetic direction, namely, the "straight" aesthetic discussed in Chapter 6. Strand declared that the "very essence" of photography is an "absolute unqualified objectivity."[19] This position, of course, was furthered by Weston, Adams, and many others of the straight aesthetic.

A belief in the trustworthiness of the photograph was fostered by the news media, especially *Life* magazine in the 1930s, 40s, and 50s, which was very influential in society and in journalism. Gisèle Freund, photographer and writer about photography, claims that "what gave so much credibility to *Life* was its extensive use of photographs. To the average man photography, which is the exact reproduction of reality, cannot lie."[20] She explains that "few people realize that the meaning of a photograph can be changed completely by the accompanying caption, by its juxtaposition with other photographs, or by the manner in which people and events are photographed." The electronic news media today also relies on the credibility of the images recorded by cameras.

Advertisers have long been knowingly using photographs. David Ogilvy persuades his colleagues in his book *Confessions of an Advertiser* to use photographs because of their credibility: a photograph "represents reality, whereas drawings represent fantasy, which is less believable."

Susan Sontag comments cuttingly on such uses of photographs:

> A capitalist society requires a culture based on images. It needs to furnish vast amounts of entertainment in order to stimulate buying and anesthetize the injuries of class, race, and sex. And it needs to gather unlimited amounts of information, the better to exploit the natural resources, increase productivity, keep order, make war, give jobs to bureaucrats.[21]

Roland Barthes, in the last book he wrote before his death in 1981, *Camera Lucida: Reflections on Photography,* also placed himself in a realist mode regarding photography. He theorizes about photography in a very personal manner: "Now, one November evening shortly after my mother's death, I was going through some photographs."[22] He reflects upon a single photograph of his mother as a young girl, standing in a garden. He wanted "to learn at all costs what Photography was 'in itself,' by what essential feature it was to be distinguished from the community of images." Ultimately, Barthes declares photography to be "a magic; not an art." The magic of photography, for Barthes, is that the photograph emanates past reality and authenticates the past existence of what it represents. Its power of authentication exceeds its power of representation. He declares the essence of photography to be "that which has been"—"what I see has been here."

Barthes explains that photography is different from other systems of representation, because the thing that is photographed has really been there. In painting or writing, however, the things to which the words or strokes refer are not necessarily real. But in photography, because of the way photographs are made, because photographs result from light reflected from objects to light-sensitive material, he "can never deny that *the thing has been there."* No writing, or painting, can give Barthes the certainty of photography: "Photography never lies: or rather it can lie as to the meaning of the thing… never to its existence."

Barthes's method of building theory is phenomenological. His writing in *Camera Lucida* is in the first person singular, and he draws upon his direct experience in looking at photographs. He has, in the book, an interesting and insightful subtheory of portraiture that he derives from his experiences of being photographed, as elucidated in the following quotation:

> In front of the lens, I am at the same time: the one I think I am, the one I want others to think I am, the one the photographer thinks I am, and the one he makes use of to exhibit his art. In other words, a strange action: I do not stop imitating myself, and because of this, each time I am (or let myself be) photographed, I invariably suffer from a sensation of inauthenticity, sometimes of imposture (comparable to certain nightmares). In terms of image-repertoire, the Photograph (the one I *intend)* represents that very subtle moment when, to tell the truth, I am neither subject nor object but a subject who feels he is becoming an object: I then experience a micro-version of death (of parenthesis): I am truly becoming a specter.[23]

Another contribution to theories of realism is the concept of "transparency." Kendall Walton, an aesthetician who does not usually write about photography, identifies transparency as a unique and distinguishing characteristic of the medium of photography.[24] In Walton's account, photography is special and significant because it gives us a new manner of seeing—a manner of "seeing through" photographs to the thing photographed. He is not claiming that the photograph gives us the impression or illusion of seeing reality but rather that the photograph

allows us "to see things which are not in our presence" and that "the viewer of the photograph sees, literally, the scene that was photographed." In an argument similar to Barthes's, Walton argues that because the photograph is caused by objects in the photograph, it allows us to see what was there. Paintings are not caused by what they depict. In cases of doubt about the existence of things painted, we have to rely on the painter's belief about what was seen; regardless of what the photographer believes, however, the photograph shows what was before the lens.

Although, for Walton, photographs are transparent, they are not invisible; that is, we can notice them. Also, they are often subjective and expressive, rather than bound to an objective realism. Photographs also rely on conventions borrowed from other media such as painting. Nevertheless, for Walton, they are unique because they are transparent.

Theoretician Joel Snyder opposes realist theories of photography:

> The notion that a photograph shows us "what we would have seen had we been there ourselves" has to be modified to the point of absurdity. A photograph shows us "what we would have seen" at a certain moment in time, *from* a certain vantage point *if* we kept our head immobile *and* closed one eye *and* *if* we saw things in Agfacolor or in Tri-X developed in D-76 and printed on Kodabromide #3 paper. By the time all the conditions are added up we are positing the rather unilluminating proposition that, if our vision worked like photography, then we would see things the way a camera does.[25]

Snyder agrees that photographs seem like natural phenomena, but they are not, and he directs our attention to how we ever came to think of photographs as natural phenomena.[26] In opposition to Barthes and others, Snyder insists that photography is no more privileged than painting or language in getting us to the "really real." He argues that we have falsely come to believe that the camera gives us privileged access to the world because of our ignorance of the historical developments in the invention and refinement of photography. The camera was invented to match the ways of picturing developed by Renaissance artists, namely, drawing in Western, Renaissance perspective. The standards for rendering developed by Renaissance artists are invented and not natural; they are conventions for depicting the world. Snyder points out that cameras themselves have been made to conform to standards of painting: The round lens of the camera obscura that "naturally" creates a circular image was modified by Renaissance painters and draughtsmen to a rectangular format to meet traditional expectations for paintings and drawings.

Snyder and coauthor Neil Allen Walsh point out some common conventions operant in supposedly realistic photography. In photographing a horse running, photographers ordinarily choose one of three conventions. By keeping the camera stationary and using a slow shutter speed, they render the horse blurred and the background stationary. By panning the camera with the horse, they render the horse sharp against a blurred background. By using a fast shutter speed and

stationary camera, they freeze both horse and background. Each of these pictures, the authors argue, might seem natural enough to us now, but we have forgotten that photographers had to invent these ways of conveying motion in their still photographs and we had to learn their conventions for representing motion in order to accurately understand their photographs.[27]

Snyder's conventionalist arguments owe much to the theories of Ernst Gombrich and Nelson Goodman. Gombrich writes about the history of art to reveal how different people in different cultures and time represent the world and understand their representations. Goodman is a philosopher also interested in the different ways we represent our world through symbol systems such as graphs, maps, charts, and paintings. Both Gombrich and Goodman argue that pictorial realism is culturally bound. That is, what was realistic for the ancient Egyptians is not for us; and perhaps more importantly, our version of realism, to which we are so accustomed as convincingly realistic, would not be decipherable to them. Styles of representation, realistic and otherwise, are invented by artists and draughtsmen in a culture and learned by viewers in that culture. Styles of picturing are made up of invented codes that become conventional. Realism, for Goodman, is a matter of a picture's codes being easily decipherable, readily readable. Ease of information retrieval from a style of picturing is mistaken by a culture for pictorial accuracy because the viewers are unaware of the representational system within their own culture; they are too familiar with it to notice it. A style becomes so easily readable that it seems realistic and natural—it seems to be the way the world is.

Regardless of what a person thinks about the nature of photography, whether it is better or more accurately thought of as a unique medium or as a medium of conventions it shares with other media, most agree that photography is accepted by the public as believable. "People believe photographs," Coleman wrote,[28] and Andy Grundberg reiterates the point: Photography "is the most stylistically transparent of the visual arts, able to represent things in convincing perspective and seamless detail. Never mind that advertising has taught us that photographic images can be marvelous tricksters: what we see in a photograph is often mistaken for the real thing."[29] The transparency that Grundberg mentions is allayed to the transparency that Walton discusses and also to cultural tendencies to see through the photograph to what is photographed, to forget that the photograph is an artifact, made by a human, and to wrongly accept it as a natural phenomenon rather than a human construct.

Modernism and Postmodernism

Postmodernism encompasses more than photography. Todd Gitlin, a sociologist, offers his list of examples of persons, places, and things he considers postmodernist:

Michael Graves's Portland Building, Philip Johnson's AT&T, and hundreds of more or less skillful derivatives; Robert Rauschenberg's silk screens, Warhol's multiple-image paintings, photo-realism, Larry Rivers's erasures and pseudo-pageantry, Sherrie Levine's photographs of "classic" photographs; Disneyland, Las Vegas, suburban strips, shopping malls, mirror-glass office building facades; William Burroughs, Tom Wolfe, Donald Barthelme, Monty Python, Don DeLillo, Isuzu "He's lying" commercials, Philip Glass, "Star Wars," Spalding Gray, David Hockney ("Surface is illusion, but so is depth"), Max Headroom, David Byrne, Twyla Tharp (choreographing Beach Boys and Frank Sinatra songs), Italo Calvino, "The Gospel at Colonus," Robert Wilson, the Flying Karamazov Brothers, George Coates, the Kronos Quartet, Frederick Barthelme, MTV, "Miami Vice," David Letterman, Laurie Anderson, Anselm Kiefer, John Ashbery, Paul Auster, the Pompidou Center, the Hyatt Regency, *The White Hotel*, E. L. Doctorow's *Book of Daniel, Less than Zero*, Kathy Acker, Philip Roth's *Counterlife* (but not *Portnoy's Complaint*), the epilogue to Rainer Werner Fassbinder's "Berlin Alexanderplatz," the "Language of poets"; the French theorists Michel Foucault, Jacques Lacan, Jacques Derrida and Jean Baudrillard; television morning shows; news commentary gluing us in to the image-making and "positioning" strategies of candidates; remote-control-equipment viewers "grazing" around the television dial.[30]

Although postmodernism encompasses more than photography, permeating all aspects of society, and its cultural forms, including fiction, architecture, and painting, photography is central to it. But before we examine photography and postmodernism, we will examine modernism because postmodernism is best understood as antimodernism rather than as something that merely follows modernism chronologically. Postmodernism rejects modernism.

Modernism in art is known for such tenets as these: a superior attitude toward and opposition to popular culture; an emphasis on high art and superiority to the crafts; an objection to art as entertainment; an insistence on its own self-sufficiency and transcendency ("art for art's sake"); a belief that art primarily refers to other art, rather than the social world; a desire to be judged by formalist criteria and how the artwork furthers the history of art; a disregard for context in interpretation; a preoccupation with the purity of a medium ("flatness" in painting, for example[31]); a rejection of narrative content as appropriate for serious art; a belief in the individual genius of the artist; a desire for originality; a thirst for the new; and reverence for the precious, unique art object.

The modernist mission in photography is to have photography accepted as a legitimate artform. Among the champions of modernism in photography are Alfred Stieglitz, Paul Strand, and Edward Weston, photography historian Beaumont Newhall, and photography curator John Szarkowski. Photography modernists attempt to establish that the medium is unique, that realism is its proper mode, and that the straight photograph is the embodiment of what photography does best.

Over the past twenty-five years, John Szarkowski has had a major role in shaping modernist theory in art photography. According to critic Richard Woodward, "He is one of the great figures of American art; and the Museum of Modern Art has shown a longer, deeper regard for the art of photography than any institution in the world."[32] Woodward credits Szarkowski with cutting "the photograph's ties to journalistic themes and captions and let work stand on its own, without relying on subject matter for its importance." Letting the work "stand on its own" is a modernist theme, that of transcendency and independence. Letting the work stand on its own "without relying on subject matter" is also a modernist tenet that looks to form, rather than subject, as the important element. For more than twenty-five years, Woodward adds, Szarkowski has "done more than anyone to analyze how a photograph differs from any other kind of art." Szarkowski's analysis is a typically modernist project, one of sorting characteristics of photography from those of painting and other media, establishing its uniqueness.

Modernism in photography has its own tradition different from the tradition of fine art. Modernism in photography and in fine art are based on the same beliefs, but the photographic community, desiring to have photography accepted as a legitimate and respected fine art on a par with painting, defensively developed its own history books, its own departments in universities, its own journals, and favored educational separatism from other artists at the same time it was seeking acceptance in the art community.

Today photography is not only recognized as a legitimate artform, but it is collected and displayed in museums all over the world. The J. Paul Getty Museum in Los Angeles, for example, bought up nine private collections, 65,000 photographs, in 1984, for an estimated $20 million.[33]

Critic Abigail Solomon-Godeau sees such acceptance of photography as art as a "dubious reward":

> Today art photography reaps the dubious reward of having accomplished all that was first set out in its mid-nineteenth century agenda: general recognition as an art form, a place in the museum, a market (however erratic), a patrimonial lineage, an acknowledged canon. Yet hostage still to a modernist allegiance to the autonomy, self-referentiality, and transcendence of the work of art, art photography has systematically engineered its own irrelevance and triviality. It is, in a sense, all dressed up with nowhere to go.[34]

She also addresses educational consequences of the modernist photography influence in the college education of photography students:

> The teaching of photography tends to be cordoned off from what goes on in the rest of the art department. So while young painters are reading art magazines and as often as not following developments in film, performance and video, photography students are reading photography magazines, disputing the merits of documentary over self-expression, or resurrecting unto the

fourth generation an exhausted formalism that can no longer generate either heat or light.[35]

Postmodernism, in the views of Solomon-Godeau and other critics, has rightly replaced modernism. Jan Zita Grover writes: "Individual genius, the object as unique and precious, art as the new, the violate (yet the pearl beyond price) had run smack into a highly persuasive, hugely pervasive mass culture that obscured the differences between original and reproduction, high and low art, entertainment and information, art and advertising."[36]

Both statements by Solomon-Godeau and Grover reiterate principles of modernism that they reject: "the autonomy, self-referentiality, and transcendence of the work of art"; "individual genius, the object as unique and precious, art as the new, the violate." Those embracing postmodernist art generally recognize that art exemplifies the political, cultural, and psychological experience of a society; they are aware of and make reference to the previously hidden agendas of the art market and its relation to art museums, dealers, and critics; they are willing to borrow widely from the past; they have returned to the figurative in art; they embrace content over form, and they represent a plurality of styles.

Walter Benjamin is an early and influential figure who has contributed to postmodernist practices and particularly to photography's centrality in postmodernism. He is a German cultural theorist who in the 1930s wrote two essays on photography that are frequently cited by recent theorists, especially those of postmodernist and leftist persuasions. The essays are "The Work of Art in the Age of Mechanical Reproduction" and "A Short History of Photography." In these essays Benjamin stressed different aspects of the photographic medium than those that Strand and Weston were emphasizing in America. While Strand and Weston herald the honesty of the medium and the infinite detail of the negative and the beautiful photographic print, Benjamin stresses that, unlike the painting, the photograph is infinitely reproducible. Photography could also reproduce the painting. So while the modernists were promoting the precious image, Benjamin's notions suggested possibilities for a mass-produced image in the age of mechanical reproduction.

Today photography is at the center of postmodernism. As critic Woodward writes, "In the last few years, as neo-conceptualism—an art of ideas, riddles and barbed queries in which the inner life of the artist is irrelevant—has replaced neo-expressionism in critics' conversation, photography has moved from the margins toward the center of the art world's interests."[37] With an implicit nod to Benjamin's thought, Woodward cites reproduction as photography's main contribution to postmodernist practice: "Unlike a painting, a photograph is an infinitely reproducible image. (Paintings can be reproduced only by means of photography.) A photograph is also readily adaptable: It can be blown up, shrunk, cropped, blurred, used in a newspaper, in a book, on a billboard." Similarly, Abigail Solomon-Godeau lists the formal devices "seriality and repetition, appropriation, intertextuality, simulation or pastiche"[38] as the primary means of such artists

using photography as John Baldessari, Victor Burgin, Hilla and Bernd Becher, Dan Graham, Sarah Charlesworth, Barbara Kruger, Louise Lawler, Sherrie Levine, Richard Prince, Cindy Sherman, Laurie Simmons, and James Welling.

Marxist Theory and Criticism

Allan Sekula rejects postmodernism as a "cynical and self-referential mannerism," which he calls "a chic vanguardism by artists who suffer from a very real isolation from larger social issues."[39] Sekula instead embraces a critical social documentary in his photography and his writing: "I am arguing, then, for an art that documents monopoly capitalism's inability to deliver the conditions of a fully human life." He adds:

> Against violence directed at the human body, at the environment, at working people's ability to control their own lives, we need to counterpose an active resistance, simultaneously political and symbolic, to monopoly capitalism's increasing power and arrogance, a resistance aimed ultimately at socialist transformation.[40]

Sekula discusses the work of Philip Steinmetz, Martha Rosler, Fred Lonidier, Chauncey Hare, and himself as photographers who are working against the strategies of "high art photography." They, like the postmodernists, refuse to treat the photograph as a privileged object and instead use it as an ordinary cultural artifact. They add language to their photographs to "anchor, contradict, reinforce, subvert, complement, particularize, or go beyond the meanings offered by the images themselves."

 Their work is also very different from "liberal documentary work." Sekula writes:

> For all his good intentions, for example, Eugene Smith in *Minamata* provided more a representation of his compassion for mercury-poisoned Japanese fisherfold than one of their struggle for retribution against the corporate polluter. I will say it again: the subjective aspect of liberal esthetics is compassion rather than collective struggle. Pity, mediated by an appreciation of "great art," supplants political understanding.[41]

Sekula is arguing for political understanding of the corruption of capitalism, and then radical change. Mere compassion, through art photography, is not enough, and worse, it distracts understanding and deflects rage. He insists that "the expressionist liberalism of the find-a-bum school of concerned photography" is not a solution.

Critic James Hugunin groups Sekula, Rosler, and Lonidier with Marshall Mayer, Steve Cagan, Connie Hatch, Victor Burgin, Carole Conde, and Karl Beveridge under the term "Marxist Realism."[42] Hugunin differentiates these Marxist realists from "traditional documentary" or "concerned photography" in the

tradition of Lewis Hine, Eugene Smith, and Roy DeCarava. According to Hu-gunin, traditional documentary photography is based on assumptions that the photograph represents a one-to-one correspondence with reality which is nearly accurate and adequate and that the photographic image is capable of conveying information, needing language only as a verbal aside. Traditional documentary be-lieves the viewer to be a receptive subject taking in the objective information of the world through the photograph. Another traditional assumption is that the photograph is transparent, that is, it hides its own ideology and presents itself, and is easily received, as the thing itself. Marxism and postmodernism reject these assumptions of traditional documentary as naive and posit that traditional, human-istic, concerned photography makes social comments that merely evoke sympathy rather than encourage resistance. Further, photography deals with surface appear-ances, and surfaces obscure rather than reveal the actual complex social relations that underlie appearances.

Victor Burgin insists that when Marxist cultural theory is applied to photog-raphy theory, it "must take into account the determinations exerted by the means of representation upon that which is represented."[43] Through his writing and photography he is interested in determining how representation affects what is represented. Part of this project is to make visible ideologies operant within society and reinforced by all images including photographs. Marxist cultural theory sees ideology as a system of representations including images, myths, beliefs, which exist in a society at a certain historical time and have a role within the society, and these representations act on men and women by a process that escapes them. Burgin credits the women's movement as initially and continually critically examining how women are represented and the detrimental conse-quences of those representations.

Feminist Theory and Criticism

This statement by Abigail Solomon-Godeau reveals how feminist theory is con-cerned with how women are represented: "Central to feminist theory is the recognition that woman does not speak herself: rather, she is spoken for and all that that implies: looked at, imagined, mystified and objectified."[44] Barbara DeGenevieve is a feminist photographer committed to changing oppressive rep-resentations of women (and other minority groups) in society. She writes:

> Photographic images carry ideological messages which cumulatively shape the culture's ideas, values, and attitudes. They are the bearers of cultural mythologies. If we see enough pictures of a certain type (women being brutalized by men, minorities as ghetto residents) we can conclude that such imagery is valuable to the culture. Especially, if certain aspects of society are not represented, it is most likely due to the fact that no importance is given to them or that they have a negative value for the culture (vulnerability in male sexuality, non-stereotypical images of women and people of color).[45]

Griselda Pollack and Deborah Cherry, two feminist art historians, make a related point about how women have been positioned in fine art: "Representing creativity as masculine and circulating Woman as the beautiful image for the desiring male gaze, High Culture systematically denies knowledge of women as producers of culture and meaning."[46] Solomon-Godeau explains how feminist theory is embodied in the work of two feminist artists who use photography, Silvia Kolbowski and Vikki Alexander. Both deal directly with images of women in the fashion industry. Both appropriate fashion imagery in mass circulation sources to subvert them. Kolbowski exposes how the fashion image constructs the female as different, as other, and therefore estranges and oppresses her by making her the voyeuristic object of the male gaze. When fashion imagery is presented for women, the female viewer must project her own sexual identity as existing by and for the eyes of men.[47] In her work Alexander exposes how women in fashion imagery are presented as ritual objects and as commodities. In Solomon-Godeau's analysis, "By de-naturing such images, Alexander unmasks them." About these two artists, and others like them, she concludes:

> Differences in emphasis, tactics and degree of appropriation notwithstanding, Alexander, Kolbowski, Kruger, Levine and Prince are artists whose concerns are grounded in the cultural, the political, the sexual. Viewed individually, collectively, or as sample representatives of postmodernist art practice, their work contrasts vividly with parochialism, insularity, and conservatism of much art photography.[48]

Feminist production in writing or art making, however, is not restricted to how women are represented. On an image appropriated from *Newsweek* of two policemen dragging a a pro-choice woman away from a rally, Lynette Molnar superimposes these words: "Keep your self-righteous right wing fundamentalist Christian male laws off my body." The image is about two feet by three feet, an assemblage of color photocopies, and made as a placard for street demonstrations to oppose Right to Life demonstrators who are attempting to repeal laws that allow abortion. Molnar's work is socially activist, direct, and accessible to a wide audience and is intended for the street rather than the museum. Feminists in the field are also working to achieve full participation in the art world, including reaching equality in arts funding and representation in galleries and museums, and to improve the number and status of women on photography faculties. An allied project is the recovering of lost and unknown women artists in history. In art criticism, some feminists have interjected a personal voice and style of writing and have eschewed the notion of objectivity—Lucy Lippard's activist criticism discussed in Chapter 1 is a clear example.

Other Influential Theories

Structuralism, poststructuralism, deconstructionism, semiology, semiotics, neo-Freudianism, neo-Marxism, Ferdinand de Saussure, Lévi-Straus, C. S. Pierce,

Noam Chomsky, Roman Jakobson, Roland Barthes, Jacques Lacan, Jacques Derrida, Michel Foucault, Louis Althusser, *langue, parole,* synchrony, diachrony, signifier, signified, the text, desire, the gaze… these are names of movements and people and terms that are sprinkled throughout photography criticism. They are for the most part European influences. And they are from disciplines other than art: anthropology, linguistics, psychology, and literary criticism. They intermingle and intermesh and inform postmodernism, feminism, art theory, art criticism, art teaching, and art making. Detailed discussions of these concepts and theories are beyond the scope of this book. More information about them can be gathered in courses of literary criticism, anthropology, linguistics, social theory, philosophy, psychology, and mythology.

Several of the ideas of these scholars have been used throughout this book. Barthes's analysis of the Panzani tomato sauce ad in Chapter 3 is a structuralist, semiotic analysis. Hugunin's following summary of Lacan's theory of the self reads as a description of Cindy Sherman's early, self-portrait film stills in which she poses herself as a series of others, a series of representations by others. Hugunin writes:

> For Lacan, the Self is not the unitary ego of the Cartesian *Cogito ergo sum.*
> That sense of a unitary Self is, according to Lacan, an illusion, an effect of
> ideology; rather, the subject only exists as if it were a unitary subject. It is
> actually a misrecognized Self formed from an idealized image which it forms
> of itself in the mirror of the idealized Other, be that one's family, Big Brother,
> or cultural forms of reflection like film, television, and literature.[49]

Other important themes of poststructuralism are these. The signifier is different from the signified: The photograph is different from what is photographed. Nature is only intelligible by the structures we invent to understand it. A book, or a photograph, is an object in the world that needs to be deciphered. It is not the product, nor the masterpiece, of one mind but rather arises from a culture at a point in history. It is part of a system of signs, or of language. Language, and other systems of representation, are formed by humankind, but they also are formative. Ideologies are also structured and formative, but invisible to those they affect. An important project is to make them visible, because they are often oppressive.

CONCLUSION

There is no single Marxism, no single feminism, no single, universally accepted postmodernism. Instead, there are many variations of each and much cross-pollination—for example, Marxist feminisms and humanistic feminisms. Nor do these various theories merge to form a comprehensive, unitary theory of photography. Some theories complement and supplement others, but some are

incompatible. Modernism is at odds with postmodernism. Marxist realism rejects humanistic liberalism.

Theoretical questions receive different answers, as do interpretive and evaluative questions. Theorizing about photography, like interpreting and evaluating photographs, results in conclusions that are more or less enlightening, more or less informative, more or less helpful in making photography, photographs, and the world understandable. Theories or theoretical points, like interpretations and evaluations, are offered, considered, modified, and accepted or rejected. Some are dismissed as misguided; others are saved and mulled over and altered over time through argument.

Critics and theoreticians frequently take issue with each other's ideas. Rudolph Arnheim rejects Barthes's notions of how photographs signify as "too lexical," corresponding too closely to verbal language.[50] Susan Sontag's book is extremely critical of photography, and it particularly upset several photographers. Sometimes the debates become quite heated. Bill Jay, a photography historian, resorts to name calling ("pseudo/marxists" who are "pernicious and vicious"[51]) in objecting to the influence of the Women's Caucus on the field of photography. Nevertheless, these debates and conflicting views contribute to an ongoing, interesting, and informative dialogue about photography and photographs that enlivens the viewing of photographs as well as their making. Theories of photography are important and valuable, even if they are sometimes contradictory. They are important because they affect practice. They are valuable because they help us understand more about photography and photographs and increase our understanding and appreciation of the medium, individual pictures, and the world. Knowing some of the issues and theoretical assumptions allows us to better join the discussions and to be better informed about what we are doing in making and in criticizing photographs.

APPENDIX A
WRITING ABOUT PHOTOGRAPHS

You should be well equipped now to write about photographs. We have identified four main questions that can be asked of any photograph: What is here? What is it about? Is it good? Is it art? Answering any of these questions will give you something significant to write about.

To write well you need to want to write. Choose a photograph, a book, or an exhibition that interests you and about which you care. You may be interested because you like the work, or because you object to it. You may be intrigued for reasons you haven't yet identified, or because the work appeals to you but you don't yet feel you understand it. If you don't care about the work, however, you will have difficulty writing about it.

Study the photograph or exhibition intently, and jot down notes as you reflect on the work. Some writers use three-by-five-inch cards for note taking, with one note per card. This method will allow you to later sort and arrange your cards in a logical order before you begin to write your essay.

To learn more about the photographs you will write about, follow the activities of description, interpretation, and evaluation. Describe both subject matter and form. Gather evidence for your interpretation from within and outside of the photograph, recalling what you know about the photographer and the time and place in which he or she made the photograph. Decide by which criteria the photograph would fare best in your judgment of it. Write down all your thoughts, and indicate on the top of your note cards whether the item is descriptive, interpretative, evaluative, or theoretical.

While you are observing a photograph, listen to your feelings and determine what in the work has triggered them. Freely write down phrases and words that

come to mind; the more phrases you write now, the fewer you will have to construct later. Afterwards you can arrange them logically and discard the irrelevant. Allow yourself the time to set aside your work for a while and come back to it later to check your initial reactions. Write down new thoughts. Decipher why you care about the work, and determine what you want someone else to know about it and your reaction to it.

Before you begin to write, it is important to determine who you are writing to, how much background information your reader will have, and what information you will have to supply. Organize how you are going to proceed with your essay. Think about an opening that will draw your reader in—that will make someone want to read the rest of what you have written. Although we have studied criticism in the logical order of description, interpretation, evaluation, and theory, remember that critics rarely write in such a sequence. They write to be read with some enjoyment, in a way that will involve the reader in what they have to say. What do you want to tell your reader and how do you want to tell it? What will be your main point, and what evidence do you need to establish it?

Next sort and resort your note cards, arranging them in a way that is logical and interesting. It may help to make a one-page outline based on how you have ordered the cards. Then start writing! If you have difficulty getting started, begin with whatever section is the easiest for you to write and then add the other sections. If you have a good organization for your essay, it does not matter where you begin, as long as you eventually put all the pieces into a logical order.

Keep your reader in mind as you write, and as you read what you have written, read it through the eyes of your imaginary reader. First imagine a friendly reader who will be sympathetic to what you think. Then, for a second reading, imagine a reader who would be difficult to convince, so that you will build a strong case for what you believe. Don't assume too much of your reader: Describe the work sufficiently so that the reader can form a good mental picture of what you are writing about.

Convey your enthusiasm for the photograph with your choice of words. Once you've described it in sufficient detail, don't assume that the photograph's meaning is now evident. Provide your reader with your interpretation, and give reasons why you think it is a valid interpretation. Be sure that your judgment of the work is clear—that your reader knows that you strongly approve of it and why, or that you have reservations and what they are. If you are using specific criteria for evaluating the work, you may want to make them explicit. Be persuasive by your choice of language, and be convincing by the evidence you cite to support your claims.

If you use the ideas of others to support your argument, credit them in the body of the essay or in footnotes. Remember that plagiarism is not just taking another's words without credit but also is borrowing their ideas without proper citations.

Each paragraph should focus on one major point with evidence to support the point. Your ideas should progress logically from paragraph to paragraph: If your paragraphs can be rearranged without loss of effectiveness, your essay is probably not as logically constructed as it ought to be. Provide your reader with transitions from one paragraph to another. Sometimes the whole first sentence of a new paragraph will provide the transition from one idea to another; other times a simple bridge like "however" or "moreover" will suffice.

Your conclusion should be brief, clear, and forceful. In a short essay it is not necessary to review your argument. Avoid the error of making the conclusion into a beginning of another essay by introducing a new idea or further evidence. Also avoid double endings.

Consider your completed paper to be your first draft, and read it over critically. The following questions may help you to consider what you have written and perhaps to improve it:

- What is your main point? Do you state it soon enough and reinforce it throughout your essay?

- Does each paragraph have a topic?

- Do you proceed logically with your argument, with one point leading to the next?

- Do you move smoothly and effectively from one paragraph to another?

- Do you provide enough internal and external descriptive information for your reader to visualize the work you are discussing?

- Do you provide evidence for your interpretations?

- Do you provide reasons for your judgments?

- Have you been clear without being redundant?

- Do you get your reader's attention right at the beginning of your essay?

- Have you created the tone you want? Have you refrained from being sarcastic or insulting?

- Have you been fair in your judgments?

- Is the final paragraph a clear and forceful conclusion?

- Have you refrained from being and sounding dogmatic about your views?

Proof your writing for proper grammar and correct spelling. Once you have done what you can to strengthen your essay, ask someone to read what you have written and to tell you what they think about what you have done. Every writer can benefit from an editor. Polishing your writing at this point is similar to matting and framing a favorite photograph, presenting it in the best way possible.

If you enjoy writing and are good at it, consider writing for a publication. An increasing number of campus, local, and regional publications on art and photography are in need of writers. Browse the periodical sections of libraries and bookstores and peruse publications. When you find a periodical you would like to write for, locate the name and address of the editor in the first several pages. Write to the editor and ask for writer's guidelines, or make an appointment to visit the editor of a local publication to discuss your possible contributions.

TALKING ABOUT PHOTOGRAPHS

Talking about photographs is often spontaneous. We casually talk with others about photographs as we move through an exhibition. More often than not in this situation, our comments are evaluative: "This is a great show," or "I don't like this stuff." Frequently, a discussion does not go beyond a comment of approval or a succinct dismissal, especially if others agree with our comment.

Some talk about photographs is loosely organized, often in classroom situations, around students' photography. These critiques, usually led by a teacher, can take many forms, but they are usually evaluative. The purpose of these critiques is often thought to be the improvement of students' photography. Many of the comments, either by the teacher or fellow students, are directed toward improving specific prints with detailed advice on how to accomplish this. These kinds of critiques are valuable, but compared to the kinds of criticism in this book, they are very limited.

In both casual and directed talk about photographs, we often find ourselves uncomfortably short on things to say about a photograph or an exhibition. Critiques can be very strained if no one except the teacher talks. You can use the information in this book to expand these discussions and make them more informative and lively. You should now be capable of saying a lot, particularly if you carefully attend to description, interpretation, evaluation, and the roles of theory in criticizing photographs.

Here are some suggestions to help you be a better participant in a critique:

- *Describe what you see.* To describe a photograph to a group when everyone can see the image may seem silly; we tend to believe that everyone can see what we see, so we feel awkward in describing what we perceive

to be obvious. But what is apparent to you might be overlooked by someone else. If a group of twenty people describe a photograph, each will attend to different aspects of it, with different points of emphasis and varying degrees of enthusiasm.

- *Consider both subject matter and form.* Photographers tend to discuss photographic form and shy away from considering subject matter, thinking it too obvious to discuss. But considerations of subject matter in professional critics' writing about Avedon or Mapplethorpe, for example, are essential to their criticisms.

 The act of description also extends the time a group will actively attend to a photograph. Descriptive discussions can be very enlightening, to the group and to the photographer. You will be surprised by what others notice and what they ignore.

- *Let your interpretation be a communal endeavor.* When talking about photographs casually or in organized critiques, people often neglect interpretation altogether or treat it very superficially. This is especially true when the photographer is present. Often the photographer will supply the meaning by telling what the work is about. This is a flawed form of criticism known as intentionalism. It is flawed for several reasons, the most important of which is that the photographer does not own the meaning of the work. What the photographer thinks the image is about should be one among several competing interpretations, and not necessarily the best, even though he or she may pronounce the meaning of the photograph with great confidence and authority.

- *Suggest that the photographer be silent.* When conducting critiques with people who make images, I find the discussions to be most productive if the photographer whose work we are considering does not contribute to the discussion of his or her pictures. This way, the photographer is much less likely to tell nervous jokes, or irrelevant anecdotes, make defensive statements, or verbally justify his or her images. Without the responsibility to talk or defend, the photographer is better able to absorb what is being said about his or her photographs. The silence of the photographer also puts the responsibility for criticism on the viewers rather than on the photographer, and this is where it should be.

- *Avoid hasty judgments.* When judging photographs, we should avoid impulsive judgments and premature evaluative closures. If we do begin an evaluative conversation with a hasty judgment, we should back it up with reasons and appeal to criteria on which our judgments are based. We should also be willing to listen to views that challenge our own.

- *Be honest and open.* Attitudes of honesty and openness will improve critiques and all discussions about photographs. If we resolve to try to

express rather than to impress, the discussions will be much livelier and will include more participants. Avoiding dogmatic responses will also further discussions. Dogmatic pronouncements irritate people, cause non-productive arguments, and end conversations rather than extend thinking and talking.

In any discussion, it is important to actively listen, acknowledge to the speaker that you have heard what he or she has said, respond to it, and build upon it, even though it may be by disagreeing. Speaking aloud is a risky act, especially in a group, and the more comfortable we can make such situations for ourselves and others, the more enjoyable and productive the discussions will be.

NOTES

CHAPTER ONE

1. Rene Ricard, "Not about Julian Schnabel," *Artforum* 19, no. 10 (1981): 74–80.

2. Lucy Lippard, "Headlines, Heartlines, Hardlines: Advocacy Criticism as Activism," in *Cultures in Contention*, ed. Douglas Kahn and Diane Neumaier (Seattle, Wash.: Real Comet Press, 1985), pp. 242–47.

3. Morris Weitz, *Hamlet and the Philosophy of Literary Criticism* (Chicago: University of Chicago Press, 1964), p. vii.

4. Abigail Solomon-Godeau interviewed by Vince Leo, "What's Wrong with This Picture?" *Artpaper,* December 1987, pp. 12–14.

5. Edmund B. Feldman, "The Teacher as Model Critic," *Journal of Aesthetic Education* 7, no. 1 (1973): 50–57.

6. A. D. Coleman, "Because It Feels So Good When I Stop: Concerning a Continuing Personal Encounter with Photography Criticism," in Coleman, *Light Readings: A Photography Critic's Writings 1968–1978* (New York: Oxford University Press, 1979). (Originally published in *Camera 35,* October 1975.)

7. Weitz, p. vii.

8. Harry S. Broudy, *Enlightened Cherishing* (Champaign-Urbana: University of Illinois Press, 1972).

9. *New Art Examiner,* "Reviewer's Guidelines," editorial office, Chicago, Ill., 1988.

10. *Dialogue: An Art Journal,* "Writer's Guidelines," editorial office, Columbus, Ohio, 1987.

11. Kay Larson quoted by Amy Newman, "Who Needs Art Critics?" *Art News,* September 1982, p. 60.

12. Andy Grundberg, "Toward a Critical Pluralism," in *Reading into Photography: Selected Essays, 1959–1982,* ed. Thomas Barrow, et al. (Albuquerque, N.M.: University of New Mexico Press, 1982), pp. 247–53. (Originally published in *Afterimage,* October 1980.)

13. Solomon-Godeau interviewed by Leo, p. 12.

14. Ibid.

15. Glueck quoted by Newman, p. 56.

16. Coleman, "Because It Feels So Good," p. 207.

17. Ibid., p. 208.

18. Stevens quoted by Newman, p. 58.

19. Lippard, "Headlines, Heartlines, Hardlines," p. 243.

20. Larson quoted by Newman, p. 59.

21. Stevens quoted by Newman, p. 59.

22. Terry Barrett, "A Comparison of the Goals of Studio Professors Conducting Critiques and Art Education Goals for Art Criticism," *Studies in Art Education,* Fall 1988 pp. 22–27.

23. Hilton Kramer, in *The New Criterion,* 1982, quoted by Lippard in "Headlines, Heartlines, Hardlines," p. 242.

24. Terence Pitts, book review of *Mining Photographs and Other Pictures 1948–1968,* ed. Robert Wilke and Benjamin Buchloh (Cape Breton, Nova Scotia: Nova Scotia College of Art and Design, 1983), *Exposure* 22, no. 3 (1984): 48–53.

25. Stevens quoted by Newman, p. 57.

26. Marcia Siegel quoted by Irene Ruth Meltzer, "The Critical Eye: An Analysis of the Process of Dance Criticism as Practiced by Clive Barnes, Arlene Croce, Deborah Jowitt, Elizabeth Kendall, Marcia Siegel, and David Vaughan," (Master's thesis, The Ohio State University, 1979), p. 55.

27. Coleman, "Because It Feels So Good," p. 254.

CHAPTER TWO

1. Richard Avedon, *In the American West* (New York: Abrams, 1985).

2. Douglas Davis, "A View of the West," *Newsweek,* September 23, 1985, p. 82.

3. William Wilson, Review, *Artforum,* September 1985, p. 7.

4. Susan Weiley, "Avedon Goes West," *Artnews,* March 1986, pp. 86–91.

5. Wilson, p. 7.

6. Weiley, p. 91.

7. Davis, p. 83.

8. Wilson, p. 7.

9. Weiley, p. 86.

10. Richard Bolton, "In the American East: Avedon Incorporated," *Afterimage* 15, no. 2 (1987): 14.

11. Susan Kismaric, Introduction, *Jan Groover* (New York: Museum of Modern Art, 1987).

12. Michael Brenson, "Art: Whitney Shows Cindy Sherman Photos," *New York Times,* July 24, 1987.

13. Eleanor Heartney, "Cindy Sherman," *Afterimage,* October 1987, p. 18.

14. Cindy Chris, "Witkin's Others," *Exposure* 26, no. 1 (1988): 17.

15. Hal Fischer, "Looking into Darkness," *Artweek,* November 10, 1983.

16. Chris, p. 17.

17. Van Deren Coke, Introduction, *Joel-Peter Witkin* (San Francisco: Museum of Modern Art, 1985), pp. 6–18.

18. Edward Weston, "Seeing Photographically," in *A Modern Book of Esthetics,* 4th ed., ed. Melvin Rader (New York: Holt, Rinehart & Winston, 1973), p. 207.

19. John Szarkowski, *Looking at Photographs: 100 Pictures from the Collection of the Museum of Modern Art* (New York: Museum of Modern Art, 1973), p. 134.

20. Kismaric, Introduction, *Jan Groover.*

21. A. D. Coleman, "Bea Nettles," in *Light Readings* (New York: Oxford University Press, 1979), p. 105.

22. Weiley, "Avedon Goes West," p. 87.

23. Kismaric, Introduction, *Jan Groover.*

24. Gary Indiana, "Joel-Peter Witkin at Hardison Fine Arts," *Art in America,* September 1983, p. 175.

25. Hal Fischer, "Looking into Darkness," *Artweek,* August 13, 1983.

26. Jim Jordan, "Chaplin in Hell," *Artweek,* November 10, 1984.

27. A. D. Coleman, "The Directorial Mode: Notes Toward a Definition," in *Light Readings,* pp. 246–57.

28. Jonathan Green, ed., *The Snapshot* (Millerton, New York: Aperture, 1974).

29. Weiley, p. 87.

30. Davis, "A View of the West," p. 83.

31. Weiley, p. 89.

32. Coke, *Joel-Peter Witkin.*

33. Chris, "Witkin's Others," p. 17.

34. Ibid., p. 18.

35. Fischer, "Looking into Darkness."

36. Gene Thornton, "A Gothic Vision of Man Seen with the Camera's Eye," *New York Times,* August 24, 1986, p. 27.

37. Indiana, "Joel-Peter Witkin at Hardison Fine Arts," p. 175.

38. Bill Berkson, *Artforum,* February 1984, p. 117.

39. Jim Jordan, "Chaplin in Hell."

CHAPTER THREE

1. Andy Grundberg, "A Quintessentially American View of the World," *New York Times,* September 18, 1988, p. 35.

2. Ernst Gombrich, *Art and Illusion* (New York: Pantheon Books, 1960), pp. 297–98.

3. Nelson Goodman, *Languages of Art* (Indianapolis, Ind.: Hackett, 1976), p. 7.

4. Roland Barthes, "Rhetoric of the Image," 1964, in *Image-Music-Text,* ed. Roland Barthes (New York: Hill and Wang, 1971), pp. 32–51.

5. Ibid.

6. John Szarkowski, *Looking at Photographs: 100 Pictures from the Collection of the Museum of Modern Art* (New York: Museum of Modern Art, 1973), p. 202.

7. Sally Eauclaire, *American Independents: Eighteen Color Photographers* (New York: Abbeville Press, 1984), p. 219.

8. Shelley Rice, "Mary Ellen Mark," in *4 x 4: Four Photographers by Four Writers* (Boulder: University of Colorado at Boulder, 1987).

9. Jonathan Green, *American Photography: A Critical History* (New York: Abrams, 1984), p. 163.

10. Edward Bryant, Introduction, *Picture Windows: Photographs by John Pfahl,* ed. John Pfahl (New York: New York Graphic Society, 1987), p. 1.

11. Ronald Dworkin, "Law as Interpretation," in *The Politics of Interpretation,* ed. W. J. T. Mitchell (Chicago: University of Chicago Press, 1983), pp. 249–70.

12. Eleanor Heartney, "Cindy Sherman," *Afterimage,* October 1987, p. 18.

13. Szarkowski, p. 166.

14. Green, pp. 66, 67.

15. Diane Neumaier, "Alfred, Harry, Emmet, Georgia, Eleanor, Edith, and Me," *Exposure* 22, no. 2 (1984): 6, 7.

16. Anne H. Hoy, *Fabrications: Staged, Altered, and Appropriated Photographs* (New York: Abbeville Press, 1987), p. 47.

17. Kathleen McCarthy Gauss, *New American Photography* (Los Angeles: Los Angeles County Museum of Art, 1985), p. 30.

18. Bill Nichols, *Ideology and the Image: Social Representation in the Cinema and Other Media* (Bloomington: Indiana University Press, 1981), pp. 60–61.

19. Linda Andre, "Dialectical Criticism and Photography," *Exposure* 22, no. 4 (1984): 8.

20. Hoy, p. 16.

21. Van Deren Coke, Introduction, *Joel-Peter Witkin: Forty Photographs* (San Francisco: San Francisco Museum of Modern Art, 1985), pp. 6–18.

22. Monroe C. Beardsley, "The Testability of an Interpretation," in *Philosophy Looks at the Arts,* 3rd ed., ed. Joseph Margolis (Philadelphia: Temple University Press, 1987), pp. 466–83.

23. Joseph Margolis, ed., *Philosophy Looks at the Arts,* 3rd ed. (Philadelphia: Temple University Press, 1987), p. 366.

24. E. D. Hirsch, Jr., *Validity in Interpretation* (New Haven, Conn.: Yale University Press, 1967), p. 54.

25. Dworkin, "Law as Interpretation," p. 253.

26. Minor White, "Criticism," *Aperture* 2, no. 2 (1957): 29–30.

27. Monroe C., Beardsley, and William Wimsatt, Jr., "The Intentional Fallacy," in *Philosophy Looks at the Arts,* 3rd ed., ed. Joseph Margolis (New York: Charles Scribner's Sons, 1962), pp. 293–306.

28. Jerry Uelsmann, *Uelsmann: Process and Perception* (Gainesville: University Press of Florida, 1985), p. 23.

29. Tom Anderson, "A Structure for Pedagogical Art Criticism," *Studies in Art Education* 30, no. 1 (1988): 28.

30. Harry Broudy, *Enlightened Cherishing,* (Champaign-Urbana: University of Illinois Press, 1972).

31. Vincent Lanier quoted by Anderson, p. 28.

32. Hirsch, *Validity in Interpretation*, p. 62.

33. Hirsch, p. 63.

34. Anderson, pp. 34–35.

35. Michael Parsons, *How We Understand Art: A Cognitive Developmental Account of Aesthetic Experience* (Cambridge, England: Oxford University Press, 1987), pp. 84–85.

CHAPTER FOUR

1. Dominique François Arago, "Report," 1939, in *Classic Essays in Photography,* ed. Alan Trachtenberg (New Haven, Conn.: Leete's Island Books, 1980).

2. C. Jabez Hughes, "On Art Photography," 1891, *The American Journal of Photography,* quoted by Beaumont Newhall, *The History of Photography* (New York: Museum of Modern Art, 1982), p. 73.

3. Sadakichi Hartmann, "A Plea for Straight Photography," *American Amateur Photography,* 1904, quoted by Newhall, *History of Photography,* p. 167.

4. Weston quoted by Newhall, p. 188.

5. Beaumont Newhall, *The History of Photography: 1839 to the Present Day,* 4th ed. (New York: Museum of Modern Art, 1978) pp. 196–97.

6. John Szarkowski, *The Photographer's Eye* (New York: Museum of Modern Art, 1966).

7. John Szarkowski, *Mirrors and Windows: American Photography Since 1960* (New York: Museum of Modern Art, 1978), pp. 18–19.

8. Etienne Jules Marey, *Movement* (Appleton, N.Y., 1895), p. 127.

9. Aaron Scharf, *Art and Photography* (Middlesex, England: Pelican Books, 1974), pp. 255–57.

10. Howard S. Becker, *Exploring Society Photographically* (Chicago: Northwestern University Press, 1981), p. 11.

11. For a good selection of press photographs, see Sheryle and John Leekley, *Moments: The Pulitzer Prize Photographs* (New York: Crown, 1978).

12. Szarkowski, *Mirrors and Windows,* p. 23.

13. Shelley Rice on Mary Ellen Mark, in *4 x 4: Four Photographers by Four Writers* (Boulder: University of Colorado at Boulder, 1987), p. 25.

14. A. D. Coleman, "The Directorial Mode: Notes Toward a Definition," *Artforum,* September 1976, in Coleman, *Light Readings: A Photography Critic's Writings 1968–1978* (New York: Oxford University Press, 1979), p. 250.

15. Sandy Skoglund's work may be seen in Anne H. Hoy, *Fabrications: Staged, Altered, and Appropriated Photographs* (New York: Abbeville Press, 1987).

16. Jo Ann Callis's work can be seen in Hoy, *Fabrications,* pp. 46–50, and in *Contemporary American Photography,* Part I (Tokyo: Gallery Min, 1986).

17. *Contemporary American Photography,* Part I.

18. Andy Grundberg, "Homelessness at a Remove: An Urge to Stare," *New York Times,* September 25, 1988, sec. H, pp. 33, 40.

19. *The International Center of Photography Encyclopedia of Photography* (New York: Crown, 1984), p. 434.

20. *The International Center of Photography Encyclopedia of Photography,* p. 189.

21. Douglas Kahn, *John Heartfield: Art and Mass Media* (New York: Tanam Press, 1985).

22. Fred Lonidier's work can be seen in Jonathan Green, *American Photography: A Critical History 1945 to the Present* (New York: Abrams, 1984).

23. Laurie Simmons's work can be seen in Hoy, *Fabrications,* pp. 46–50.

24. Vikky Alexander's work can be seen in Hoy, *Fabrications,* p. 130.

25. Barbara Kruger's work can be seen in Kathleen McCarthy Gauss, *New American Photography* (Los Angeles: Los Angeles County Museum of Art, 1985), pp. 89–104.

26. Brian Lanker, *I Dream a World: Portraits of Black Women Who Changed America* (New York: Stewart, Tabori & Chang, 1989), p. 10.

27. John Szarkowski, *Irving Penn* (New York: Museum of Modern Art, 1984).

28. In John Szarkowski, *Mirrors and Windows: American Photography Since 1960* (New York: Museum of Modern Art, 1978), p. 109.

29. Szarkowski, *Mirrors and Windows,* p. 17.

30. Barbara Kasten's work can be seen in Hoy, *Fabrications,* pp. 105–7.

31. *The International Center of Photography Encyclopedia of Photography,* p. 491.

32. The photographs of Mark Klett can be seen in Gauss, *New American Photography,* pp. 42–56.

33. A Ray Metzker's photograph can be seen in Green, *American Photography*, p. 151.

34. Betty Hahn's photographs can be seen in Hoy, *Fabrications*, p. 148.

35. Linda Connor's photographs can be seen in *Contemporary American Photography*, Part I.

36. *Contemporary American Photography*.

37. Green, *American Photography*, p. 190.

38. Cindy Sherman's photographs can be seen in Hoy, *Fabrications*, pp. 90–93.

39. Richard Prince's photographs can be seen in Hoy, *Fabrications*, pp. 124–27.

40. Vikky Alexander's photographs can be seen in Hoy, *Fabrications*, p. 135.

41. Hoy, *Fabrications*, p. 135.

42. Sherrie Levine's photographs can be seen in Hoy, *Fabrications*, pp. 122–23.

43. One of Thomas Barrow's cancellation photographs can be seen in Hoy, *Fabrications*, p. 142.

44. Kelly Wise, *The Photographers' Choice* (Danbury, N.H.: Addison House, 1975), pp. 113–17.

45. Ibid., p. 226.

46. Wise, pp. 100–107.

47. Ibid., p. 224

48. Green, *American Photography*, p. 226.

49. Andy Grundberg, "Photography," *New York Times*, Book Review Section, December 4, 1988, p. 20.

50. Green, p. 181.

CHAPTER FIVE

1. Sheryle and John Leekley, *Moments—The Pulitzer Prize Photographs* (New York: Crown, 1978), p. 46.

2. Edward Weston, *The Daybooks of Edward Weston, Volume II: California* (Millerton, N.Y.: Aperture, 1973).

3. A Sherrie Levine "After Walker Evans" photograph may be seen in Anne Hoy, *Fabrications: Staged, Altered, and Appropriated Photographs* (New York: Abbeville Press, 1987), p. 123.

4. In Leekley, *Moments*, p. 89.

5. Gisèle Freund, *Photography and Society* (Boston, Mass.: David R. Godine, 1980), pp. 178–79.

6. John Szarkowski, *Looking at Photographs: 100 Pictures from the Collection of the Museum of Modern Art* (New York: Museum of Modern Art, 1973), p. 172.

7. Roland Barthes, "The Photographic Message," in *Image-Music-Text*, ed. Barthes (New York: Hill and Wang, 1977), p. 17.

8. Martha Rosler, "Lookers, Buyers, Dealers, and Makers: Thoughts on Audience," *Exposure* 17, no. 1 (1979): 21.

9. Walter Benjamin, a 1934 address delivered in Paris at the Institute on the Study of Fascism, quoted by Susan Sontag, *On Photography* (New York: Farrar, Straus & Giroux, 1978), p. 105.

10. Sontag, *On Photography,* p. 105.

11. John Szarkowski, *Mirrors and Windows: American Photography Since 1960* (New York: Museum of Modern Art, 1972), p. 30.

12. Carol Squiers, "Diversionary (Syn)tactics," *Artnews,* February 1987, p. 81.

13. Ibid., p. 82.

14. Craig Owens, "The Medusa Effect or, The Specular Ruse," *Art in America,* January 1984, p. 98.

15. Squiers, pp. 84–85.

16. Kruger, in Squiers, p. 85.

17. Ibid., p. 80.

18. Anne H. Hoy, *Fabrications: Staged, Altered, and Appropriated Photographs* (New York: Abbeville Press, 1987), p. 134.

19. Le Anne Schreiber, "Talking to Barbara Kruger," *Vogue,* October 1987, p. 268.

20. Ibid.

21. Lynn Zelevansky, "Barbara Kruger," *Artnews,* May 1983, p. 154.

22. Squiers, p. 85.

23. Owens, p. 98.

24. Hal Foster, "Subversive Signs," *Art in America,* November 1982, pp. 88–90.

25. Le Anne Schreiber, p. 268.

26. Zelevansky, p. 154.

27. Jean Fisher, review of Barbara Kruger at Annina Nosei Gallery, *Artforum,* January 1984, pp. 115–16.

28. John Sturman, "Barbara Kruger, Annina Nosei," *Artnews,* May 1986, p. 129.

29. Fisher, pp. 115–16.

30. Hoy, p. 131.

31. Shaun Caley, "Barbara Kruger," *Flash Art,* May/June 1986, p. 55.

32. Squiers, p. 85.

33. S. H. M., "Documenta: Making the Pointed Pointless," *Artnews,* September 1987, pp. 160–61.

34. See, for example, Susan Sontag, *On Photography* (New York: Farrar, Straus & Giroux, 1978), and Allan Sekula, "The Instrumental Image: Steichen at War," in *Photography Against the Grain* (Halifax, Nova Scotia: The Press of the Nova Scotia College of Art and Design, 1984), pp. 32–51.

CHAPTER SIX

1. Owen Edwards, "Small World in a Room," *Saturday Review,* October 1, 1977.

2. Mark Stevens, "The Bad and the Beautiful," *Newsweek,* September 26, 1977.

3. Hilton Kramer, "From Fashion to Freaks," *New York Times Magazine,* November 5, 1972, p. 38.

4. Robert Hughes, "To Hades with Lens," *Time,* November 13, 1972, p. 84.

5. Susan Sontag, *On Photography* (New York: Farrar, Straus & Giroux, 1978), pp. 33, 34.

6. Andy Grundberg, "Images from Winogrand's Mosaic of Life," *New York Times,* May 15, 1988, p. 45.

7. Richard Lacayo, "Drunk on a World Served Straight," *Time,* October 12, 1987, p. 88.

8. *Cindy Sherman,* "Cindy Sherman's Cindy Sherman," catalogue essay by Lisa Phillips (New York: Whitney Museum of American Art, 1987), p. 16.

9. Deborah Drier, "Cindy Sherman at Metro Pictures," *Art in America,* January 1986, p. 138.

10. Mark Johnstone, in *Contemporary American Photography Part I* (Tokyo: Gallery Min, 1986).

11. Jonathan Green, *American Photography: A Critical History 1945 to the Present* (New York: Abrams, 1983), p. 157.

12. Amy Goldin, "Diane Arbus: Playing with Conventions," *Art in America,* March/April 1973, p. 73.

13. Douglas Davis, "A Way of Seeing," *Newsweek,* December 3, 1979, pp. 108–12.

14. Gene Thornton, "A Show That Reveals an Artist at the Height of His Powers," *New York Times,* Arts and Leisure section, January 20, 1985, p. 29.

15. John Szarkowski, *Mirrors and Windows: American Photography Since 1960* (New York: Museum of Modern Art, 1978), p. 9.

16. Paul Strand, "Photography," 1917, in *Photographers on Photography,* ed. Nathan Lyons (Englewood Cliffs, N.J.: Prentice-Hall, 1966), p. 136.

17. Edward Weston quoted by Beaumont Newhall, *The History of Photography* (New York: Museum of Modern Art, 1982), p. 184.

18. John Szarkowski, *The Photographer's Eye* (New York: Museum of Modern Art, 1966), p. 8.

19. Kramer, "From Fashion to Freaks," p. 38.

20. Sadakichi Hartmann, "A Plea for Straight Photography," 1904, in *American Amateur Photographer,* 1964, quoted by Newhall, *History of Photography,* p. 171.

21. Strand in Lyons, *Photographers on Photography,* p. 136.

22. Edward Weston, "Seeing Photographically," 1943, in *A Modern Book of Esthetics,* 4th ed., ed. Melvin Rader (New York: Holt, Rinehart & Winston, 1973), p. 207.

23. Minor White, "Found Photographs," 1957, in *Photography: Essays and Images,* ed. Beaumont Newhall (New York: Museum of Modern Art, 1980), p. 77.

24. In Lyons, *Photographers on Photography,* p. 67.

25. C. Jabez Hughes quoted by John L. Ward, *The Criticism of Photography as Art: The Photographs of Jerry N. Uelsmann* (Gainesville: University of Florida Press, 1970), p. 4.

26. Roger Fry, "Pure and Impure Art," 1924, in *A Modern Book of Esthetics,* 3rd ed., ed. Melvin Rader (New York: Holt, Rinehart & Winston, 1965); Clive Bell, *Art* (New York: Putnam, 1985).

27. Jan Zita Grover and Lynette Molnar, in *AIDS: The Artists' Response,* exhibition catalogue (Columbus: The Ohio State University Gallery of Fine Arts, 1989), p. 56.

28. Michael Kimmelman, "Bitter Harvest: AIDS and the Arts," *New York Times,* Arts and Leisure section, March 19, 1989, pp. 1, 6.

29. Nicholas Nixon, in *AIDS: The Artists' Response,* p. 45.

30. Greg Bordowitz, in Douglas Crimp, "Art and Activism," *AIDS: The Artists' Response,* p. 10.

31. Robert Atkins, "Photographing AIDS," *AIDS: The Artists' Response,* pp. 26–27.

32. John Szarkowski, *Mirrors and Windows,* pp. 16–17.

33. Allan Sekula, "The Traffic in Photographs," in *Photography Against the Grain: Essays and Photo Works 1973–1983* (Halifax, Nova Scotia: The Press of the Nova Scotia College of Art and Design, 1983), pp. 76–101.

34. Green, *American Photography,* pp. 46–51.

35. John Corry, "Hollywood Virtue, Hollywood Vice," *New York Times,* Arts and Leisure section, February 17, 1985, p. 1.

36. Serrano's photograph may be seen in *Art in America,* September 1989, p. 43.

37. Quoted by Grace Glueck, "Art on the Firing Line," *New York Times,* Arts and Leisure section, July 9, 1989, p. 9.

38. Schuyler Chapin, "An Advocate for the Arts," *New York Times,* July 24, 1989, p. 19.

39. Hilton Kramer, "Is Art Above the Laws of Decency?" *New York Times,* Arts and Leisure, July 2, 1989, pp. 1, 7.

40. Glueck, pp. 1, 9.

41. "Letters," *New York Times,* Arts and Leisure section, July 30, 1989, p. 3.

42. Ibid., p. 3.

43. Kay Larson, "Getting Graphic," *New York Magazine,* August 15, 1988, pp. 66–67.

44. Stephen Koch, "Guilt, Grace, and Robert Mapplethorpe," *Art in America,* November 1986, pp. 146, 150.

45. Stuart Morgan, "Something Magic," *Artforum,* May 1987, pp. 119–23.

46. Andy Grundberg, "The Allure of Mapplethorpe's Photographs," *New York Times,* Arts and Leisure section, July 31, 1988, pp. 29–30.

47. Andy Grundberg, "Blaming the Medium for the Message," *New York Times,* Arts and Leisure section, August 6, 1989, p. 33.

CHAPTER SEVEN

1. Eleanor Heartney, "Cindy Sherman," *Afterimage,* October 1987, p. 18.

2. Richard B. Woodward, "It's Art, but Is It Photography?" *New York Times Magazine,* October 9, 1988, p. 42.

3. Edward Weston, "Seeing Photographically," 1943, in *A Modern Book of Esthetics,* 4th ed., ed. Melvin Rader (New York: Holt, Rinehart & Winston, 1973), p. 207.

4. In Woodward, p. 46.

5. Douglas Crimp, "The Museum's Old/The Library's New Subject," *Parachute,* no. 22 (Printemps 1981): 32–37.

6. Max Kozloff, "The Etherealized Figure and the Dream of Wisdom," in *Vanishing Presence,* exhibition catalogue (Minneapolis, Minn.: Walker Art Center, 1989), p. 33.

7. Allan Sekula, "Dismantling Modernism, Reinventing Documentary (Notes on the Politics of Representation)," in *Photography Against the Grain: Essays and Photo Works 1973–1983* (Halifax, Nova Scotia: The Press of the Nova Scotia College of Art and Design, 1984), p. 53.

8. Owen Edwards,"Small World in a Room," *Saturday Review,* October 1, 1977.

9. Andy Grundberg, "Hands Pose for Their Portraits," *New York Times,* Arts and Leisure section, January 29, 1989, p. 35.

10. Sekula, p. ix.

11. See, for example, Kendall K. Walton, "Transparent Pictures: On the Nature of Photographic Realism," *Critical Inquiry* 11 (December 1984): 246–77; and Roger Scruton, "Photography and Representation," *Critical Inquiry* 7 (Spring 1981): 577–603.

12. Cit. Jonathan Green, *American Photography: A Critical History, 1945 to the Present* (New York: Abrams, 1983).

13. *Cross-References: Sculpture into Photography,* exhibition catalogue (Minneapolis, Minn.: Walker Art Center, 1987), p. 4.

14. *Vanishing Presence,* p. 74.

15. Dominique François Arago, "Report," in *Classic Essays on Photography,* ed. Alan Trachtenberg (New Haven, Conn.: Leete's Island Books, 1980), pp. 11–13.

16. Louis-Jacques-Mandé Daguerre, "Daguerreotype," in *Classic Essays,* p. 12.

17. Cited by Trachtenberg, p. 71.

18. Lewis Hine, "Social Photography, How the Camera May Help in the Social Uplift," in *Classic Essays,* p. 111.

19. Paul Strand, "Photography," in *Photographers on Photography,* ed. Nathan Lyons (Englewood Cliffs, N.J.: Prentice-Hall, 1966), pp. 136–37.

20. Gisèle Freund, *Photography and Society* (Boston, Mass.: David R. Godine, 1980), p. 149.

21. Susan Sontag, *On Photography* (New York: Farrar, Straus & Giroux, 1978), p. 178.

22. Roland Barthes, *Camera Lucida: Reflections on Photography* (New York: Hill & Wang, 1981), p. 63.

23. Ibid., p. 14.

24. Kendall Walton, "Transparent Pictures," an address delivered at The Ohio State University, Columbus, Ohio, June 2, 1982.

25. Joel Snyder and Neil Allen Walsh, "Photography, Vision, and Representation," *Critical Inquiry* 2, no. 1 (1975): 152.

26. Joel Snyder, "Picturing Vision," in *The Language of Images,* ed. W. J. T. Mitchell (Chicago: University of Chicago Press, 1980).

27. Snyder and Walsh, p. 156.

28. A. D. Coleman, "The Directorial Mode; Notes Toward a Definition," in *Light Readings,* p. 248.

29. Andy Grundberg, "Blaming a Medium for Its Message," *New York Times,* Arts and Leisure section, August 6, 1989, p. 1.

30. Todd Gitlin, "Hip-Deep in Post-modernism," *New York Times Review of Books,* November 6, 1988, p. 35.

31. For a sarcastically critical treatment of modernist painting, see Tom Wolfe, *The Painted Word* (New York: Farrar, Straus & Giroux, 1975).

32. Woodward, "It's Art, but Is It Photography?" p. 42; see also Richard B. Woodward, "Picture Perfect," an article about Szarkowski, *Artnews,* March 1988.

33. Ibid., p. 42.

34. Abigail Solomon-Godeau, "Photography after Art Photography," in *Art after Modernism: Rethinking Representation,* ed. Brian Wallis (New York: New Museum of Contemporary Art, 1984), p. 80.

35. Abigail Solomon-Godeau, "Winning the Game When the Rules Have Been Changed, Art Photography and Postmodernism," *Exposure* 23, no. 1 (1985): 15.

36. Jan Zita Grover, "Introduction to AIDS: The Artists' Response," *AIDS: The Artists' Response,* exhibition catalogue (Columbus: The Ohio State University, 1989), p. 2.

37. Woodward, p. 30.

38. Solomon-Godeau, "Winning the Game," p. 80.

39. Sekula, "Dismantling Modernism," p. 74.

40. Ibid., p. 60.

41. Ibid., p. 62.

42. James Hugunin, "The Map Is Not the Territory," *Exposure* 22, no. 1 (1984): 12.

43. Victor Burgin, ed., *Thinking Photography* (London: Macmillan, 1982), p. 2.

44. Abigail Solomon-Godeau, "Winning the Game," p. 13.

45. Barbara DeGenevieve, "Guest Editorial: On Teaching Theory," *Exposure* 26, no. 2/3 (1988): 10.

46. Deborah Cherry and Griselda Pollack, quoted by Pollack, "Art, Art School, Culture: Individualism After the Death of the Artist," *Exposure* 24, no. 3 (1986): 22.

47. Solomon-Godeau, "Winning the Game," p. 13.

48. Ibid., p. 15.

49. Hugunin, p. 11.

50. Rudolph Arnheim, "On the Nature of Photography," *Critical Inquiry* 1, no. 1 (1974): 158–59.

51. Bill Jay quoted by Richard Margolis, "The Battle at the SPE Conference," *Images/Ink* 4, no. 2 (1989): 40.

BIBLIOGRAPHY

Adams, Ansel. *Ansel Adams.* Hastings-on-Hudson, N.Y.: Morgan and Morgan, 1972.

Andre, Linda. "Dialectical Criticism and Photography." *Exposure* 22, no. 4 (1984): 5–18.

Arago, Dominique François. "Report," 1939. In *Classic Essays in Photography,* edited by Alan Trachtenberg. New Haven, Conn.: Leete's Island Books, 1980, pp. 15–25.

Aristotle, *Poetics.* London: Macmillan, 1911.

Arnheim, Rudolph. "On the Nature of Photography." *Critical Inquiry* 1, no. 1 (1974): 149–61.

Aschner, Mary Jane. "Teaching the Anatomy of Criticism." *The School Review* 64, no. 7 (1956): 317–22.

Atkins, Robert. "Photographing AIDS." In *AIDS: The Artists' Response,* exhibition catalogue. Columbus: The Ohio State University Gallery of Fine Arts, 1989, pp. 26–28.

Avedon, Richard. *In the American West.* New York: Abrams, 1985.

Barrett, Terry. "A Comparison of the Goals of Studio Professors Conducting Critiques and Art Education Goals for Art Criticism." *Studies in Art Education* 30, no. 1 (1988): 22–27.

Barthes, Roland. "The Photographic Message," 1961. In *Image-Music-Text,* pp. 15–31. New York: Hill & Wang, 1971.

_____. "Rhetoric of the Image," 1964. In *Image-Music-Text,* pp. 30–51. New York: Hill & Wang, 1971.

_____. *Camera Lucida: Reflections on Photography.* New York: Hill & Wang, 1981.

Beardsley, Monroe C. "The Testability of an Interpretation." In *Philosophy Looks at the Arts.* 3rd ed., edited by Joseph Margolis, pp. 466–83. Philadelphia: Temple University Press, 1987.

Becher, Bernd and Hilla. *Water Towers*. Cambridge, Mass.: MIT Press, 1988.

Becker, Howard. *Exploring Society Photographically*. Chicago: Northwestern University Press, 1981.

Bell, Clive. *Art*. New York: Putnam, 1985.

Benjamin, Walter. "The Work of Art in the Age of Mechanical Reproduction," 1935. In *Film Theory and Criticism,* edited by Gerald Mast and Marshall Cohen. London: Oxford University Press, 1979.

_____. "A Short History of Photography," 1931. In *Classic Essays in Photography,* edited by Alan Trachtenberg, pp. 199–216. New Haven, Conn.: Leete's Island Books, 1980.

Berkson, Bill, Review, *Artforum,* February 1984, p. 117.

Bolton, Richard. "In the American East: Avedon Incorporated." *Afterimage* 15, no. 2 (1987): 12–17.

Brandt, Bill. *Nudes*. London: G. Fraser, 1980.

Brenson, Michael. "Art: Whitney Shows Cindy Sherman Photos." *New York Times,* July 24, 1987.

Bresson, Henri-Cartier. *The World of Henri-Cartier Bresson*. New York: Viking, 1968.

Broudy, Harry S. *Enlightened Cherishing*. Champaign-Urbana: University of Illinois Press, 1972.

Bryant, Edward. Introduction. *Picture Windows: Photographs by John Pfahl,* John Pfahl. New York: New York Graphic Society, 1987.

Bullock, Wynn. *Wynn Bullock*. San Francisco: Scrimshaw Press, 1971.

Burgin, Victor, ed. *Thinking Photography*. London: Macmillan, 1982.

Caley, Shaun. "Barbara Kruger." *Flash Art,* May/June 1986, p. 55.

Callahan, Harry. *Callahan*. Millerton, N.Y.: Aperture, 1976.

_____. *Harry Callahan: Color*. Providence, R.I.: Matrix, 1980.

_____. *Harry Callahan: New Color, 1978–1987*. Kansas City, Mo.: Hallmark Cards, 1988.

Cameron, Julia Margaret. "Annals of My Glass House," 1874. *Photography in Print, Writings from 1816 to the Present,* edited by Vicki Goldberg, pp. 180–187.

Caponigro, Paul. *Paul Caponigro*. Millerton, N.Y.: Aperture, 1972.

_____. *Megaliths*. New York: New York Graphic Society, 1986.

Chapin, Schuyler. "An Advocate for the Arts." *New York Times,* July 24, 1989.

Chris, Cindy. "Witkin's Others." *Exposure* 26, no. 1 (1988): 17.

Cindy Sherman. New York: Whitney Museum of American Art, 1987.

Coleman, A. D. "The Directorial Mode; Notes Toward a Definition." In *Light Readings.* (Originally published in *Artforum,* September 1976), pp. 246–57.

_____. "Bea Nettles." In *Light Readings: A Photography Critic's Writings 1968–1978.* New York: Oxford University Press, 1979.

_____. "Because It Feels So Good When I Stop: Concerning A Continuing Personal

Encounter with Photography Criticism." In *Light Readings: A Photography Critic's Writings 1968–1978.* New York: Oxford University Press, 1979, pp. 203–14. (Originally published in *Camera 35,* October 1975.)

Contemporary American Photography. Part I. Tokyo: Gallery Min, 1986.

Corry, John. "Hollywood Virtue, Hollywood Vice." *New York Times,* Arts and Leisure section, February 17, 1985, p. 1.

Cosindas, Marie. *Marie Cosindas: Color Photographs.* Boston: New York Graphic Society, 1978.

Crane, Barbara. *Barbara Crane: Photographs 1948–80,* Tucson, Ariz.: Center for Creative Photography, 1981.

Crimp, Douglas. "The Museum's Old/The Library's New Subject." *Parachute,* no. 22 (Printemps 1981): 32–37.

————. "Pictures." In *Art After Modernism: Rethinking Representation,* edited by Brian Wallis, pp. 175–87. New York: New Museum of Contemporary Art, 1984.

————. "Art and Activism." In *AIDS: The Artists' Response,* exhibition catalogue. Columbus: The Ohio State University Gallery of Fine Arts, 1989, pp. 8–11.

Cross References: Sculpture into Photography, exhibition catalogue. Minneapolis: Walker Art Center, 1987.

Cunningham, Imogen. *Imogen Cunningham: Photographs.* Seattle: University of Washington Press, 1971.

Daguerre, Louis-Jacques-Mandé. "Daguerreotype." In *Classic Essays in Photography,* edited by Alan Trachtenberg, pp. 11–13. New Haven, Conn.: Leete's Island Books, 1980.

Danto, Arthur. *The Transfiguration of the Commonplace: A Philosophy of Art.* Cambridge, Mass.: Harvard University Press, 1981.

Dater, Judy. *Judy Dater: Twenty Years.* Tucson: University of Arizona Press, 1986.

Dater, Judy, and Jack Welpott. *Women and Other Visions.* Dobbs Ferry, N.Y.: Morgan and Morgan, 1975.

Davidson, Bruce. *East 100th Street.* Cambridge , Mass.: Harvard University Press, 1970.

Davis, Douglas. "A Way of Seeing." *Newsweek,* December 3, 1979, pp. 108–12.

————. "A View of the West." *Newsweek,* September 23, 1985, pp. 82–83.

DeGenevieve, Barbara. "Guest Editorial: On Teaching Theory." *Exposure* 26, no. 2/3 (1988): 10–13.

Drier, Deborah. "Cindy Sherman at Metro Pictures." *Art in America,* January 1986, pp. 136–38.

Dworkin, Ronald. "Law as Interpretation." In *The Politics of Interpretation,* edited by W. J. T. Mitchell, pp. 249–70. Chicago: University of Chicago Press, 1983.

Eauclaire, Sally. *The New Color Photography.* New York: Abbeville Press, 1981.

————. *American Independents: Eighteen Color Photographers.* New York: Abbeville Press, 1984.

Edgerton, Harold. *Moments of Vision: The Stroboscopic Revolution in Photography.* Cambridge, Mass.: MIT Press, 1979.

_____. *Stopping Time: The Photographs of Harold Edgerton.* New York: Abrams, 1987.

Edwards, Owens. "Small World in a Room." *Saturday Review,* October 1, 1977.

The Family of Man. New York: Museum of Modern Art, 1955.

Fastman, Raisa. *A Portrait of American Mothers and Daughters.* Pasadena, Calif.: New Sage Press, 1987.

Feldman, Edmund B. "The Teacher as Model Critic." *Journal of Aesthetic Education* 7, no. 1 (1973): 50–57.

_____. *Thinking About Art.* Englewood Cliffs, N.J.: Prentice-Hall, 1984.

_____. *Varieties of Visual Experience: Art as Image and Idea.* 3rd ed. Englewood Cliffs, N.J.: Prentice-Hall and Abrams, 1987.

Fischer, Hal. "Looking into Darkness." *Artweek,* August 13, 1983.

Fisher, Jean. "Barbara Kruger, Annina Nosei Gallery." *Artforum,* January 1984, pp. 115–16.

4 x 4: Four Photographers by Four Writers, exhibition catalogue. Boulder: University of Colorado at Boulder, 1987.

Frank, Robert. *The Americans.* New York: Grove Press, 1959.

Freund, Gisèle. *Photography and Society.* Boston: David R. Godine, 1980.

Friedlander, Lee. *Lee Friedlander Photographs.* New City, N.Y.: Haywire Press, 1978.

Fry, Roger. "Pure and Impure Art," 1924. In *A Modern Book of Esthetics.* 3rd ed., edited by Melvin Rader. New York: Holt, Rinehart & Winston, 1965.

Gauss, Kathleen McCarthy. *New American Photography.* Los Angeles: Los Angeles County Museum of Art, 1985.

Gibson, Ralph. *The Somnambulist.* New York: Lustrum Press, 1973.

_____. *Déjà-Vu.* New York: Lustrum Press, 1973.

_____. *Days at Sea.* New York: Lustrum Press, 1974.

Gitlin, Todd. "Hip-Deep in Post-modernism." *New York Times Review of Books,* November 6, 1988.

Glueck, Grace. "Art on the Firing Line. *New York Times,* Arts and Leisure section, July 9, 1989, pp. 1, 9.

Goldin, Amy. "Diane Arbus: Playing with Conventions." *Art in America,* March/April 1973, p. 73.

Gombrich, E. H. *Art and Illusion: A Study of the Psychology of Pictorial Representation.* Princeton, N.J.: Princeton University Press, 1960.

_____. "Standards of Truth: The Arrested Image and the Moving Eye." In *The Language of Images,* edited by W. J. T. Mitchell. Chicago: University of Chicago Press, 1980.

Goodman, Nelson. *Languages of Art.* Indianapolis, Ind.: Hackett, 1976.

Gowin, Emmet. *Photographs.* New York: Knopf, 1976.

Green, Jonathan. *The Snapshot.* Millerton, N.Y.: Aperture, 1974.

_____. *American Photography: A Critical History 1945 to the Present.* New York: Abrams, 1983.

Greenough, Sarah, and Juan Hamilton, eds. *Alfred Stieglitz: Photographs and Writings.* New York: Calloway Editions, 1982.

Groover, Jan. *Jan Groover.* New York: Museum of Modern Art, 1987.

Grover, Jan Zita. Introduction. *AIDS: The Artists' Response,* exhibition catalogue. Columbus: The Ohio State University Gallery of Fine Arts, 1989, pp. 2–7.

Grundberg, Andy. "Toward a Critical Pluralism." In *Reading into Photography: Selected Essays, 1959–1982,* edited by Thomas Barrow, et al., pp. 247–53. Albuquerque: University of New Mexico Press, 1982. Originally published in *Afterimage,* October 1980.)

_____. "Images from Winogrand's Mosaic of Life." *New York Times,* May 15, 1988, p. 45.

_____. "The Allure of Mapplethorpe's Photographs," *New York Times,* Arts and Leisure section, July 31, 1988, pp. 29–30.

_____. "A Quintessentially American View of the World." *New York Times,* September 18, 1988, p. 35.

_____. "Homelessness at a Remove: An Urge to Stare." *New York Times,* September 25, 1988, section H, pp. 33, 40.

_____. "Review of *Water Towers.*" *New York Times Review of Books,* December 4, 1988, p. 20.

_____. "Hands Pose for Their Portraits." *New York Times,* Arts and Leisure section, January 29, 1989, p. 35.

_____. "Blaming a Medium for Its Message." *New York Times,* Arts and Leisure section, August 6, 1989.

Heartney, Eleanor. "Cindy Sherman." *Afterimage,* October 1987, p. 18.

Heinecken, Robert. *Heinecken: Selected Works, 1966–86.* Tokyo: Gallery Min, 1986.

Hine, Lewis. "Social Photography, How the Camera May Help in the Social Uplift." In *Classic Essays in Photography,* edited by Alan Trachtenberg. New Haven, Conn.: Leete's Island Books, 1980.

Hirsch, E. D. *Validity in Interpretation.* New Haven: Yale University Press, 1967.

Hockney, David. *Photoworks.* New York: Alfred A. Knopf, 1984.

Hoy, Anne H. *Fabrications: Staged, Altered, and Appropriated Photographs,* New York: Abbeville Press, 1987.

Hughes, Robert. "To Hades with Lens." *Time,* November 13, 1972, p. 84.

Hugunin, James. "The Map Is Not the Territory." *Exposure* 22, no. 1 (1984): 5–15.

Indiana, Gary. "Joel-Peter Witkin at Hardison Fine Arts." *Art in America,* September 1983, p. 175.

The International Center of Photography Encyclopedia of Photography. New York: Crown, 1984.

Isenberg, Arnold. "Critical Communication." *Philosophical Review* 58 (1959).

Jordan, Jim. "Chaplin in Hell." *Artweek,* November 10, 1984.

Jussim, Estelle, and Elizabeth Lindquist-Cock. *Landscape as Photograph.* New Haven, Conn.: Yale University Press, 1985.

Kahn, Douglas. *John Heartfield: Art and Mass Media.* New York: Tanam Press, 1985.

Kelly, Mary. "Re-viewing Modernist Criticism." (Originally published in *Screen* 22, no. 3 [1981].) In *Art After Modernism: Rethinking Representation,* edited by Brian Wallis, pp. 87–103. New York: New Museum of Contemporary Art, 1984.

Kimmelman, Michael. "Bitter Harvest: AIDS and the Arts." *New York Times,* Arts and Leisure section, March 19, 1989, pp. 1, 6.

Kismaric, Susan. *Jan Groover.* New York: Museum of Modern Art, 1987.

Koch, Stephen. "Guilt, Grace, and Robert Mapplethorpe." *Art in America,* November 1986, pp. 144 –46.

Kozloff, Max. "The Etherealized Figure and the Dream of Wisdom." In *Vanishing Presence,* exhibition catalogue. Minneapolis: Walker Art Center, 1989, pp. 30–61.

Kramer, Hilton. "From Fashion to Freaks." *New York Times Magazine,* November 5, 1972, p. 38.

————. "Is Art Above the Laws of Decency?" *New York Times,* Arts and Leisure section, July 2, 1989, pp. 1, 7.

Krims, Les. *The Deerslayers.* Buffalo, N.Y.: Les Krims, 1972.

————. *Making Chicken Soup.* Buffalo, N.Y.: Humpy Press, 1972.

————. *Fictcryptokrimsographs: A Bookwork.* Buffalo, N.Y.: Humpy Press, 1975.

————. "Idiosyncratic Pictures," postcard portfolio. New York: Mythology Unlimited, 1980.

Kuspit, Donald, series ed. *Contemporary American Art Critics.* Ann Arbor, Mich.: UMI Research Press, 1986.

Lacayo, Richard. "Drunk on a World Served Straight." *Time,* October 12, 1987, p. 88.

Lange, Dorothea. *Dorothea Lange: Photographs of a Lifetime.* Millerton, N.Y.: Aperture, 1982.

Lanker, Brian, *I Dream a World: Portraits of Black Women Who Changed America.* New York: Stewart, Tabori & Chang, 1989.

Larson, Kay. "Getting Graphic." *New York Magazine,* August 15, 1988, pp. 66–67.

Leekley, Sheryle, and John Leekley. *Moments: The Pulitzer Prize Photographs.* New York: Crown, 1978.

Leo, Vince. "What's Wrong with This Picture?" Interview with Abigail Solomon-Godeau. *Artpaper,* Minneapolis, December 1987, pp. 12–14.

Lippard, Lucy. "Headlines, Heartlines, Hardlines: Advocacy Criticism as Activism." In *Cultures in Contention,* edited by Douglas Kahn and Diane Neumaier, pp. 242–47. Seattle, Wash.: Real Comet Press, 1985.

Lyon, Danny. *Conversations with the Dead.* New York: Macmillan, 1971.

M., S. H. "Documenta: Making the Pointed Pointless." *Artnews,* September 1987, pp. 160–61.

Mapplethorpe, Robert. *Black Book.* New York: St. Martin's Press, 1986.

_____. *Robert Mapplethorpe: The Perfect Moment.* Philadelphia: Institute of Contemporary Art, University of Pennsylvania, 1988.

Marey, Etienne Jules. *Movement.* Appleton, N.Y., 1895.

Margolis, Richard. "The Battle at the SPE Conference." *Images/Ink* 4, no. 2 (1989): 40.

Mark, Mary Ellen. *Passport.* New York: Lustrum, 1974.

_____. *Ward 81.* New York: Fireside Books, 1979.

_____. *Falkland Road.* New York: Knopf, 1981.

Meatyard, Ralph Eugene. *The Family Album of Lucybelle Crater.* Louisville, Ky.: Jargon Society, 1974.

Meltzer, Irene Ruth. *The Critical Eye: An Analysis of the Process of Dance Criticism as Practiced by Clive Barnes, Arlene Croce, Deborah Jowitt, Elizabeth Kendall, Marcia Siegel, and David Vaughan.* Master's thesis, The Ohio State University, 1979.

Mendoza, Tony. *Ernie: A Photographer's Memoir.* Santa Barbara, Calif.: Capra Press, 1985.

_____. *Stories.* New York: Atlantic Monthly Press, 1987.

Meyerowitz, Joel. *Cape Light.* Boston: New York Graphic Society, 1978.

_____. *St. Louis and the Arch.* Millerton, N.Y.: Aperture, 1980.

Michals, Duane. *Real Dreams.* Danbury, N.H.: Addison House, 1976.

Morgan, Stuart. "Something Magic," *Artforum,* May, 1987, pp. 119–23.

Muybridge, Eadweard. *Animal Locomotion: An Electro-photographic Investigation of Consecutive Phases of Animal Movement.* 11 volumes. Philadelphia: University of Pennsylvania, 1887.

NASA. *A Meeting with the Universe: Science Discoveries from the Space Program.* Washington, D.C.: NASA, 1981.

Nettles, Bea. *Events in the Sky.* Inky Press, 1973.

_____. *The Elsewhere Bird.* Inky Press, 1974.

_____. *Mountain Dream Tarot.* Inky Press, 1975.

Neumaier, Diane. "Alfred, Harry, Emmet, Georgia, Eleanor, Edith, and Me." *Exposure* 22, no. 2 (Summer 1984): 5–8.

Newhall, Beaumont. *The History of Photography: 1839 to the Present Day.* 4th ed. New York: Museum of Modern Art, 1964.

_____. *The History of Photography: 1839 to the Present Day.* 5th ed. New York: Museum of Modern Art, 1982.

Newman, Amy. "Who Needs Art Critics?" *Art News,* September 1982, pp. 55–60.

Nichols, Bill. *Ideology and the Image: Social Representation in the Cinema and Other Media.* Bloomington: Indiana University Press, 1981.

Owens, Bill. *Suburbia.* San Francisco: Straight Arrow Press, 1973.

_____. *Our Kind of People: American Groups and Rituals.* San Francisco: Straight Arrow Press, 1975.

Owens, Craig. "The Medusa Effect or, The Spectacular Ruse." *Art in America,* January 1984, pp. 97–105.

Parsons, Michael. *How We Understand Art: A Cognitive Developmental Account of Aesthetic Experience.* New York: Oxford University Press, 1987.

Pitts, Terence. Book review of *Mining Photographs and Other Pictures 1948–1968,* edited by Robert Wilke and Benjamin Buchloh. Cape Breton, Nova Scotia: Nova Scotia College of Art and Design, 1983. In *Exposure* 22, no. 3 (1984): 48–53.

Pollack, Griselda. "Art, Art School, Culture: Individualism After the Death of the Artist." *Exposure* 24, no. 3 (1986): 20–33.

Ricard, Rene. "Not about Julian Schnabel." *Artforum* 19, no. 10 (1981): 74–80.

Rice, Shelley. "Mary Ellen Mark." In *4 x 4: Four Photographers by Four Writers.* Boulder: University of Colorado at Boulder, 1987.

Richards, Eugene. *Below the Line: Living Poor in America.* Mount Vernon, N.Y.: Consumers Union, 1987.

Rickey, Carrie. Lecture at the *Dialogue* Criticism Conference. Upper Arlington, Ohio, November, 1982.

Riis, Jacob. *How the Other Half Lives, 1901.* New York: Dover Publication, 1971.

Rosler, Martha. "Lookers, Buyers, Dealers, Makers, Thoughts on Audience." *Exposure* 17, no. 1 (1980).

_____. *3 Works.* Halifax, Nova Scotia: Nova Scotia College of Art and Design, 1981.

Samaras, Lucas. *Phantasmata: Photo-transformations.* New York: Pace Gallery, 1976.

Sander, August. "Lecture 5: Photography as a Universal Language," 1931. In *Massachusetts Review,* Winter 1978, pp. 674–79.

Scharf, Aaron. *Art and Photography.* Middlesex, England: Pelican Books, 1974.

Schreiber, Le Anne. "Talking to Barbara Kruger." *Vogue,* October 1987.

Scruton, Roger. "Photography and Representation." *Critical Inquiry* 7 (1981): 577–603.

Sekula, Allan. *Photography Against the Grain: Essays and Photo Works 1973–1983.* Halifax, Nova Scotia: Nova Scotia College of Art and Design, 1983.

Siegel, Jeanne, ed. *Artwords 2,* Ann Arbor, Mich.: UMI Research Press, 1988.

Siskind, Aaron. *Aaron Siskind: Photographs, 1966–1975.* New York: Farrar, Straus & Giroux, 1976.

Smith, Loren. *The Visionary Pinhole.* Salt Lake City, Utah: Peregrine Books, 1985.

Smith, Ralph A. "Teaching Aesthetic Criticism in the Schools." *Journal of Aesthetic Education* 7, no. 1 (1973): 38–49.

Smith, W. Eugene, and Aileen M. *Minamata.* New York: Alskog, 1975.

Snyder, Joel. "Picturing Vision." In *The Language of Images,* edited by W. J. T. Mitchell. Chicago: University of Chicago Press, 1980.

Snyder, Joel, and Neil Allen Walsh. "Photography, Vision, and Representation." *Critical Inquiry* #2, no. 2 (1975): 148–69.

Solomon-Godeau, Abigail. "Photography after Art Photography." In *Art after Modernism: Rethinking Representation,* edited by Brian Wallis, pp. 74–85. New York: New Museum of Contemporary Art, 1984.

————. "Winning the Game When the Rules Have Been Changed, Art Photography and Postmodernism." *Exposure* 23, no. 1 (1985): 5–15.

Sommer, Frederick. *Words/Images.* Tucson, Ariz.: Center for Creative Photography, 1984.

Sonneman, Eve. *Real Time.* New York: Printed Matter, 1976.

Sontag, Susan. *On Photography.* New York: Farrar, Straus & Giroux, 1978.

Squiers, Carol. "Diversionary (Syn)tactics." *Artnews,* February 1987, pp. 77–85.

Stevens, Mark. "The Bad and the Beautiful." *Newsweek,* September 26, 1977.

Strand, Paul. "Photography." In *Photographers on Photography,* edited by Nathan Lyons. Englewood Cliffs, N.J.: Prentice-Hall, 1966.

Sturman, John. "Barbara Kruger, Annina Nosei Gallery." *Artnews,* May 1986.

Szarkowski, John. *The Photographer's Eye.* New York: Museum of Modern Art, 1966.

————. *Looking at Photographs: 100 Pictures from the Collection of the Museum of Modern Art.* New York: Museum of Modern Art, 1973.

————. *Mirrors and Windows: American Photography Since 1960.* New York: Museum of Modern Art, 1978.

————. *Irving Penn.* New York: Museum of Modern Art, 1984.

————. *Winogrand: Figments for the Real World.* New York: Museum of Modern Art, 1988.

Thornton, Gene. "A Show That Reveals an Artist at the Height of His Powers." *New York Times,* Arts and Leisure section, January 20, 1985, p. 29.

————. "A Gothic Vision of Man Seen with the Camera's Eye." *New York Times,* August 24, 1986.

Time-Life Series on Photography. *The Great Themes.* New York: Time-Life Books, 1970.

————. *Photography as a Tool.* New York: Time-Life Books, 1970.

Tress, Arthur. *Theatre of the Mind.* Dobbs Ferry, N.Y.: Morgan and Morgan, 1976.

————. *The Teapot Opera.* New York: Abbeville Press, 1988.

Uelsmann, Jerry. *Jerry N. Uelsmann.* New York: Aperture, 1973.

Vanishing Presence, exhibition catalogue. Minneapolis: Walker Art Center, 1989.

Walton, Kendall K. "Transparent Pictures." Address delivered at The Ohio State University, Columbus, Ohio, June 2, 1982.

_____. "Transparent Pictures: On the Nature of Photographic Realism." *Critical Inquiry* 11 (December 1984).

Ward, John L. *The Criticism of Photography as Art: The Photographs of Jerry N. Uelsmann.* Gainesville: University of Florida Press, 1970, p. 4.

Weiley, Susan. "Avedon Goes West." *Artnews,* March 1986, pp. 86–91.

Weitz, Morris. *Hamlet and the Philosophy of Literary Criticism.* Chicago: University of Chicago Press, 1964.

Weston, Edward. "Techniques of Photographic Art." *Encyclopedia Britannica,* 1964 edition, pp. 942–43.

_____. *The Daybooks of Edward Weston, Volume II California.* Millerton, N.Y.: Aperture, 1973.

_____. *Edward Weston: Fifty Years.* Millerton, N.Y.: Aperture, 1973.

_____. "Seeing Photographically." In *A Modern Book of Esthetics.* 4th ed., edited by Melvin Rader. New York: Holt, Rinehart & Winston, 1973.

White, Minor. *Mirrors Messages Manifestations.* Millerton, N.Y.: Aperture, 1969.

_____. "Found Photographs," 1957. In *Photography: Essays and Images,* edited by Beaumont Newhall, pp. 307–9. New York: Museum of Modern Art, 1980.

Wilson, William. Review of Avedon's "In the American West." *Artforum,* September 1985, p. 7.

Wimsatt, William, and Monroe Beardsley. "The Intentional Fallacy." In *The Verbal Icon,* edited by Wimsatt and Beardsley. Louisville: University of Kentucky Press, 1954.

Winogrand, Gary. *The Animals.* New York: Museum of Modern Art, 1969.

_____. *Women Are Beautiful.* New York: Light Gallery, 1975.

Wise, Kelly. *The Photographers' Choice.* Danbury, N.H.: Addison House, 1975.

Witkin, Joel-Peter. *Joel-Peter Witkin,* San Francisco: Museum of Modern Art, 1985.

Wolfe, Tom. *The Painted Word.* New York: Farrar, Straus & Giroux, 1975.

Woodward, Richard B. "It's Art, but Is It Photography?" *New York Times Magazine,* October 9, 1988, pp. 29–31, 42, 44, 46, 54, 55, 57.

_____. "Picture Perfect." *Artnews,* March 1988.

Zelevansky, Lynn. "Barbara Kruger, Annina Nosei Gallery." *Artnews,* May 1983, p. 154.

CREDITS

INDEX